25

AND UNDER

TWENTY-FIVE AND UNDER / PHOTOGRAPHERS

A DOUBLETAKE BOOK PUBLISHED BY THE CENTER FOR DOCUMENTARY STUDIES IN ASSOCIATION WITH W. W. NORTON & COMPANY NEW YORK • LONDON

EDITED BY ALICE ROSE GEORGE INTRODUCTION BY ROBERT COLES

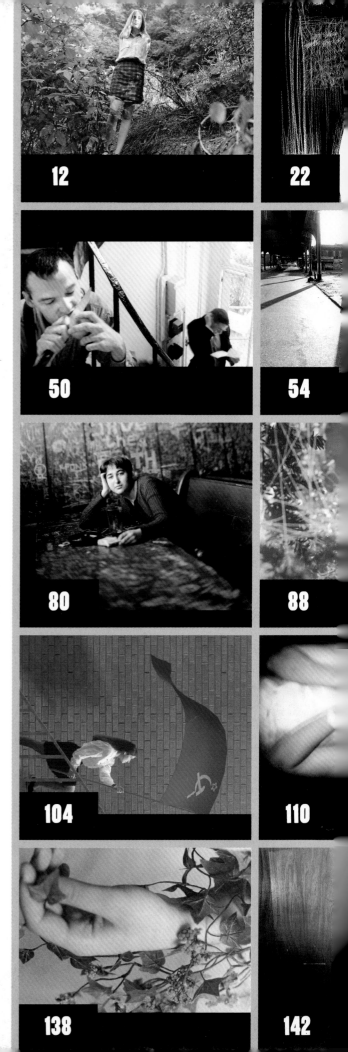

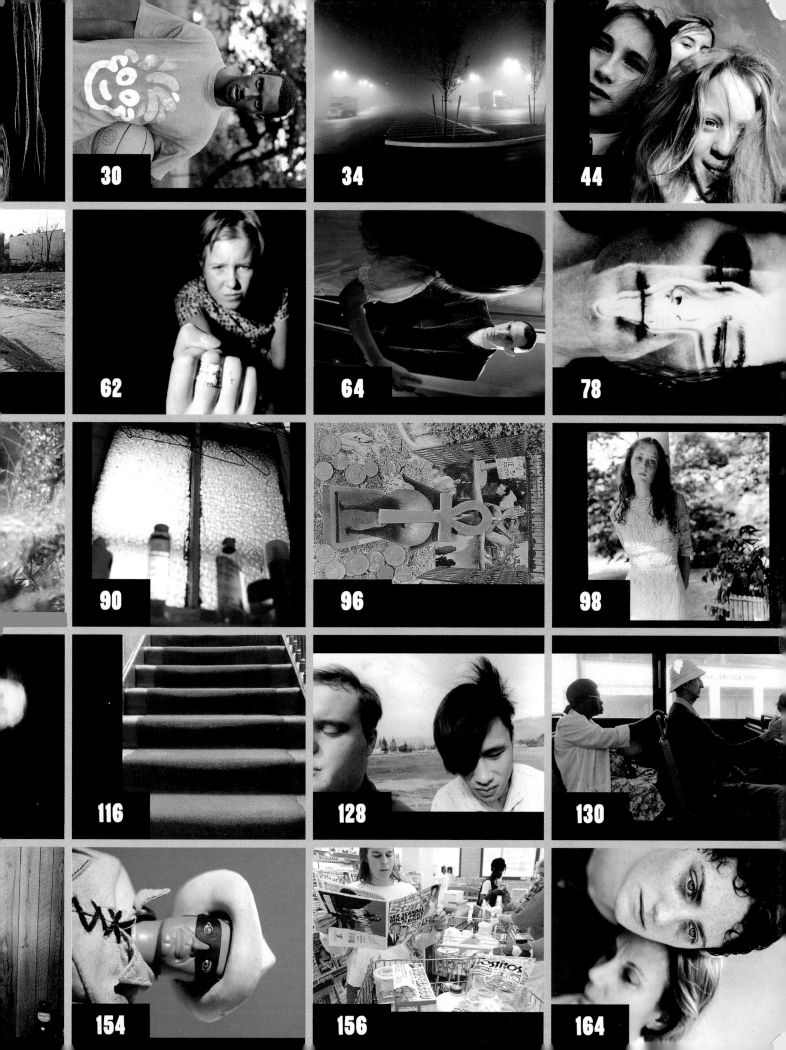

FOREWORD **ALICE ROSE GEORGE**

I had been working for the Center for Documentary Studies at Duke University for some time when Robert Coles, coeditor with Alex Harris of the center's *DoubleTake* magazine, asked what the younger generation was photographing. I have never paid special attention to age when looking at a person's work, so I had no ready answer. But my curiosity was aroused. With Coles's prompting, I began to investigate.

There had to be some parameters for the project. Age was naturally the first. Twenty-one seemed too early for talent to have begun to take shape, although there are exceptions, as seen in this book. On the other hand, a person still photographing by the age of thirty would have become more or less a professional. So I chose twenty-five as the cut-off. Drawing on an enormous Rolodex acquired from years "in the business," I called editors, educators, agencies, photographers, and friends around the country. To give some geographical shape to the project, I limited it to those living in the United States though the photographers did not have to be American citizens. I followed every lead. Colleagues were very responsive, recommending, as I had requested, only those people they considered exceptional. It is the people who made the recommendations that are the secret to what, I hope, is the success of this collection. Obviously, many photographers were recommended who did not make the book; many of them deserve to be published.

As the work came in—and there were many portfolios—I was struck by the high technical quality of the photographs. I found a reverence for fine printing that has not always been the case with young photographers and that is particularly surprising in this generation, given the predictions of the demise of print photography in the digital revolution.

These photographers use the new technology with a reassuring ease but do not allow it to consume the medium. Also of note was the obvious education that has been taking place among photographers. In the past, the profession was often learned on the street. Knowledge of the history of photography was left to the curiosity of the individual. Today, familiarity with what has gone before informs a majority of the work that I have seen. These young photographers are also realists; they have less romantic notions about what life as a photographer will be.

In terms of subject matter, I discovered a preoccupation with the photographers' immediate environment. Few of them are driven out of their own world to take pictures. The foreign is not so alluring; it is not a prerequisite for photographing, as was often the case in the past, when, for many people, photographing meant going out into the world to tell a story. Today, it is as if these young photographers acknowledge a necessity to start at home. They seem to believe that forces outside themselves—as diverse as politics or exotica—do not hold the answers.

We are all myopic when we are becoming ourselves. But this particular group seems to be preoccupied with itself less as a passing phase and more as a rethinking of the individual's place in society. There is a recognition here that the world at large offers little solace. The cynicism that follows from such a recognition, however, is not necessarily assuaged by the comforts of home. Likewise, the family and friends in these pictures offer little solace. Mainly, questions are posed, attitudes are examined. It is not lost on this group that everything has already been photographed. As a result, they are willing to create the reality they want to photograph. In general, it seems there is a more purposeful blurring of fact and fiction.

In this collection, I have not tried to make a statement about current trends or to predict the future. I have simply tried to take the best of what I saw. It was more a pleasure trip than a scientific one—except for the question of age. Having looked at such promising work, I am curious to see which young photographers continue with the medium, which choose sideroads, and which, if any, reject photography altogether.

I have to say a special thanks to my assistant through all of this—Armin Harris. I asked him to work with me on the project because I know he has a good eye, he is more organized than I, and he is under twenty-five. He was a great partner.

And I would like to thank all the people who responded to my calls with suggestions and advice, but particularly to the following, whose recommendations led to a final group from which the published photographers were taken: Bill Bamberger, Geoffrey Biddle, Eric Breitenbach, Jean Caslin, Lois Conner, Larry Fink, Allen Frame, Miguel Gandert, Stefan Garard and Gen Art, Philip Gefter, Emmet Gowin, Joel Leivick, Reagan Louie, Carole Kismaric, Manual (Ed Hill and Suzanne Bloom), Keith McElroy, Jennifer Miller, Christine Osinski, Tod Papageorge, Esther Parada, Daniel Roebuck, Thomas Roma, Margaret Sartor, Stephen Shore, Rose Shoshana, Tom Southall, Michael Spano, Joel Sternfeld, Mary Virginia Swanson, Mary Torrici, Charlie Traub, Chuck Wentzel and Scholastic Art and Writing Awards, and Lloyd Wolf. And to Lee Marks, who gave continual professional support.

I am grateful to the people at the Center for Documentary Studies who worked on the production of this book, especially Darnell Arnoult, who wrote the biographies.

And special gratitude to Robert Coles and Alex Harris for working with me to make this happen.

INTRODUCTION ROBERT COLES

These photographers, all under twenty-five, have grown to maturity in a century that itself has witnessed the emergence from obscure infancy of an art, even a profession, that is now thoroughly grown up, able to exert its particular hold on our aesthetic and moral imagination. The camera has become a mainstay of our ordinary life—the camera that brings us snapshots and family albums, and the camera that brings us the movies, not to mention the constant presence in our homes of television. In a sense, then, this has been a century of hugely expanded vision, maybe not in the introspective, ethically awake use of that word, but in the more literal meaning: we can see so very much, through telescopes that take us across unimaginable distances, aeons of time, and through microscopes that get to the very heart of matter, and again, through the constant parade of images that come our way at the beck of our call—a TV knob turned, a movie ticket bought, the click of a picture-taking instrument we have purchased at no enormous cost. Even our newspapers, magazines, books, a means to a different kind of visual experience, the sight and contemplation of words, have become more insistently illustrative, and, of course, the book itself as a pictorial rather than textual event is no stranger to us these days.

All of us are sighted, as it were, in ways and to a degree that we may take for granted, never fully realize. Indeed, as I looked at the photographs in this book, read the personal statements that go with them, I remembered many conversations I had with Erik H. Erikson, a distinguished psychoanalyst (hence someone trained to listen carefully, to attend to the spoken language of those who lie prone, their eyes unable to see him), but also an artist, whose promising career took a turn when he met Anna Freud in Vienna and

shortly thereafter, began a course of training in what he once called "looking within"—an activity he contrasted to that of his earlier life when he "looked at the world outside [himself] and tried to represent it to others, in a personal way, of course." He was, actually, much given to reflection upon that word "looking"—even decades after he'd stopped making sketches, woodcuts, in favor of making sense of what analysands told him, or through the study of lives such as those of Luther and Gandhi, in the study of history itself, as it gets shaped by such individuals. I well remember how he started one long discussion we had, triggered by that word "looking"—remember him trying to remember his own youth, lived in the first decades of this century, compared to the youths of those he treated psychoanalytically or encountered as a much revered college professor in the later decades of the same century: "I think our eyes are worked harder now—but maybe we take them for granted more."

He paused—prepared to expand upon the irony he had just summoned, and then, in a long tape-recorded reminiscence, tried to explain his sense of an important generational distinction: "When I first became involved with psychoanalysis, I was in my twenties and I wasn't sure where I was going in life. I was an artist—people called me that: I did drawings and woodcuts. Then I got a job teaching—in a school whose children were the sons and daughters of people being psychoanalyzed by Freud and his colleagues. That's how I got into [psychoanalytic] training—Anna Freud felt I'd do well, working with children. She was then developing a whole new field—child psychoanalysis. I remember saying to her one day [he was then in analysis with her] that 'I'm not for this,' words to that effect. She wanted to know why—of

course!—and even now I can hear myself replying: 'You people are listeners, and I'm someone who learns in a different way.' She wanted me to go on, and I did—I told her that my eyes were the way I took in the world, more so than my ears. She didn't say anything more—the [analytic] hour winded down; but the next day we were back at the same subject, and she very nicely told me, at one point, that 'child analysis really needed visual people.' I didn't know what she meant—so, she explained herself. She reminded me that young children take in the world through their eyes—language comes later. Then she gave me a bit of a lecture—she was a precise, clear-headed teacher. She said that in analysis we have to learn to *see*, as well as to hear—we have to 'take in' the person we're working with, through our eyes as well as our ears. We were getting into a lot of psychological symbolism, obviously—I'll spare you the details! But what I remember from that 'hour'—well, I was given a kind of sanction: I'm someone who engages with the world through my eyes, and they will be as important in my work with patients as they are when I'm working on a canvas or with a pencil or pen and paper.

"Back then, in our psychoanalytic conferences, everything was talk: the patient said this, and that—and we had this or that to say in response [as discussants of the 'case']. In contrast, I was always asking about *appearances*—and I hoped I wasn't being 'superficial.' As I look back at that time, and compare it with our time, I realize how different this world is. Now, our eyes are constantly being given something to do! Back then, many psychoanalysts talked of closing their eyes, while they listened, listened very intently. Now, we look and look and look—and our patients are telling us that they saw this, they saw that, at the movies and on TV and in the maga-

zine advertisements. You have to have come from another world, maybe, to appreciate what this one is like—and yet, I'm not sure a lot of people really *notice* things, pay attention to them, even if they're able to see everything, it seems, just by looking at the screen. Anna Freud once said, 'People hear, but they don't necessarily listen,' and I would add that these days, people look, but they don't necessarily see."

The issue, of course, is attention—whether it be visual or aural: what it is that impresses itself upon us, to the point that we pay heed, go beyond the blur of sight or sound, focus on an image, a remark in such a way that we are given reflective pause. Under such circumstances, a person is going through an experience, a moment in time that matters—something truly witnessed, something truly heard and kept in mind, as opposed to the rush of things that the existentialist philosophers (and psychologists) call "everydayness": the inattentiveness that characterizes a headlong or bored or distracted or self-absorbed drift or plunge through time, when we are "turned off," a description that applies to the relationship between our sensory apparatus (eyes and ears, both) and our cognitive and ethical eyes. In contrast, a breakthrough moment has us, suddenly, alive to the world, and of course, to ourselves—now we are awake to what is out there, and to ourselves as part of what makes up a particular scene: the self experiencing both itself and what (who) is around itself. Not that the choice is *only* ours—sometimes we are, so to speak, seized by the world, grabbed by its press of events, of stimuli, shaken into a wakefulness that brings us to full (emotional, sensual, moral) life—hence the phenomenological insistence that "the self is the way an individual structures experience." On occasion we cry, amidst boredom, for such "experience"; at

other times, we are all too self-preoccupied, hence relatively impervious to such "experience"—the world passes by us, locked as we are within a consciousness that is often more semiconsciousness.

Youth is for some who live in the relative comfort of the bourgeois West such a time of self-absorption: a well-known willfulness that fuels a decided turn from the ordinary, the conventional, and a seeming indifference (if not hostility) to what others take seriously. Once, working psychiatrically with such a young person, I heard all of the foregoing given a sharply knowing, almost revelatory condensation: "I'll be in a daze, because that's where I want to be, I guess, and then suddenly, I'll see something, I'll really grab on to it, and then I'm not just me and my thoughts, I'm me letting the world come inside. I call it, getting hit by a sight."

I kept thinking of him, under twenty-five then, as I looked at the "sights" these young men and women have chosen to offer—their take on what is around them, their visual grasp of things, their capture, as it were, of a "hit" sent their way. Their particular sights become, for us, a collective or generational sighting. They memorialize, courtesy of the camera: streets and rooms and stores and fields and cars and public conveyances, a phone booth here, a bed there, and through it all, human beings in various shapes and sizes going through the motions of life, and thereby, one speculates, bringing to life (giving direction and purpose to) these youthful observers who, as Erikson reminded us, have it in their capacity to roam a particular world in such a way that what they come to regard seriously, the rest of us are enabled to glimpse (at the least), then perhaps, take in, take seriously—a visual culture yet again coming at us, even in a book, once the exclusive province of words, which (as the poet William Carlos Williams once put it) "you hear, while reading them."

I thought of Williams, too, as I turned these pages, looked and looked again—transported, thereby, from one observed or imagined world to another. He was himself (like Erikson) an artist as well as a writer. He painted pictures, looked at them with enormous interest, had close friends such as Marsden Hartley and Charles Sheeler, whose canvases attracted much attention from those who visited galleries, museums. He was a determined "localist," ever ready to spot the arresting, the ironic, the amusing, the melancholy, or the scary in the neighborhood where he lived, the streets he traveled to do his (medical) work. In his stories and his verse (and especially in his longest, lyrical poem, *Paterson*) he cast his eyes upon a scene he knew well, even as his ears had recorded for him the rhythms of a language-in-the-making, the vernacular expression of immigrant, working-class life. "I use my eyes and ears to find my wits," he once tersely put it. Similarly, these young men and women try to apprehend what is available, courtesy of luck and chance and circumstance: their fate to be *here*, to notice what is *there*. Out of such a world, so ordinary and humble, comes nothing less than inspiration, Williams knew—and so it has gone for these young photographers, who have dared take to heart what he put forward as a challenge: "outside / outside myself / there is a world. . . ."

Such a world, always, is a mix of the objective and the subjective—the individual's sensibility coming to terms with an observable reality. Even as painters explored themselves, the range of their own feelings and attitudes, through the representation they gave to the external world (expressionism), these photographers know, upon occasion, to look inward by look-

ing outward; know to let their minds play with, amplify, modify, and distort what their eyes have chosen to recognize, their hands (courtesy of technology) to record—a camera's click becomes, in no time, Cartier-Bresson's "decisive moment." To grow up, actually, is to be able to experience such an awareness: time selected and considered; time wrested from eternity, from its endless succession; time now become the occasion of an event, which the eyes want to do more than behold—possess, then share with others, in the hope that one person's "moment" becomes that of another, even if from afar.

"We learn from one another," Dr. Williams once said impatiently, after hearing a medical student ask him about his patients, their "role" in his writing life, which he had to steal, bits and pieces, from the time required by an extremely busy medical practice. These photographers tell us in their personal statements, and through their pictures, what they have learned from the people who, and the places which have figured in their lives. In back lots and buses, in bedrooms, the camera, in knowing, subtle hands, brings us up close to a late-twentieth-century American life in all its variousness—though, of course, we also have here the universals of human experience: we all eat and sleep and form attachments, and, alas, form grudges, feel distrust, and worse. When I look at a photograph (that of Michael Lewis) in which a woman sits on the side of a bed, and a man stands with his back toward her, his face toward me, the viewer, I think of Edward Hopper's expeditions into such rooms: love and its affirmations, its possible discontents—the strange and haunting intimacy that stirs minds mightily, the minds of the ones who are or have been making love, and the minds of the rest of us, who look and remember and wander and wonder in our thoughts. Hopper, like Williams (whom he

much admired), took to the streets near his home, and what he didn't actually see, and later, recall, use in his work, he saw in a different sense: the imagination, which can create its own world of sight and sound, hence his wonderfully suggestive, evocative paintings, which "tell" of restaurants and movie houses and offices and living rooms or bedrooms, of porches and railroad stations—each the beginning of a story, one the viewer is meant to extend, conclude. The viewer's personal stamp gets imposed upon what is, after all, pigment artfully arranged on a piece of cloth tacked or framed for a painting.

In her account of this book's history, Alice Rose George mentions a curiosity on my part with respect to young photographers—their interests and concerns, and by extension, their values as their work reveals them. Well, what follows is the answer to that curiosity—and not surprisingly, it is an answer which attests to the triumph, once more, of human need and contingency over ideology, even the generational kind. Erikson was right—we today "see" so very much, courtesy of technology. But as a psychoanalyst (and as a person) he knew that all of us, no matter where and when we live, and no matter how long we have been here, and how long we have to go, must do as these people in these pictures do: get something to eat; travel to work or to our homes; have fun, play; connect with others; laugh, or look sad because we feel low; take in the world (its beauty, its ugliness) and give back to the world (our ways of being, acting). To be "under twenty-five," then, and graced with the skill to take poignant or powerful or arresting or unsettling pictures is, finally, to be a human being, put here with that camera of cameras, the mind's eye, and all it can envision, suppose, guess, dream, gather—and, not least, offer to others.

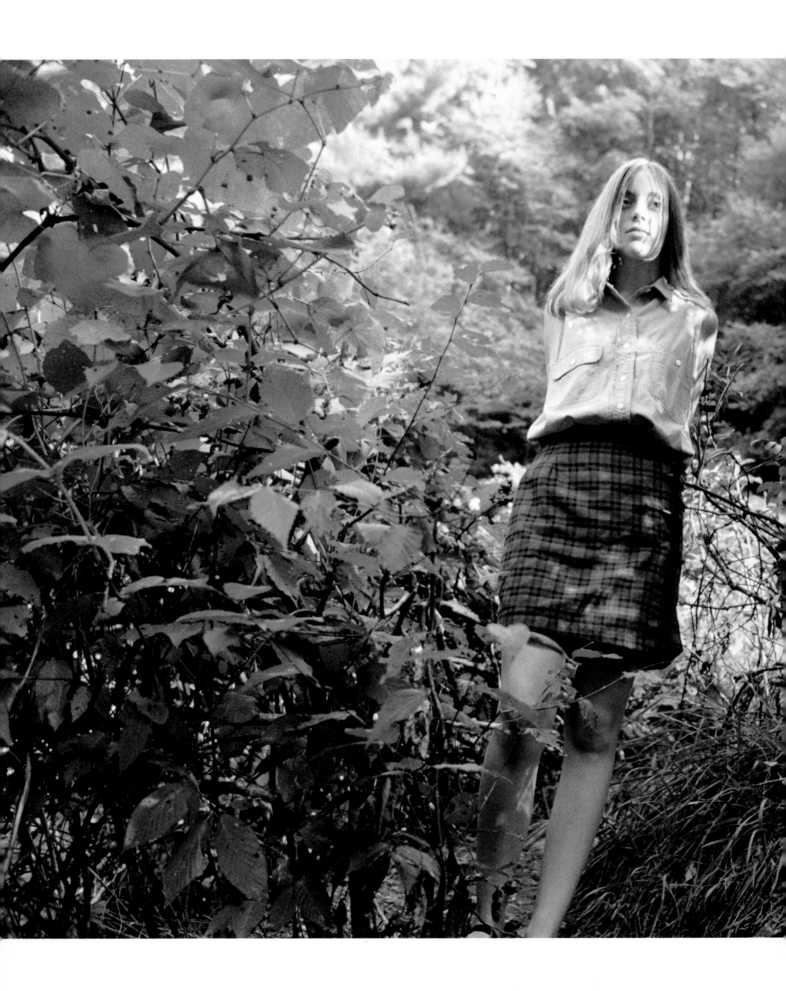

REUBEN COX

Born 28 March 1972, Highlands, North Carolina. Graduate of The Cooper Union. "I have always been mystified by the force that brought me from a log cabin out in the woods to Gotham City. Certainly, it's the same force that brings me to a photograph. When I'm photographing, I feel like I'm at a flea market; I don't know what I'm looking for until I see it. It's a collaboration with the world, and what I can find is always wilder and more interesting than what I can make up." Access to a great darkroom, a love of machines, and being a shy teenager all worked to his advantage, says Reuben Cox. He was drawn to photography as a high school student at the North Carolina School of Science and Math. ¶ To describe himself, Cox quotes poet and friend Jonathan Williams: "If you don't take a rip, you won't do diddly. . . . Guys like the Babe and Hammerin' Harmon Killebrew struck out more than all the others, just to hit the big one. That suits me just fine." "What I want from photography," adds Cox, "is to learn about the world and myself and to simply be able to buy time to photograph."

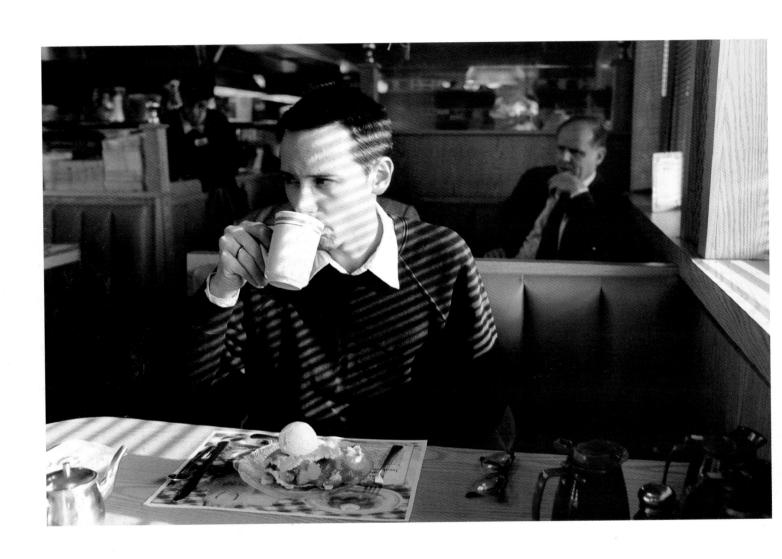

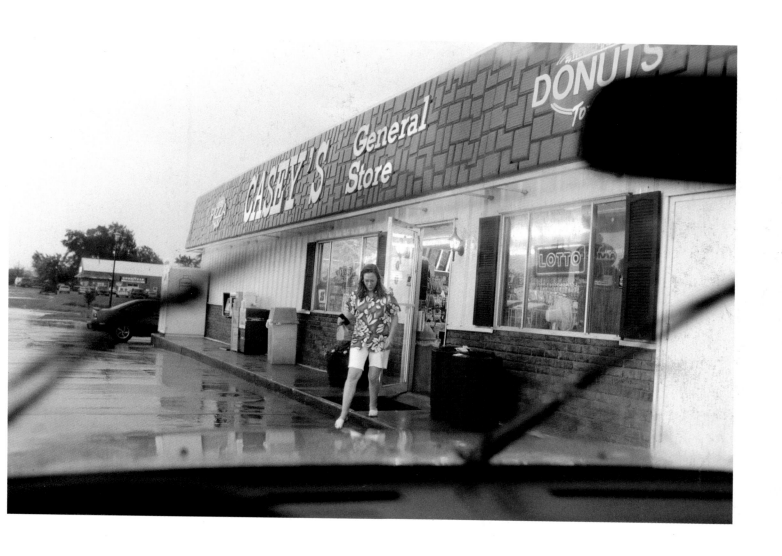

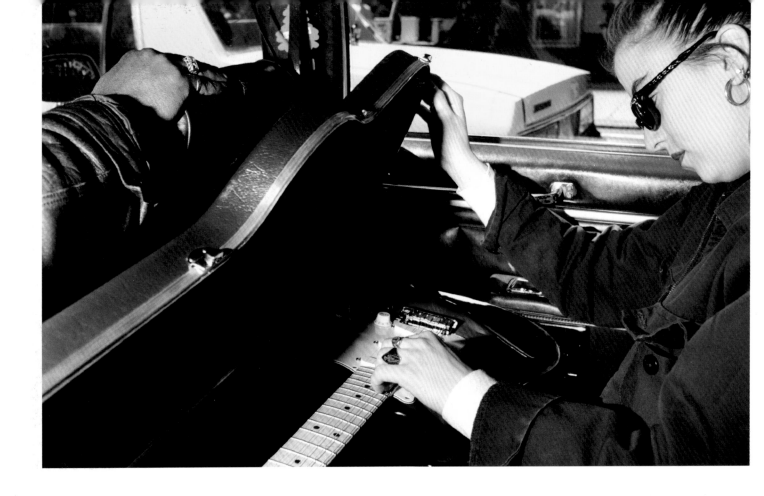

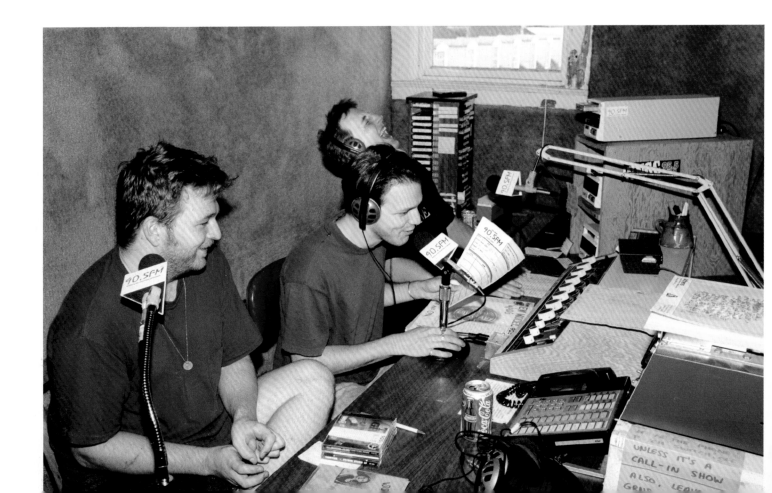

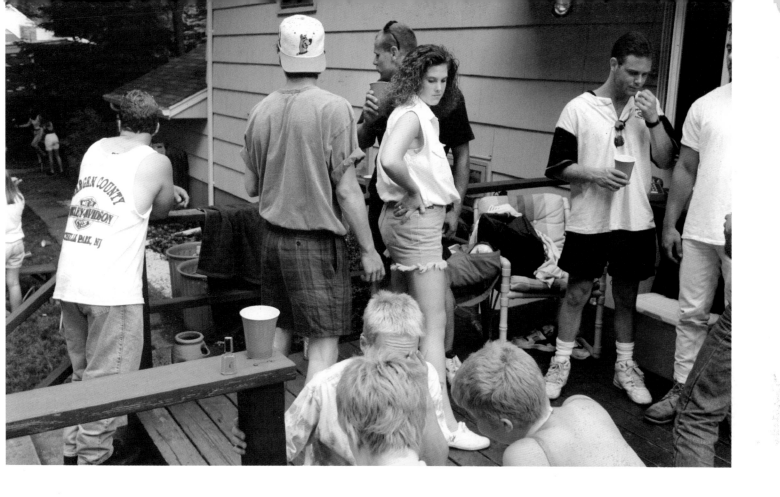

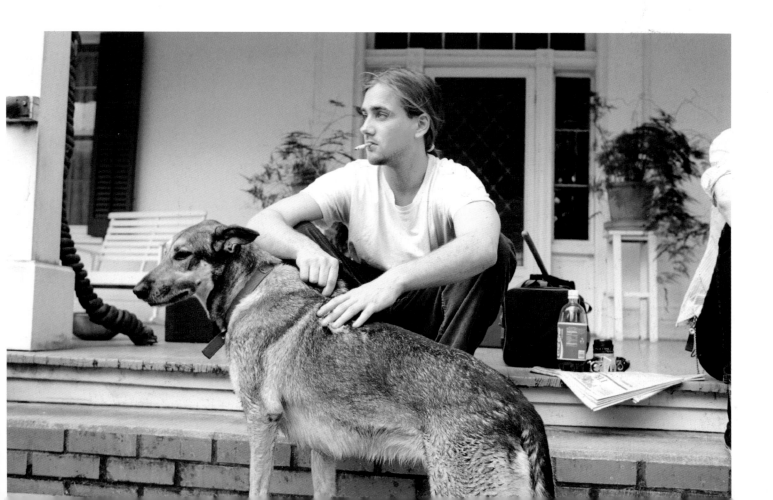

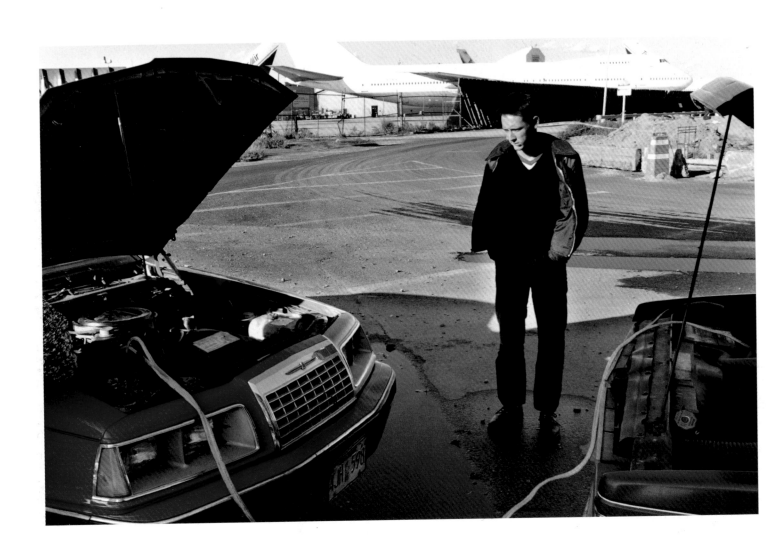

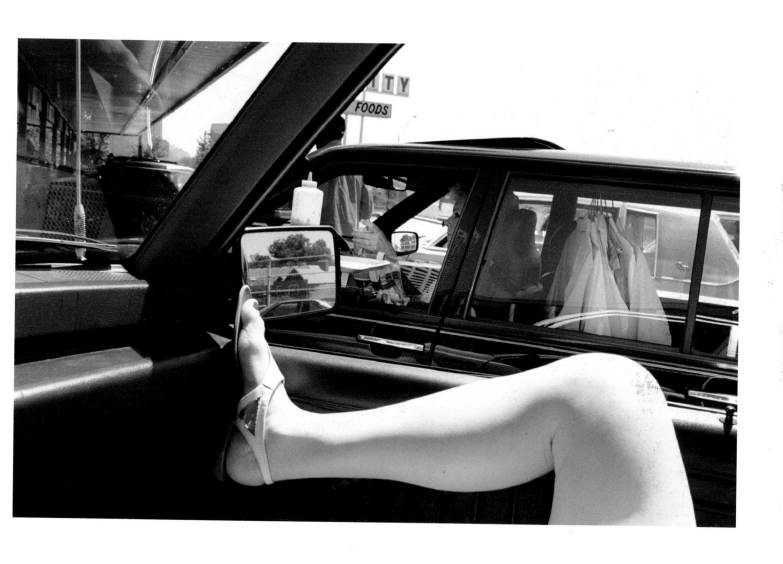

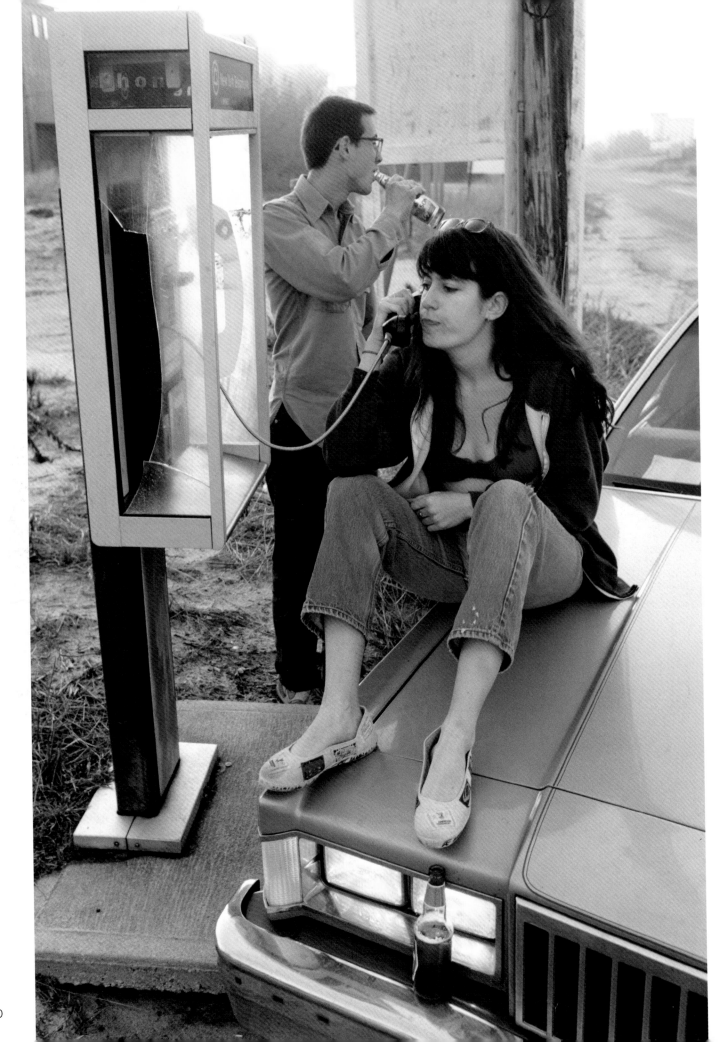

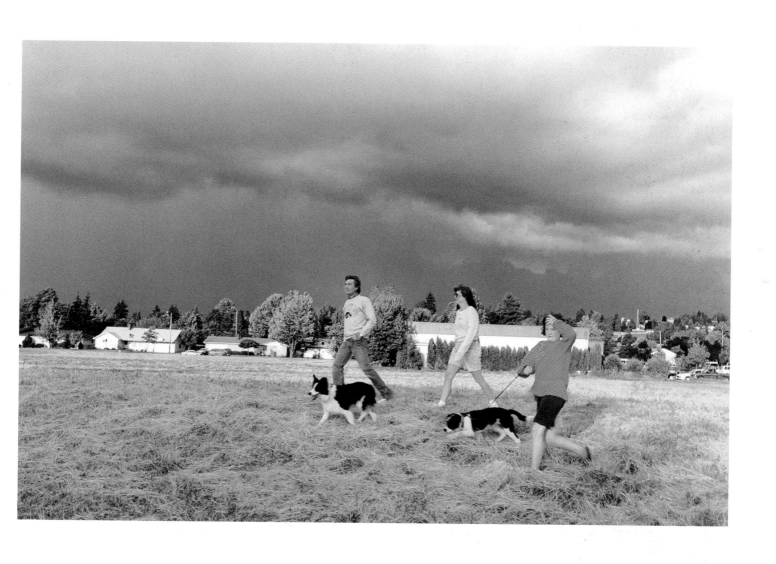

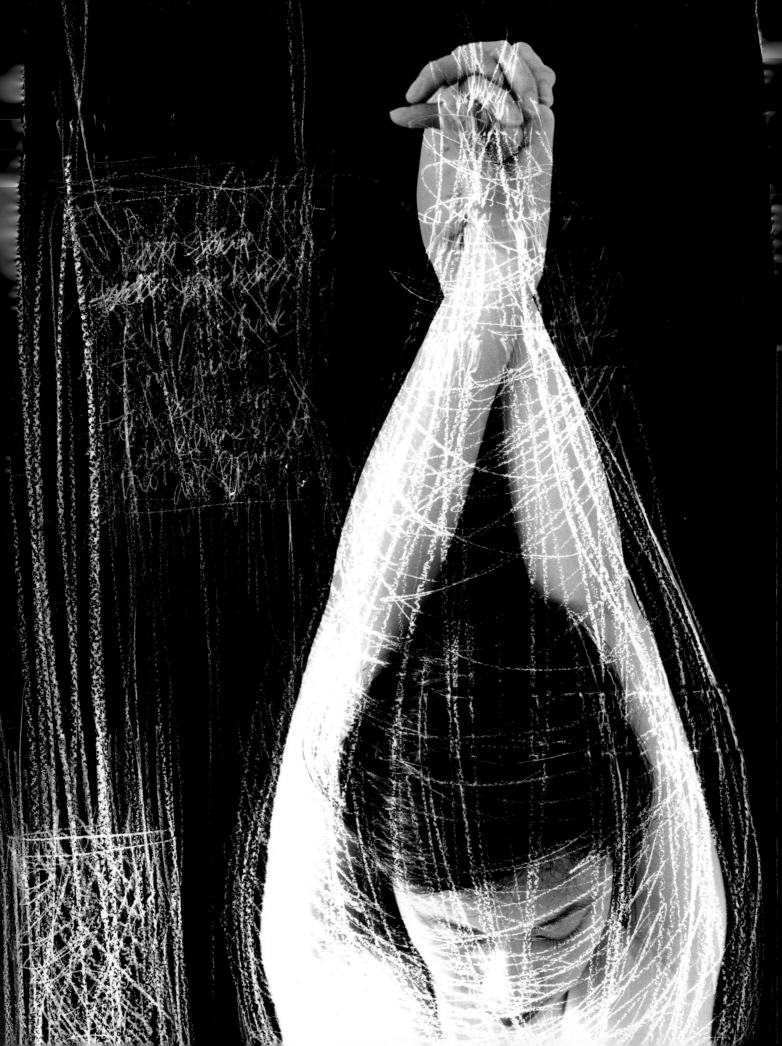

TRACEY CHIANG

Born 15 July 1970, Manchester, Connecticut. Grew up in Mansfield, Connecticut. Graduate of Brown University and the School of the Museum of Fine Arts at Tufts University; M.F.A., School of the Visual Arts. Tracey Chiang draws on her background as an artist and painter. In words and lines scratched across negatives that are self-portraits, she tells us that she can't find her thread, she has no needles. ¶ "As a child growing up in a white community, I wished my Chineseness weren't so visible; as an adult living in a non-Chinese society, I am afraid of losing the intangible elements of being Chinese. In America, a woman is respected if she can stand up for herself in a situation that she believes to be intolerable; in Asia, a woman is respected if she has the inner strength to tolerate and survive. I am never enough of one thing—Chinese, American, passive, aggressive—to be seamlessly whole, but I am afraid to be too much of one thing and, as a consequence, lose the other entirely. My work is about wanting to be understood without having to speak out loud in English or in Chinese, simply through my own visual language. I want people to recognize decisiveness within my quietness, and to understand that what is strong and what is fragile aren't so different." ¶ Chiang says she is afraid of disappearing, therefore she struggles to decipher her individual equations of rootedness and disconnection, and through her self-portraits and almost ritual markings, finds a voice to speak eloquently about race, gender, restrictions, and generations.

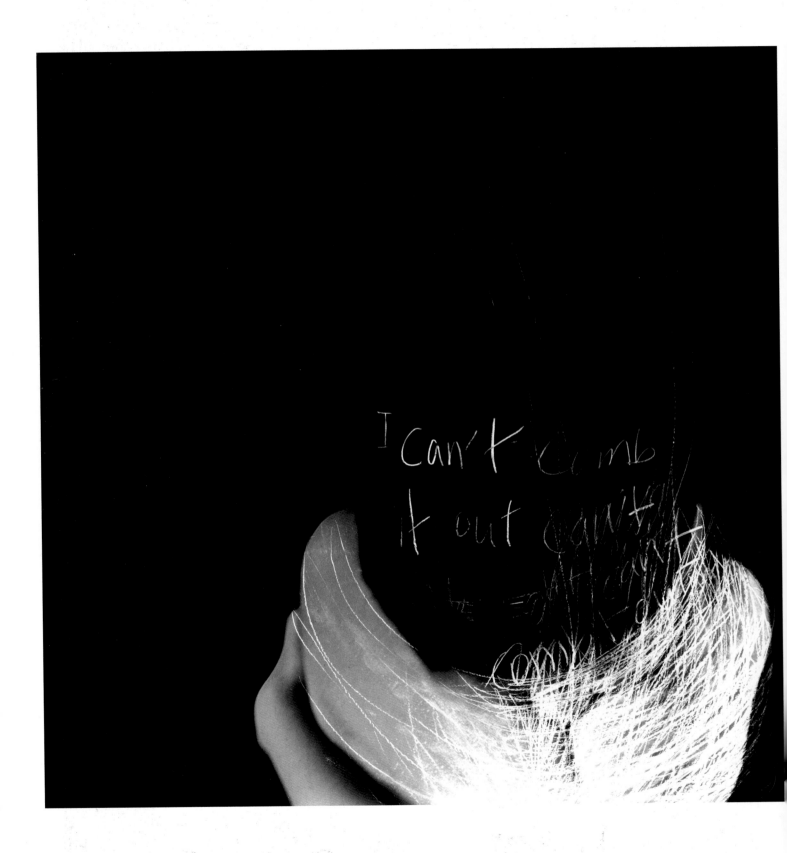

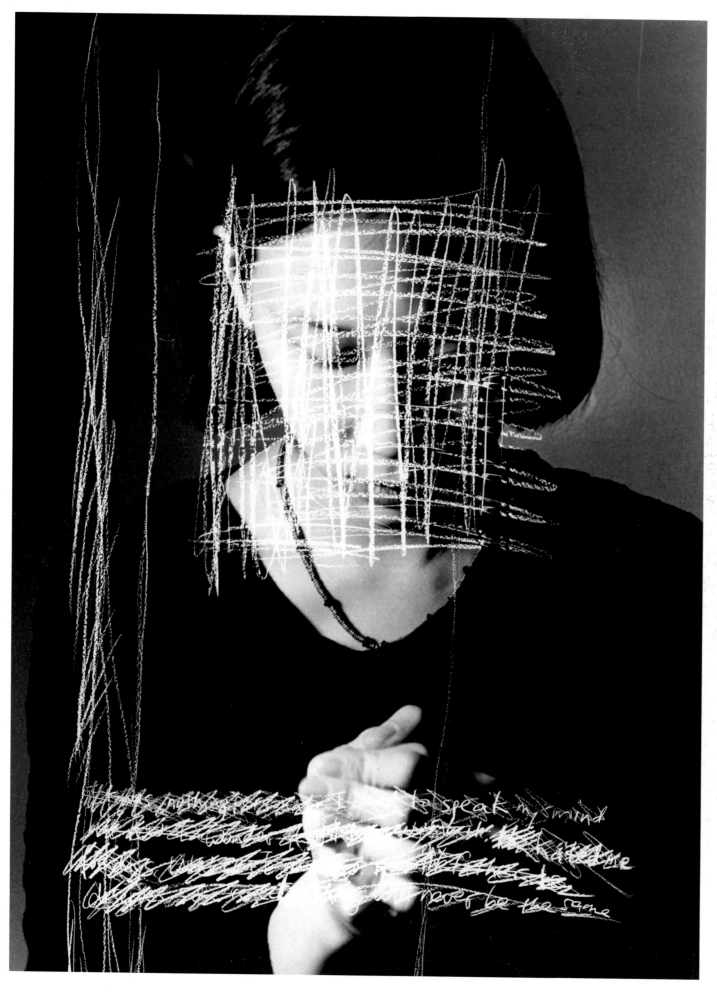

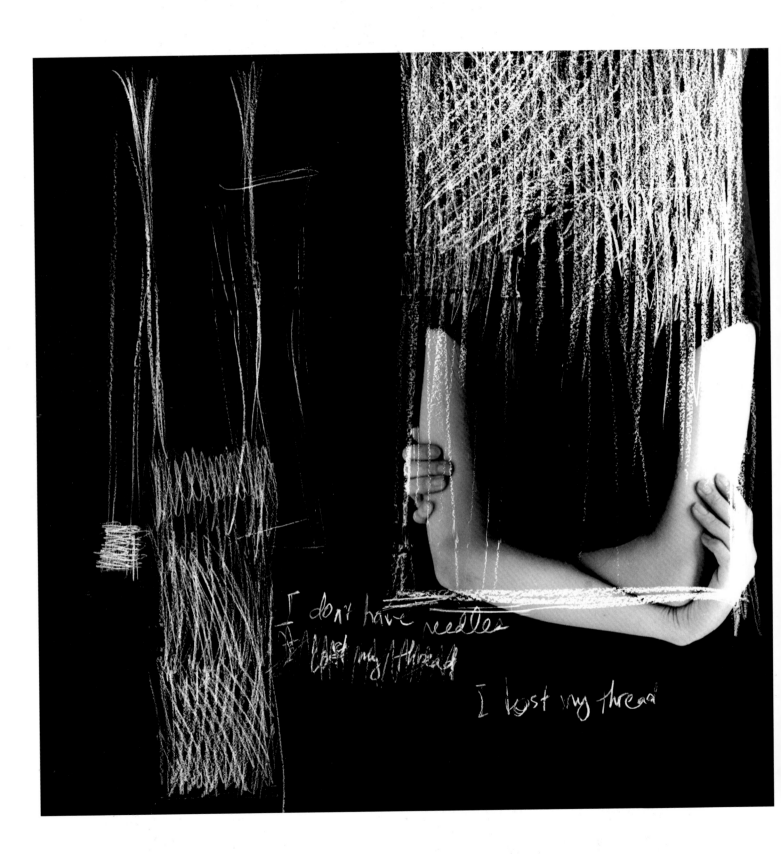

I don't have needles
I lost my thread

I lost my thread

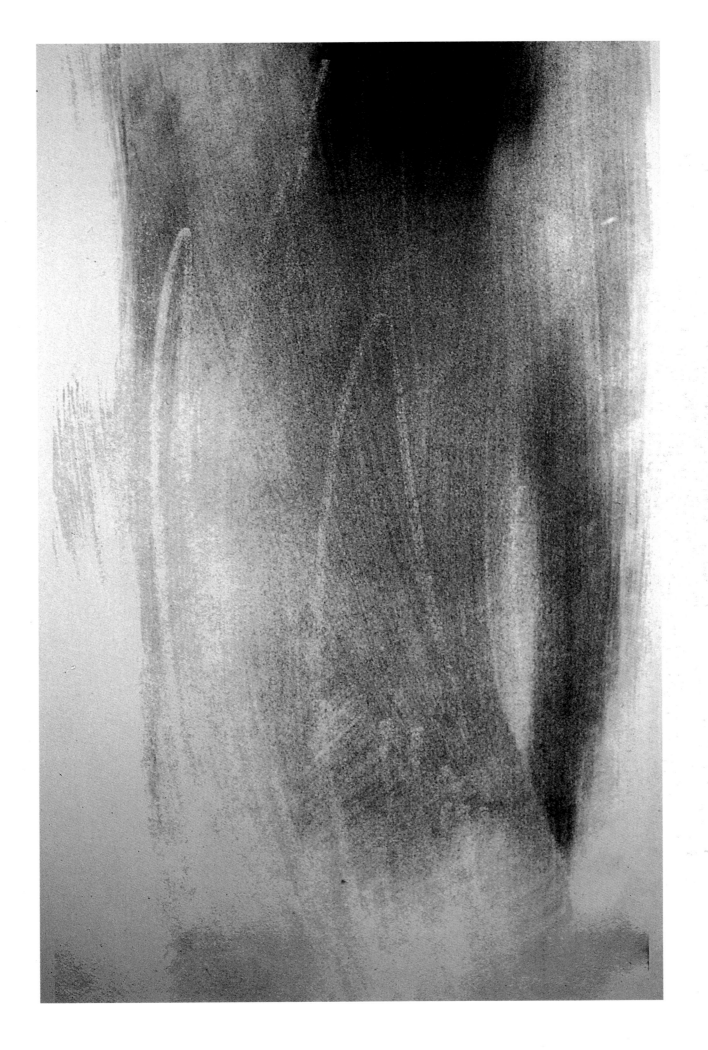

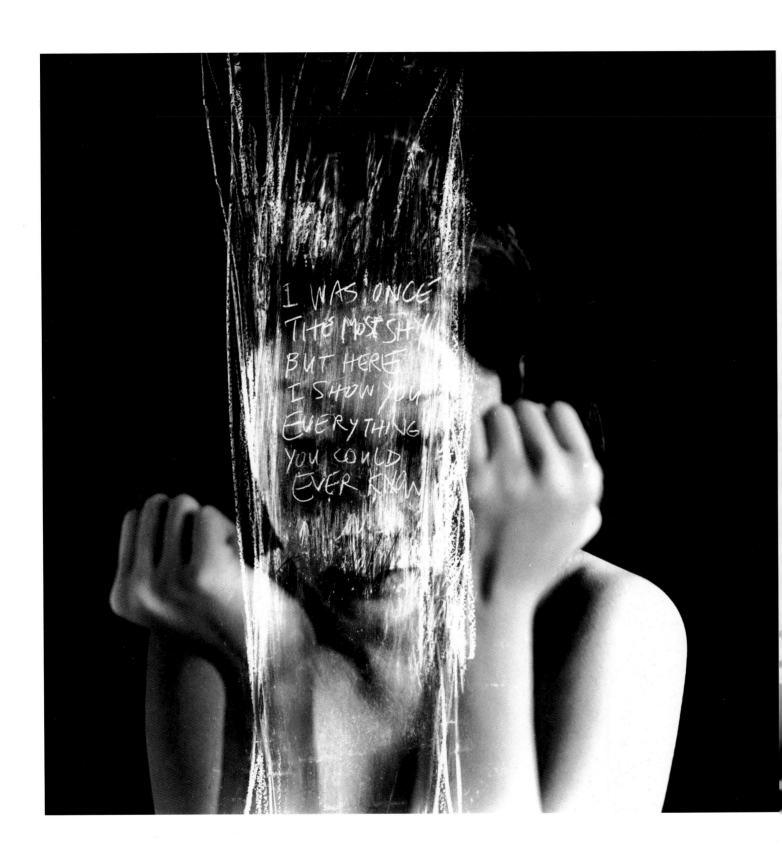

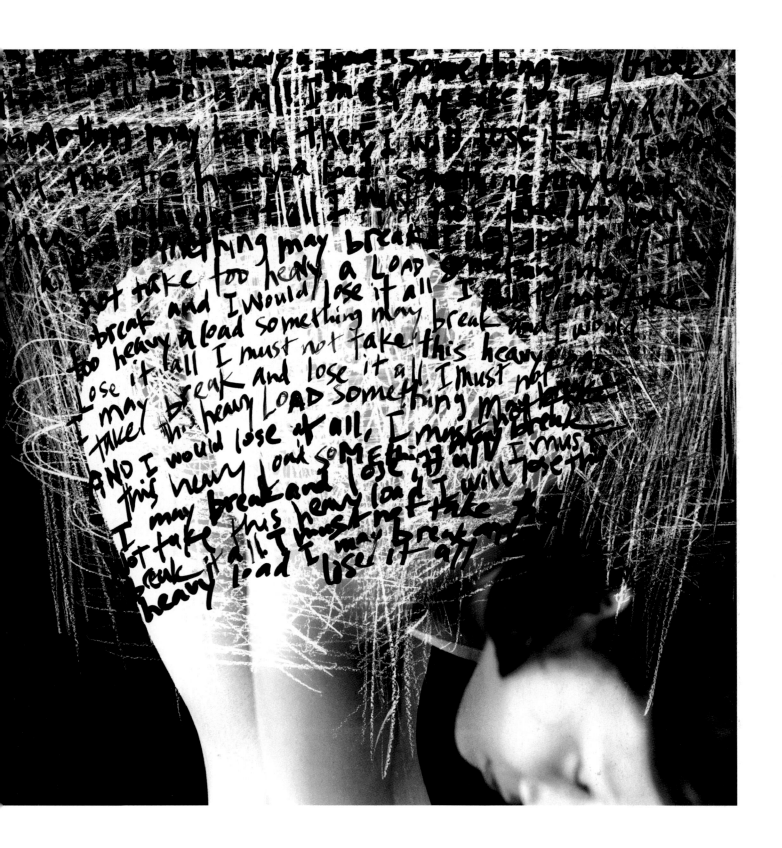

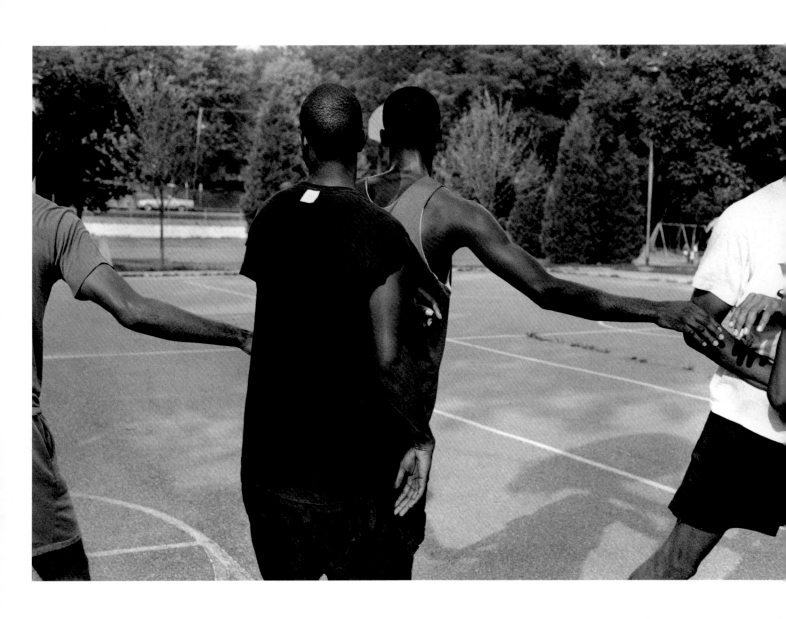

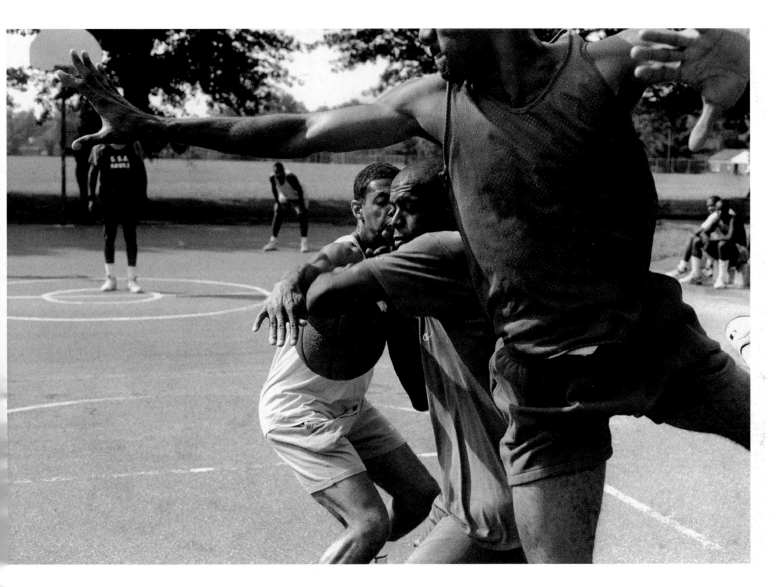

BRAD RICHMAN

Born 12 June 1971, Wilmington, Delaware. Grew up in and around Washington, D.C. Graduate of Bard College. Brad Richman was the "White Shadow," the only white kid to make the sixth-grade basketball team. "In high school, I took up what I considered two of the most practical and technical art forms imaginable, photography and drums." ¶ What Richman missed by not being on the basketball court, he discovered he could capture in a new way with photography. "I enjoy the nuances of the game—the force of people pressing against each other; the darting moves to the basket, bodies suspended in midair; and, the anticipation, looking skyward, waiting for the rebound." He is no longer concerned with who wins or who makes the great moves. "My interest lies instead with the moments of action and the actors who provide those intangible moments." ¶ Richman's wife Mari Balow, saxophonist John Coltrane, photographer Robert Frank, and mentor, photographer Larry Fink, influence his work. "I would like to emulate the passion, conviction, and quality of their creative experiments."

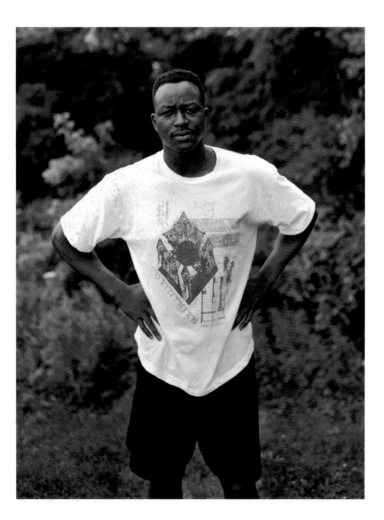

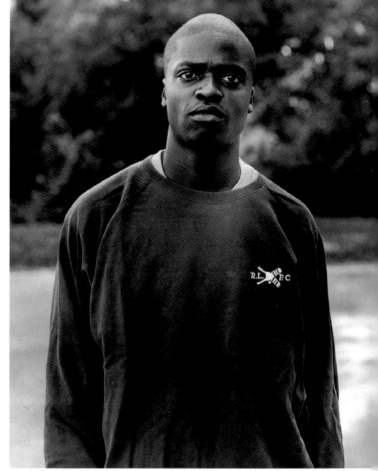

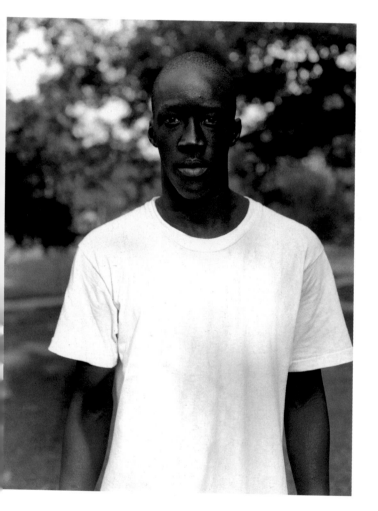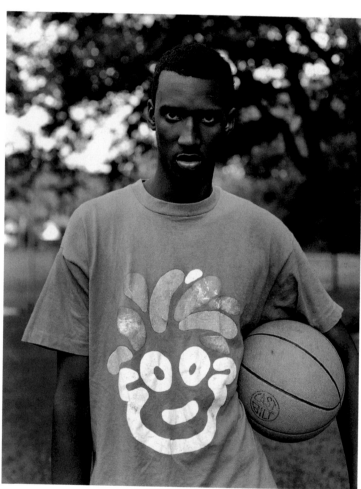

BRIAN T. MORIARTY

Born 7 December 1972, Stamford, Connecticut. Grew up in Pennsylvania. Graduate of New York University's Tisch School of the Arts; currently in M.F.A. program at Yale University. "The steel mills and interiors of mental institutions are symbolic reflections of my experience. My father, a steelworker, would often leave the house for a week at a time to work in the mills. I imagined what it was like to work in those places. I often accompanied my mother and had a first-hand view of her work as a social worker inside mental institutions." ¶ Western Pennsylvania influences Moriarty's photographs, but the photographs create places of their own: haunted, abandoned spaces with the messages left behind, or photographs with evidence of life in the present, still reflecting separation and isolation.

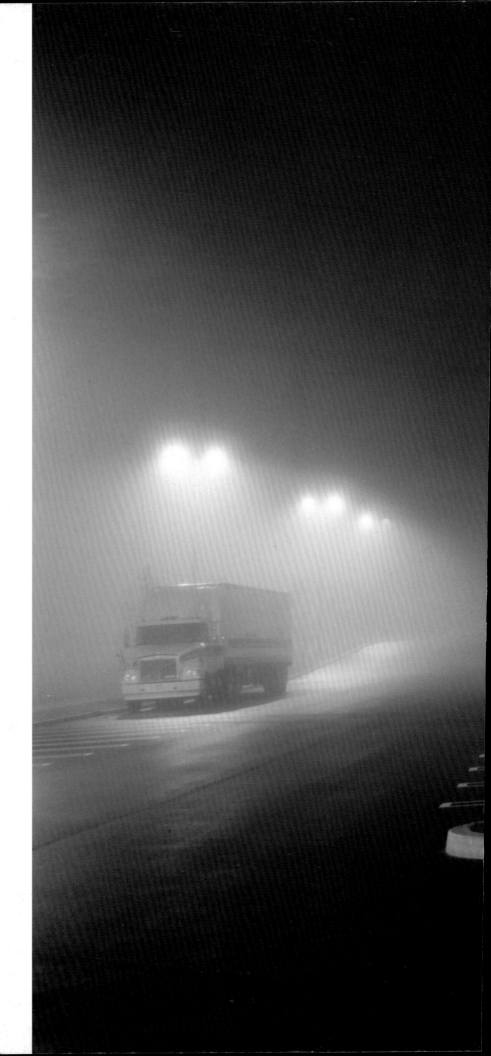

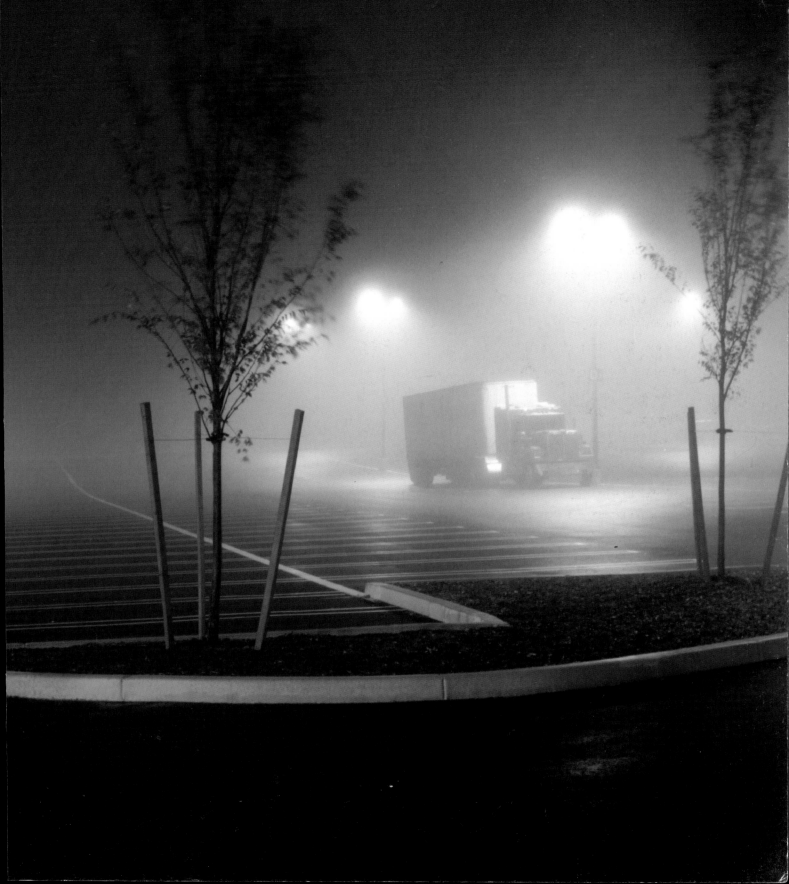

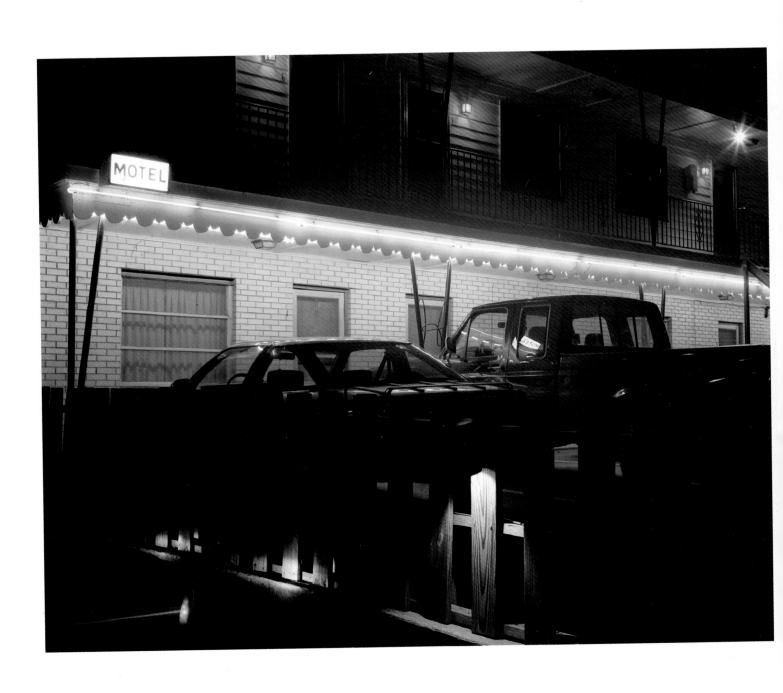

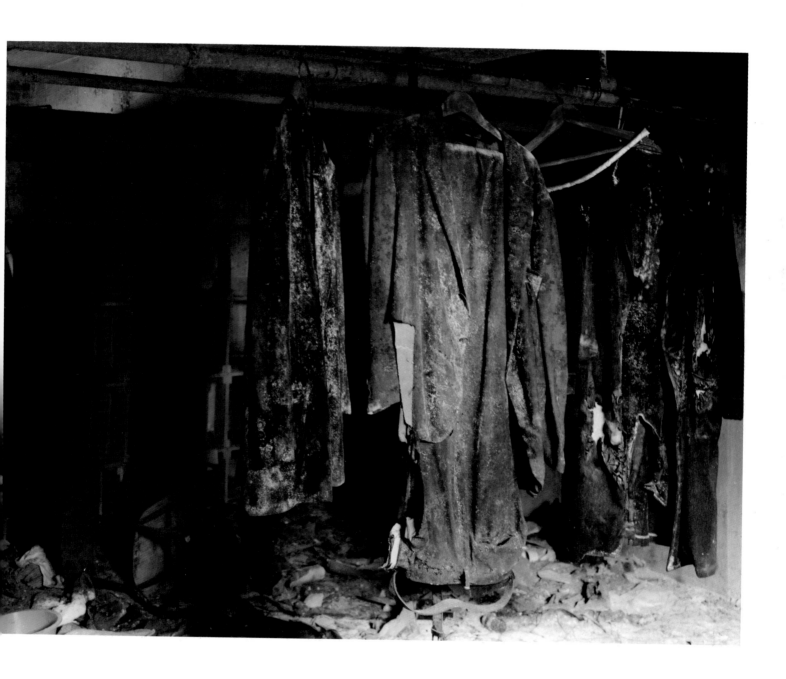

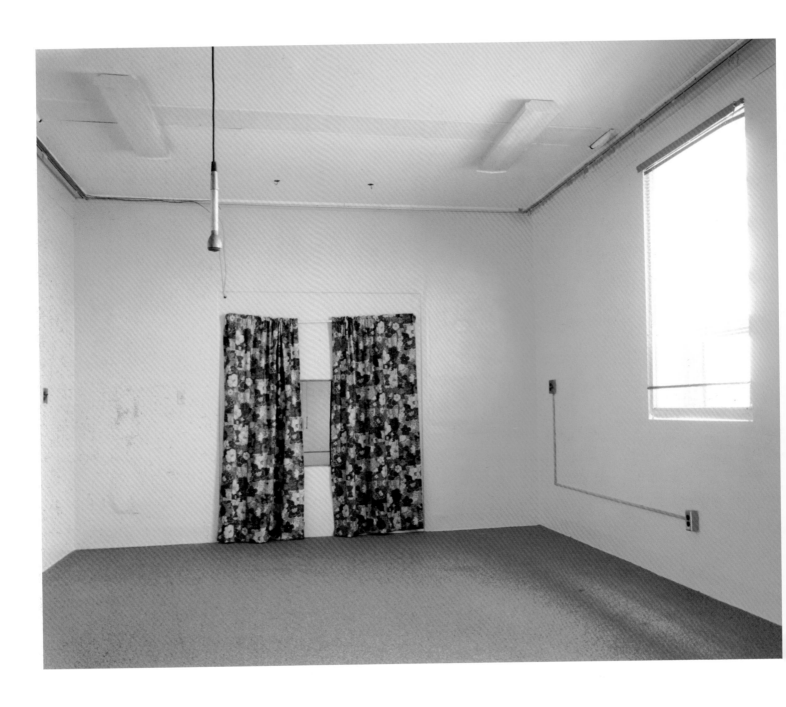

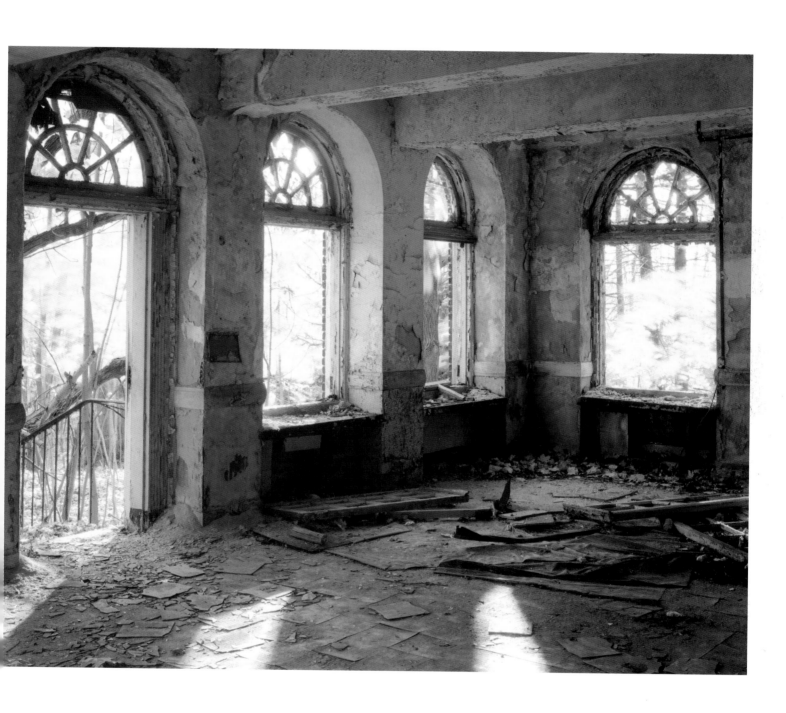

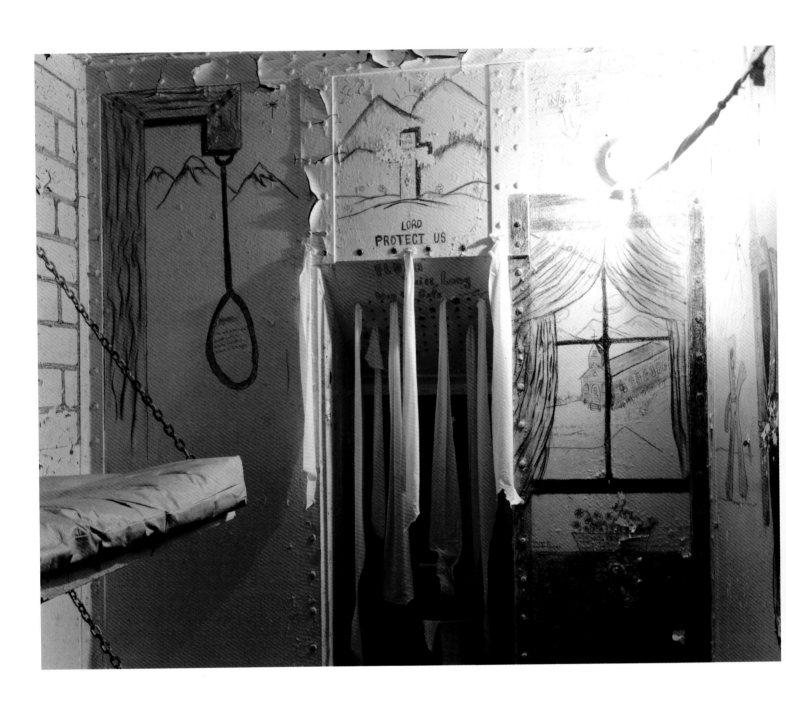

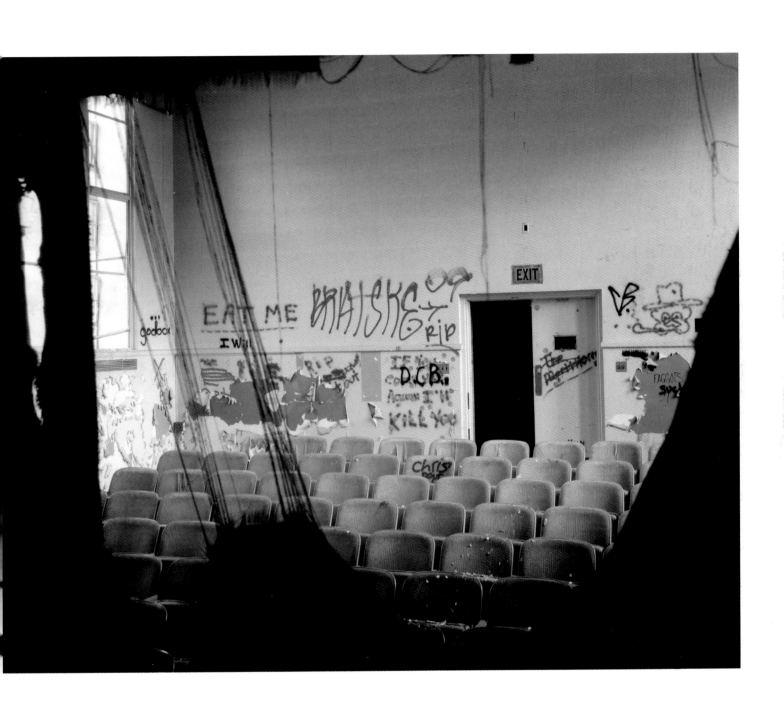

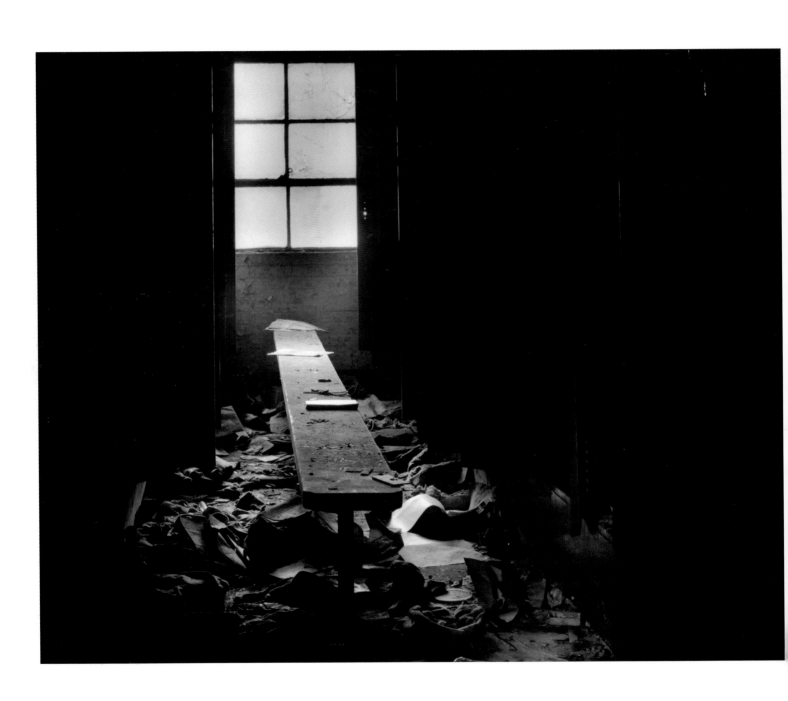

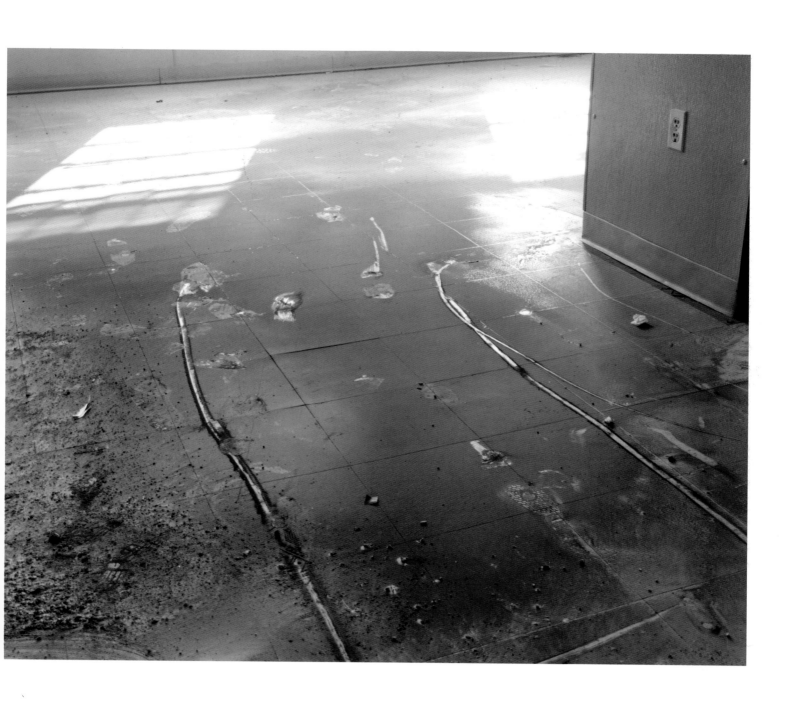

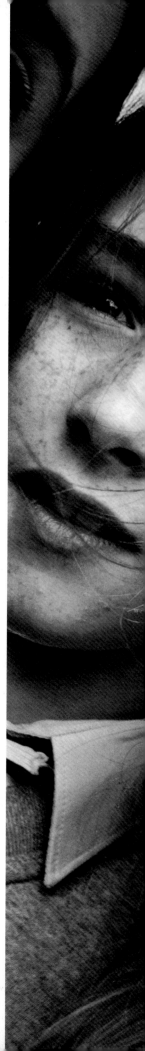

MELINDA MARY MAGUIRE

Born 21 September 1969, Bronx, New York. Graduate of the School of the Visual Arts. ¶ Maguire began photographing Traveler children and other Irish children when she was twenty-one. "Irish 'Travelers' were landowners dispossessed after the Battles of the Boyne and Aughrim in 1690–91. Travelers were mainly tin workers. Others are descendants of farmers ravaged by the potato famines. 'Tinker' is a derogatory term in Ireland; they refer to themselves as Travelers. The government calls them itinerants. Some Traveler children are fortunate enough to attend school. Others are not. Living conditions are very poor. I have heard them describe their living conditions as 'horrible, discustin', rottin', and ugly.' Yet as most children do, the Traveler children find fun wherever and whenever they can. Now I try to understand their ways and listen to their stories of fear, anger, and hope."

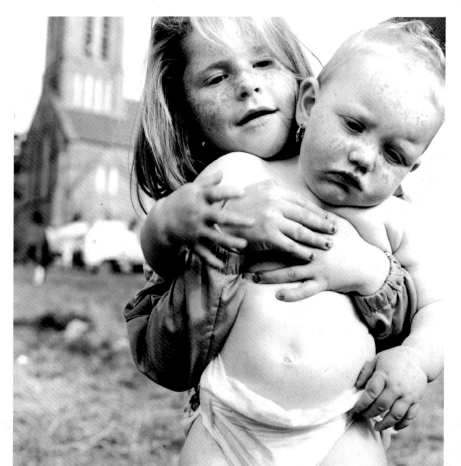

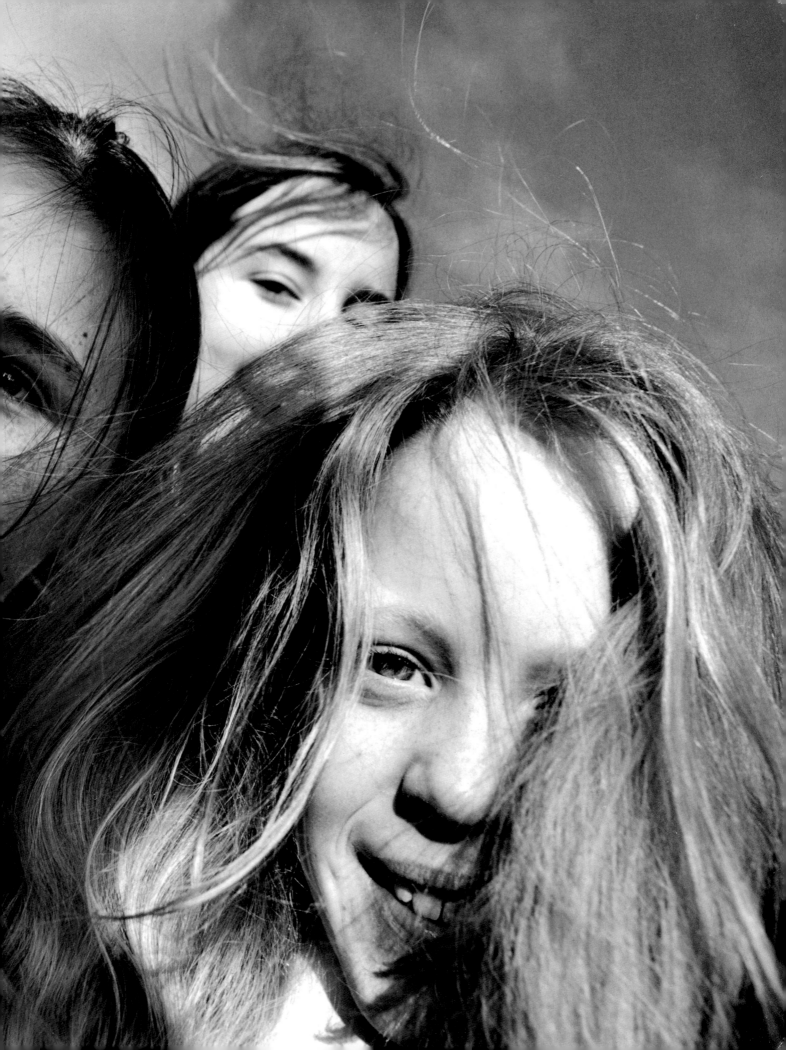

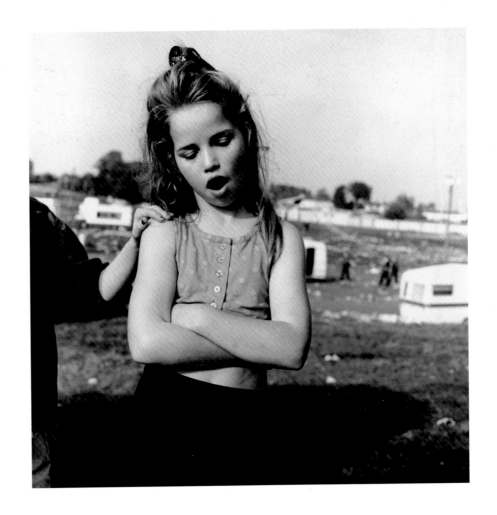

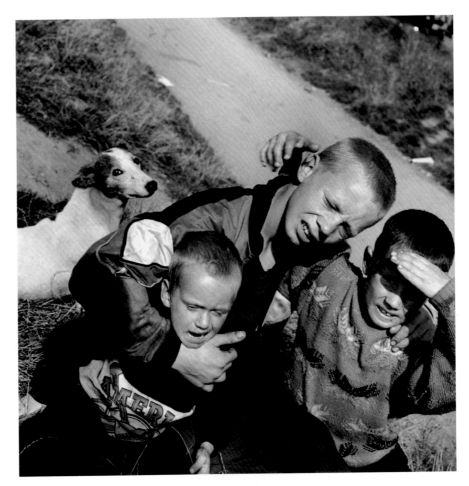

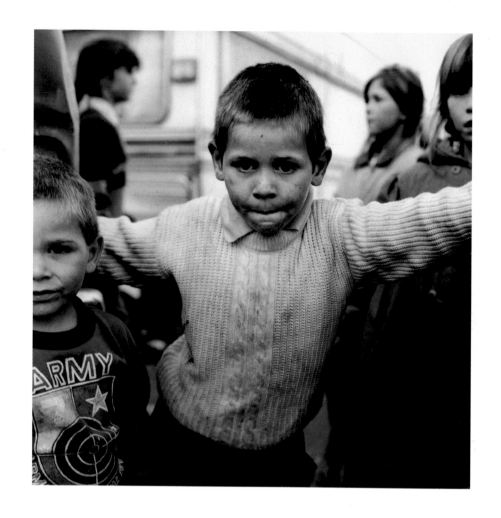

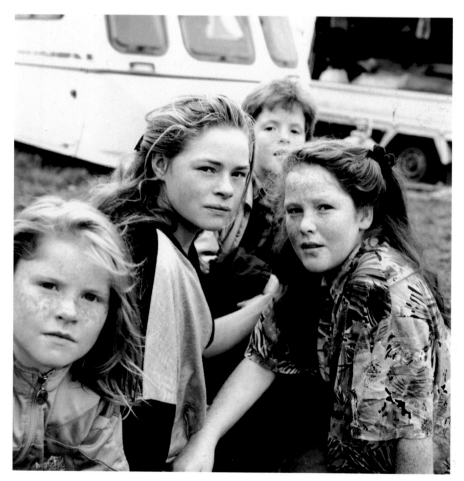

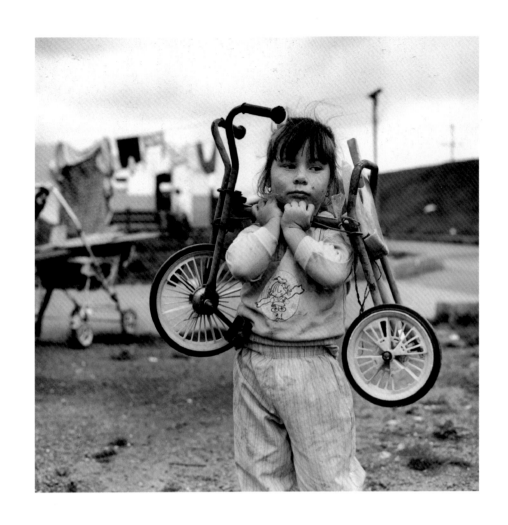

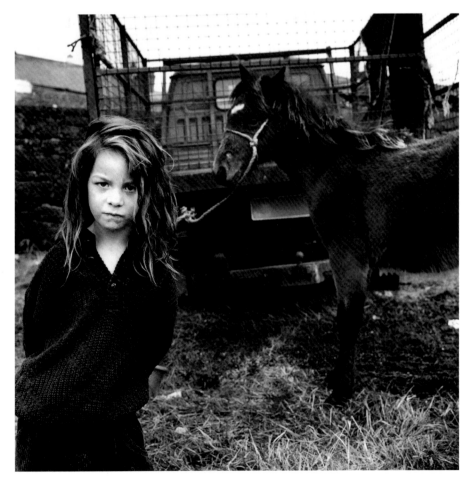

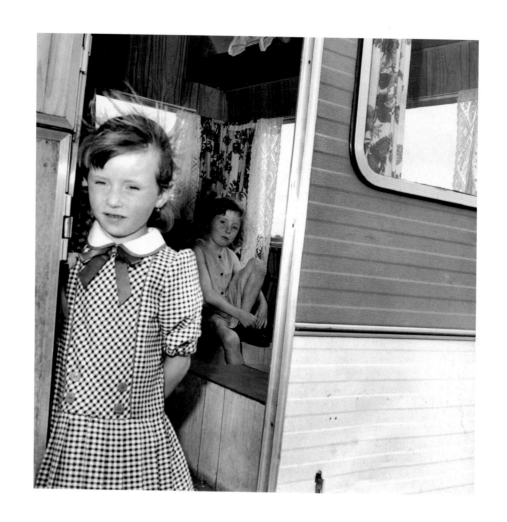

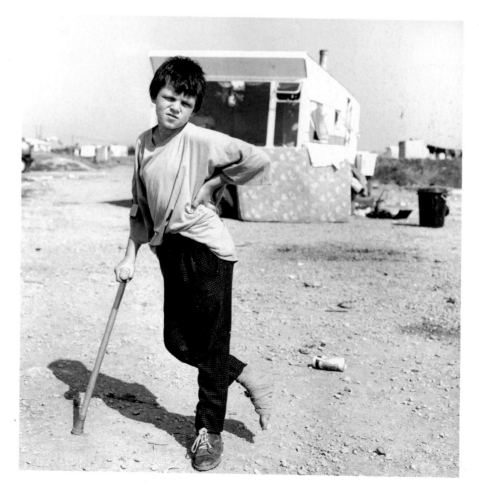

THOM LUSSIER

Born 5 April 1970, Worcester, Massachusetts. Graduate of the Massachusetts Art Institute; M.F.A., Yale University. Thom Lussier, the youngest in a family of five, grew up in Worcester, a postindustrial, economically depressed city in central Massachusetts. His childhood was filled with fantasy. ¶ "I created intricate worlds from magazines, television, and—rather tangentially—the allure of the kitchen. The center of activity and fond memories, the kitchen was a safe haven of good smells and, in winter, steamed windows. It was because of this fondness that I felt safe to experiment with my ideas; the kitchen became my studio. It was through food that I came to know creative license. ¶ "In this body of work, I found myself using food as a metaphor for care, nurturing, and the frailty of the body. Ideas of attraction and repulsion, of seduction and denial, all work to express a certain distress within the complicated role of my sexual identity. Part of the allure of creation is the inevitable revelation of ideas through the process of making. Photography can become whatever I want it to be."

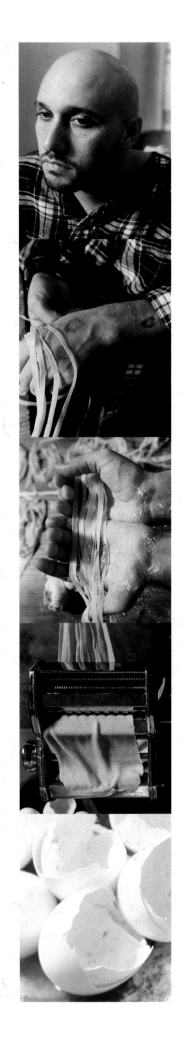

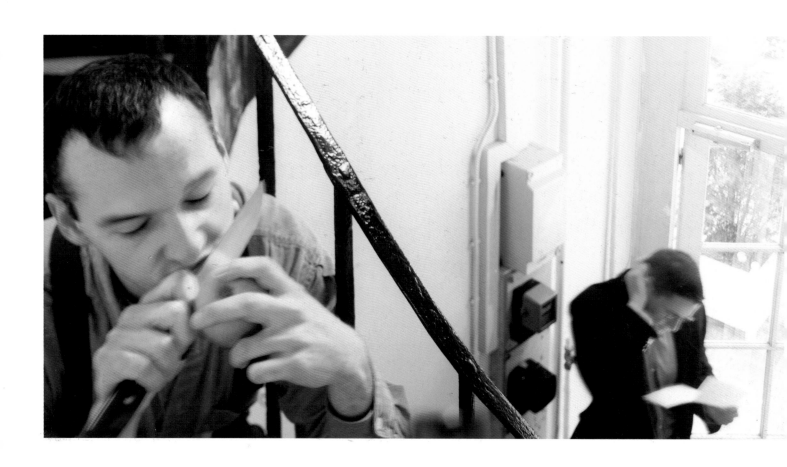

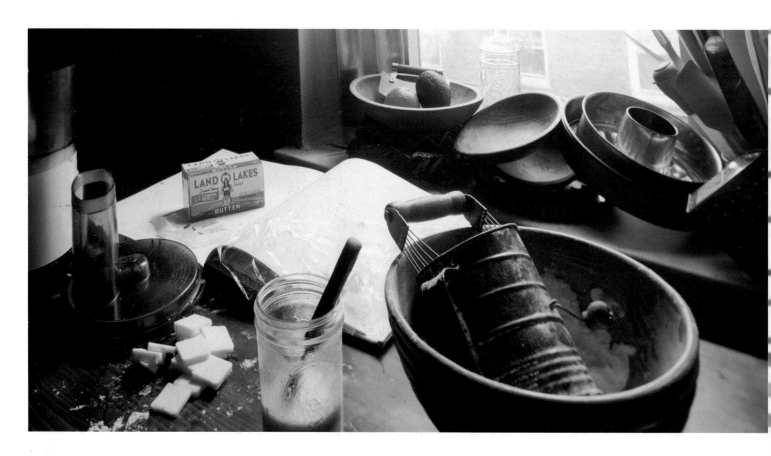

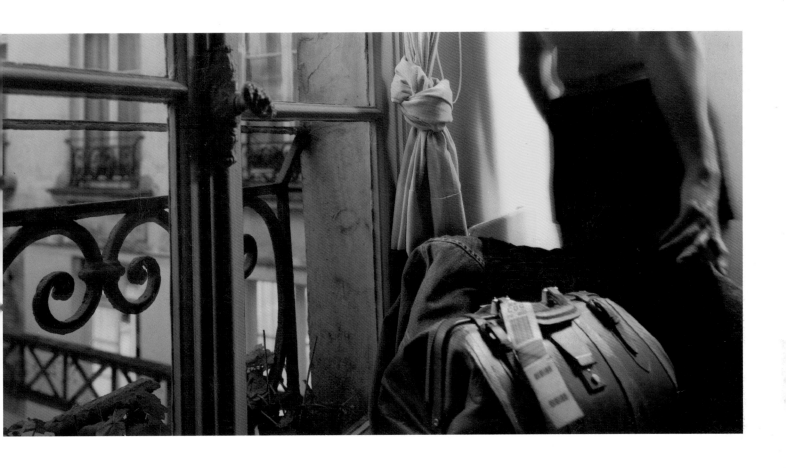

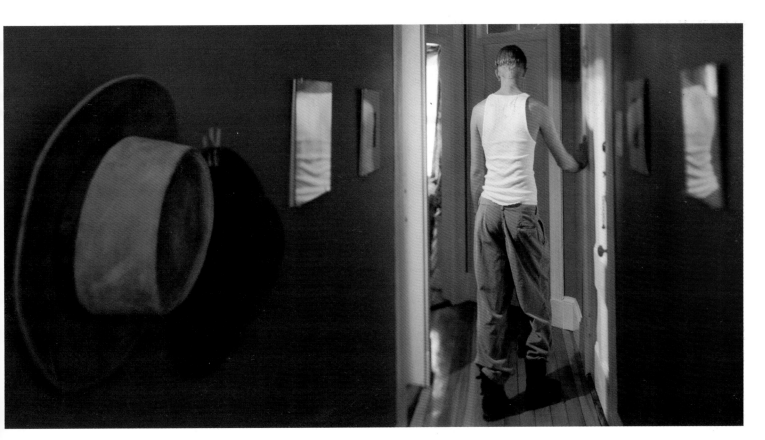

ALEX TEHRANI

Born 10 October 1970, Berkeley, California. Graduate of New York University's Tisch School of the Arts. "The route to Thomas Jefferson High School for the students who commute on the L train is littered with broken glass and garbage. Jefferson High serves students from fifty-three different housing projects, which is notable because the violence is almost entirely territory related. There are only two white and no Asian students at the school, and the Hispanic students mix easily with the Caribbean and black students. ¶ "Of a senior class of about 400, that began with 600 freshmen, a mere 92 students were expected to graduate. Of those 92, 20 hopefuls didn't make it. But what became most fascinating to me was not the oppressive atmosphere but the unimaginable resilience of the students and faculty against what are truly horrendous odds. I photographed the self-esteem and leadership classes, the conflict resolution workshops, peer mediation sessions, and the range of support groups—the programs that combat the violent tendencies of the community. ¶ "The photographers who have most inspired me are Gilles Peress, Josef Koudelka, and Susan Meiselas."

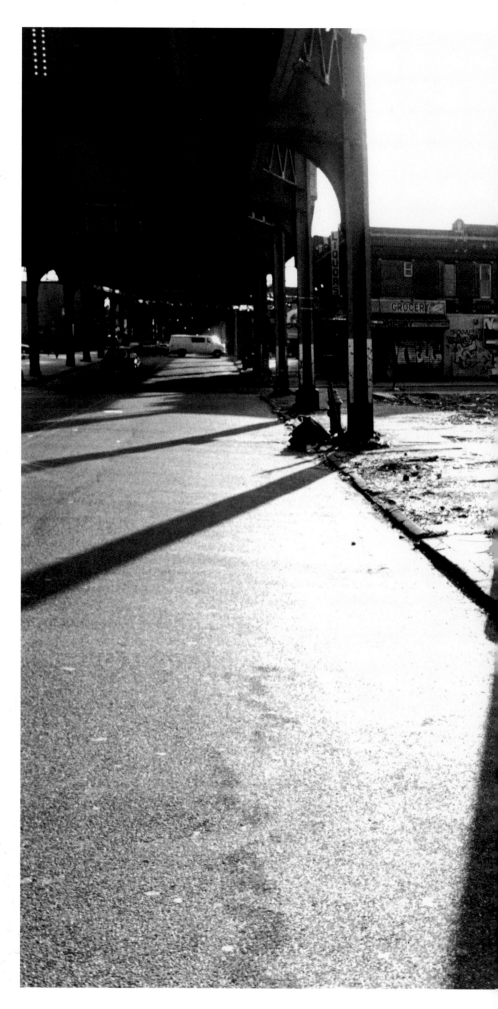

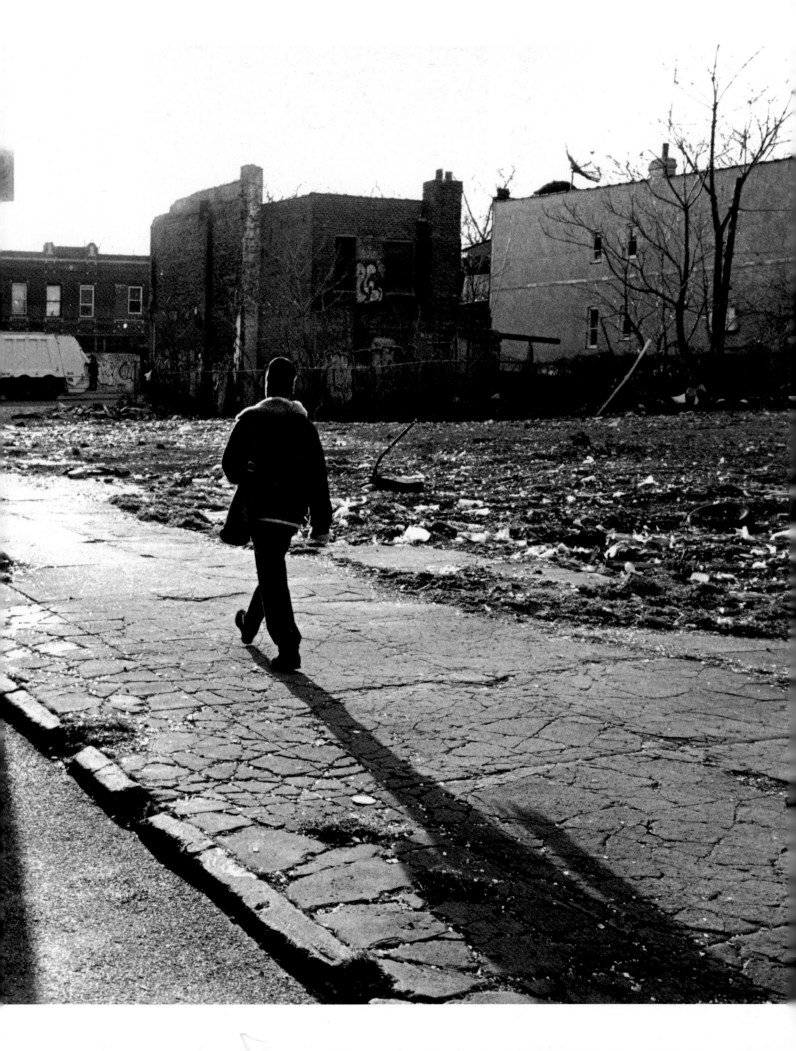

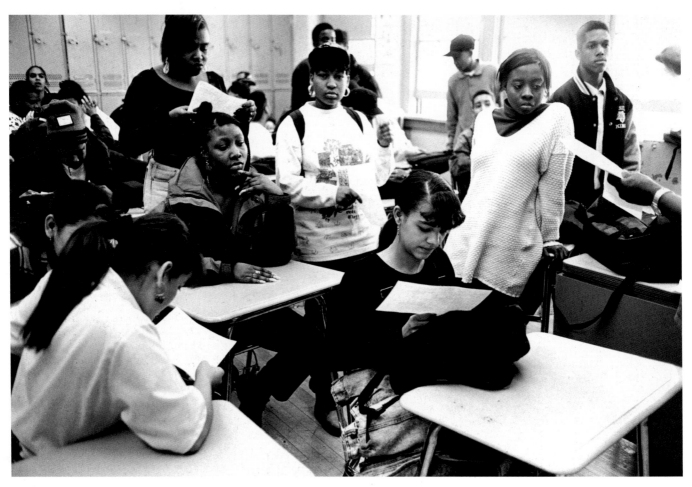

Above: Mr. Heath's bilingual class was silent as the students read their report cards. Jefferson falls short of what is considered a pitiful citywide average of seniors who graduate, 51.5%. In the 1993–94 school year, when this was taken, only 34.4% of the senior class graduated. *Below:* "You never know what the weekend might have brought," says one student. "You can't even be sure who'll come back to school after the weekend."

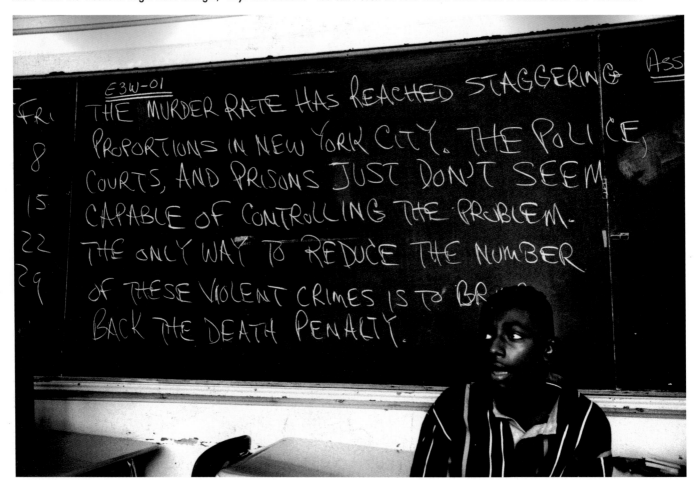

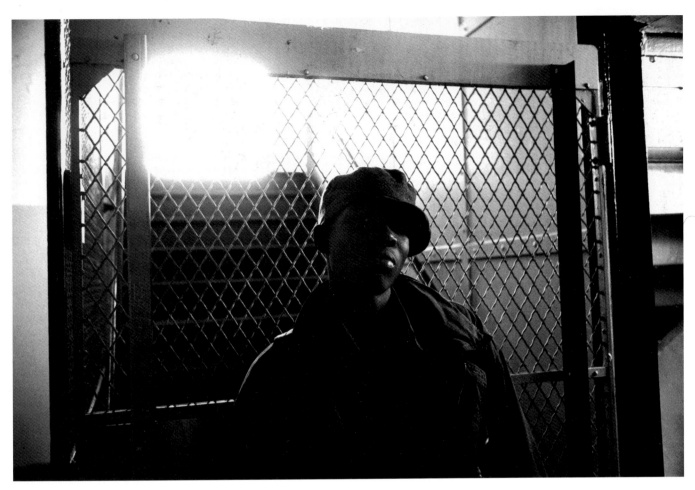

Above: Robinson Lerner, sophomore, blew up at his teacher with an onslaught of obscenities in English and Spanish and was suspended for five days.
Below: In 1993 East New York had the highest homicide rate in the country—140 dead in the summer alone. The Seventy-fifth precinct had T-shirts made that read "You give us 22 minutes, we'll give you a homicide."

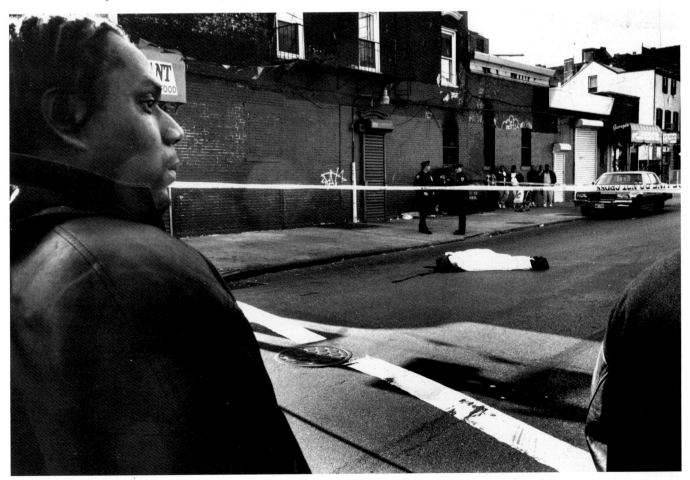

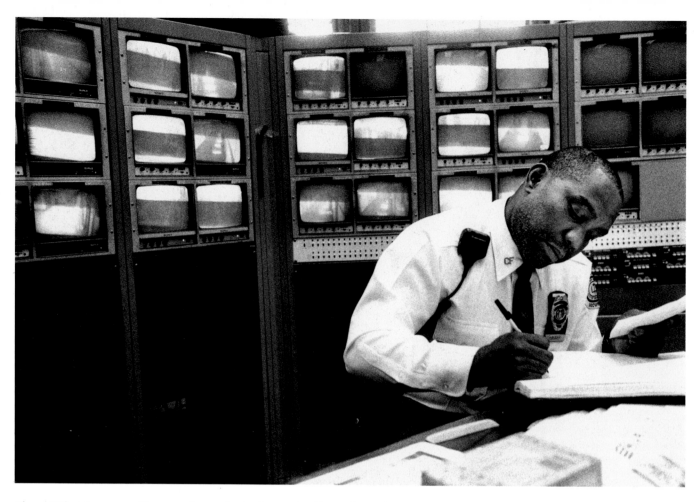

Above: With sixty-one surveillance monitors and twice the security officers of any other New York City high school, Jefferson, dubbed "Homicide High," at times feels more like a cell block than an academic institution. *Below:* Bobby Roberts works after school at a senior home in Bedford-Stuyvesant. "i guess he doesn't want to eat today. He's usually a good eater."

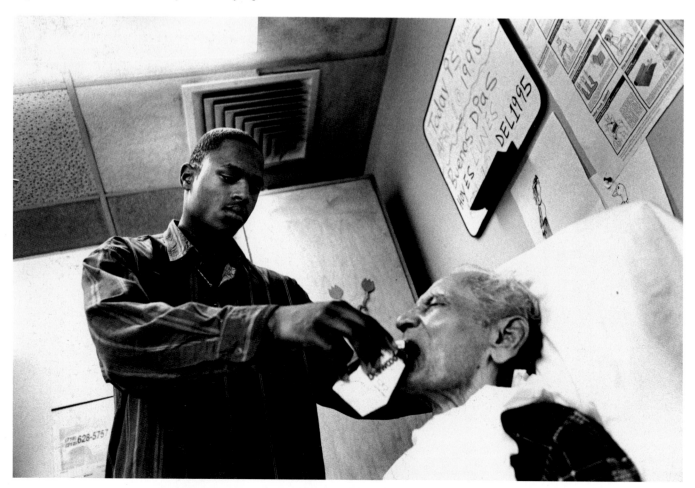

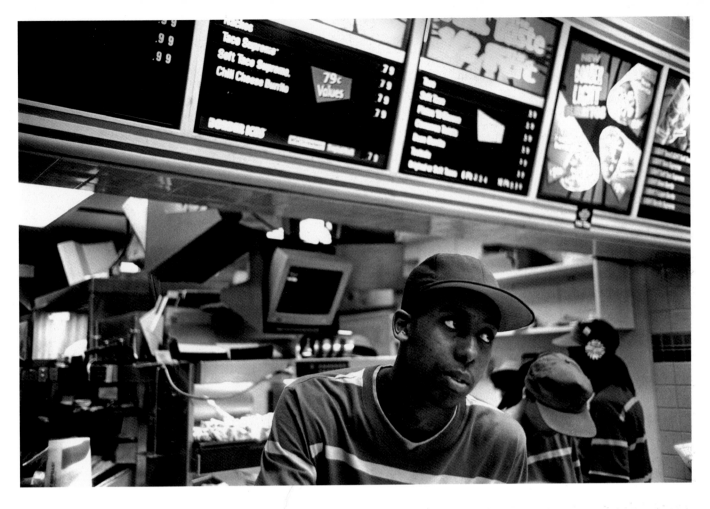

Above: Andre Hamilton, a senior, is about to get promoted to shift manager. "Me and my friend we just get together every day and talk about how we can't wait to break out." *Below:* Three of Jefferson's "hard rocks" stroll the halls wearing expensive name-brand clothing and no backpacks.

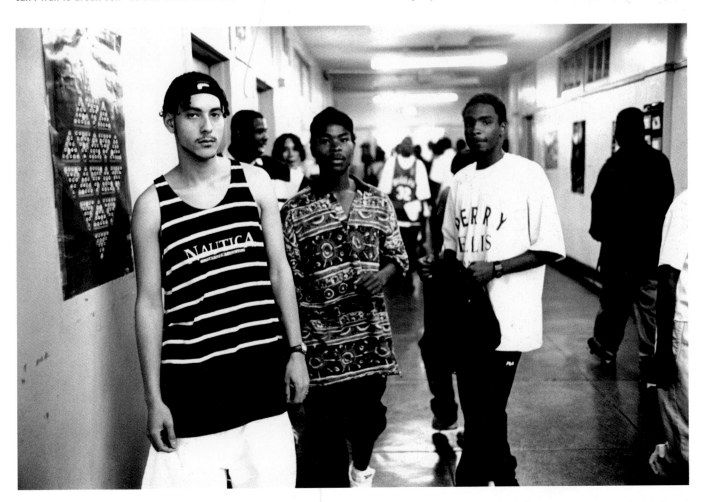

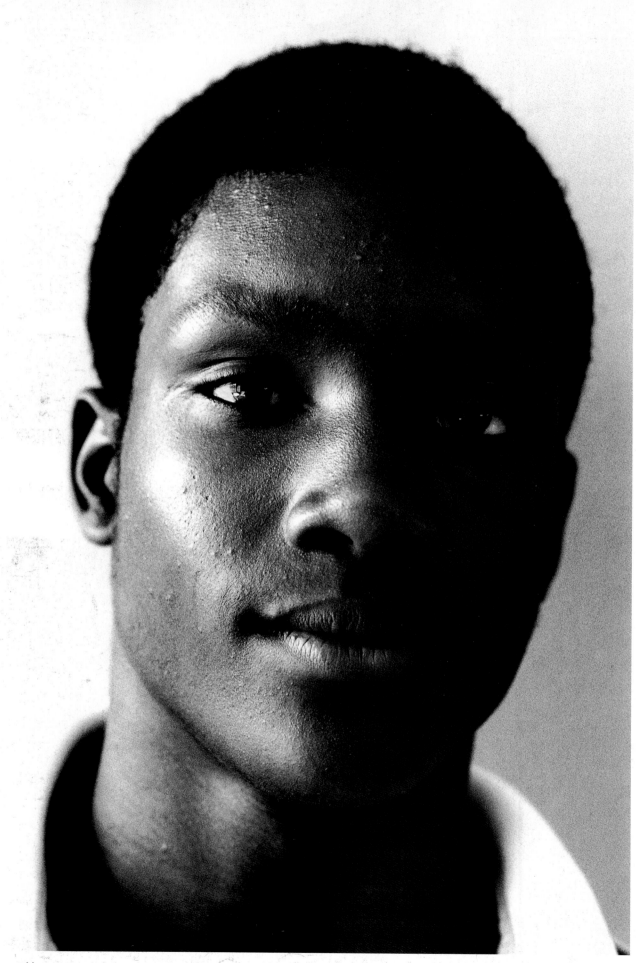

Eddy Denis worried about being jumped by the guys in the Alabama projects when he came to Jefferson as a freshman. But he has had no incidents to speak of, and told me, "Jefferson is just a school . . . not a bad school."

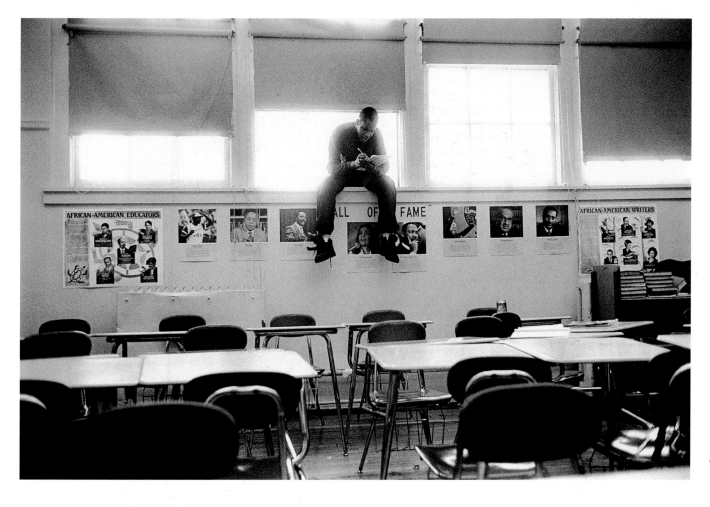

Above: Marion Johnson, like many students, stays after school rather than go home. "Someone actually wrote in my junior high yearbook, 'If you're going to Jeff, don't get shot.'" *Below:* Anyone will tell you racism is not the issue. Gangs assemble in the various housing projects.

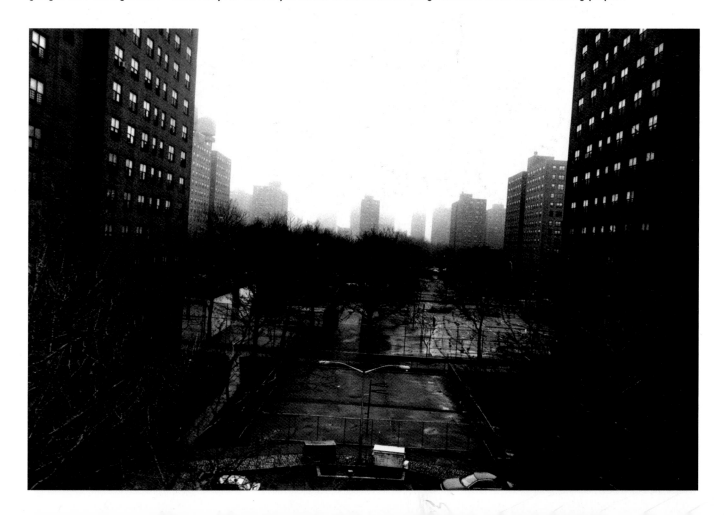

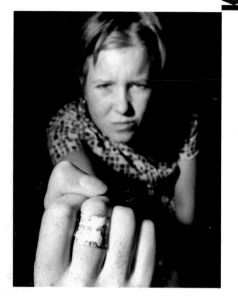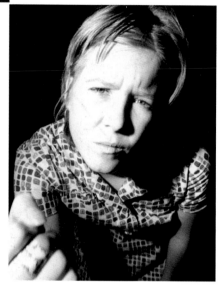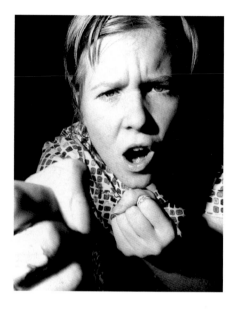

DIV

Born 19 June 1974, Tacoma, Washington. Never lived more than three consecutive years in one place, but she and her family consider the Washington, D.C., area home. Graduate of Sarah Lawrence College. "Aspects of life are absurdly unbalanced, yet blatantly accepted and relatively unchallenged," says Kate Lacey, who uses photography to investigate the role of feminism in familiar contexts. ¶ "I am always examining my experience to find the universality and humor in it. Humor is a good technique for social commentary; it allows access to different kinds of people without sacrificing the message. My self-portraiture—which doesn't always picture me—is a recognition of the importance of self-sovereignty as a way of making a personal statement. It's a saucy package of pure indulgence."

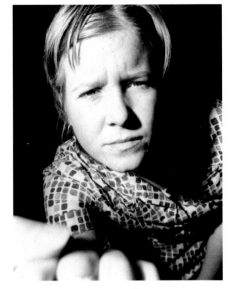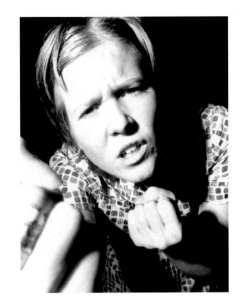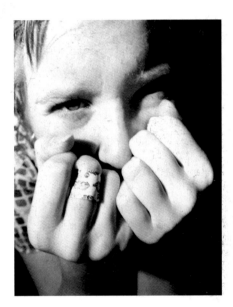

RCE

MICHAEL R. LEWIS

Born 11 March 1970, Pittsburgh, Pennsylvania. Graduate of Tyler School of Art; M.F.A., San Francisco Art Institute. "My beginnings in photography were walking the streets of Philadelphia with my father's old Nikon. This camera became a license to reexamine the world I lived in. Through the eye of the camera I rediscovered what was already there. My understanding of reality expanded. I realized that reality was merely point of view, and to better express *my* reality, I began to manipulate what was presented before the lens. ¶ "I wanted to tell stories with images. Only I realized you can't really do that; you can only imply a story. So that's what I do. I use my personal experience to get at the stories I want to tell using people as characters, but I leave it open and make the experience common enough that viewers can inject their own stories. They don't have to get my story; they can make up their own."

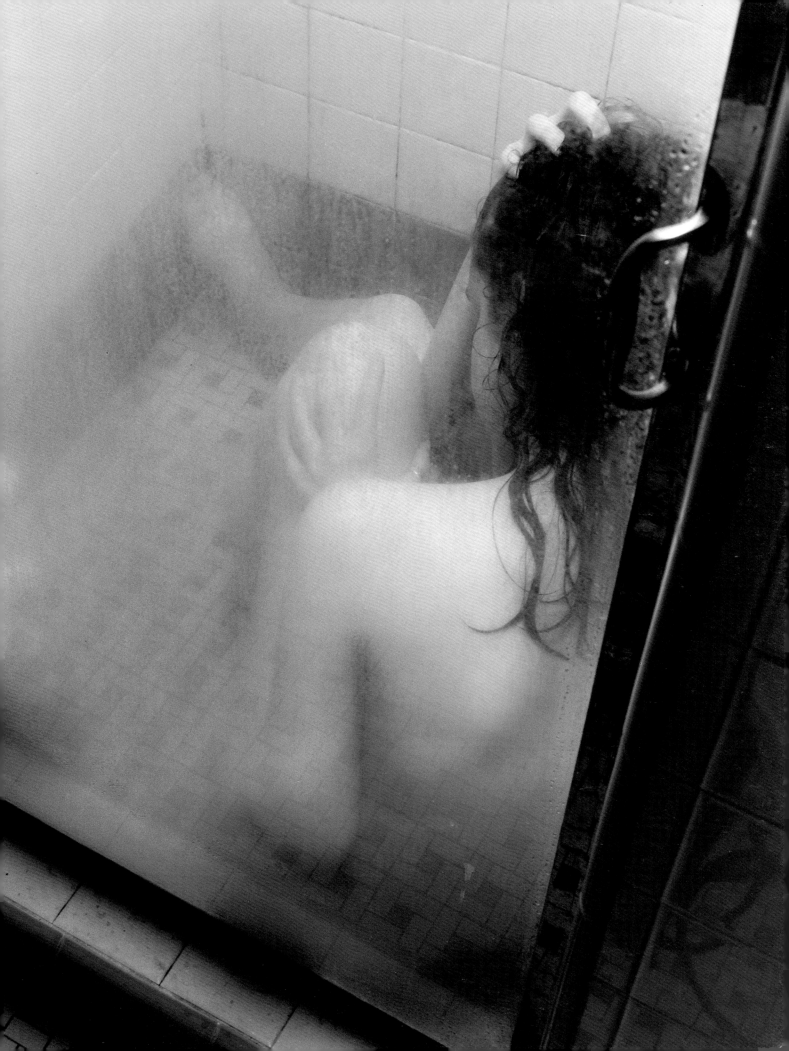

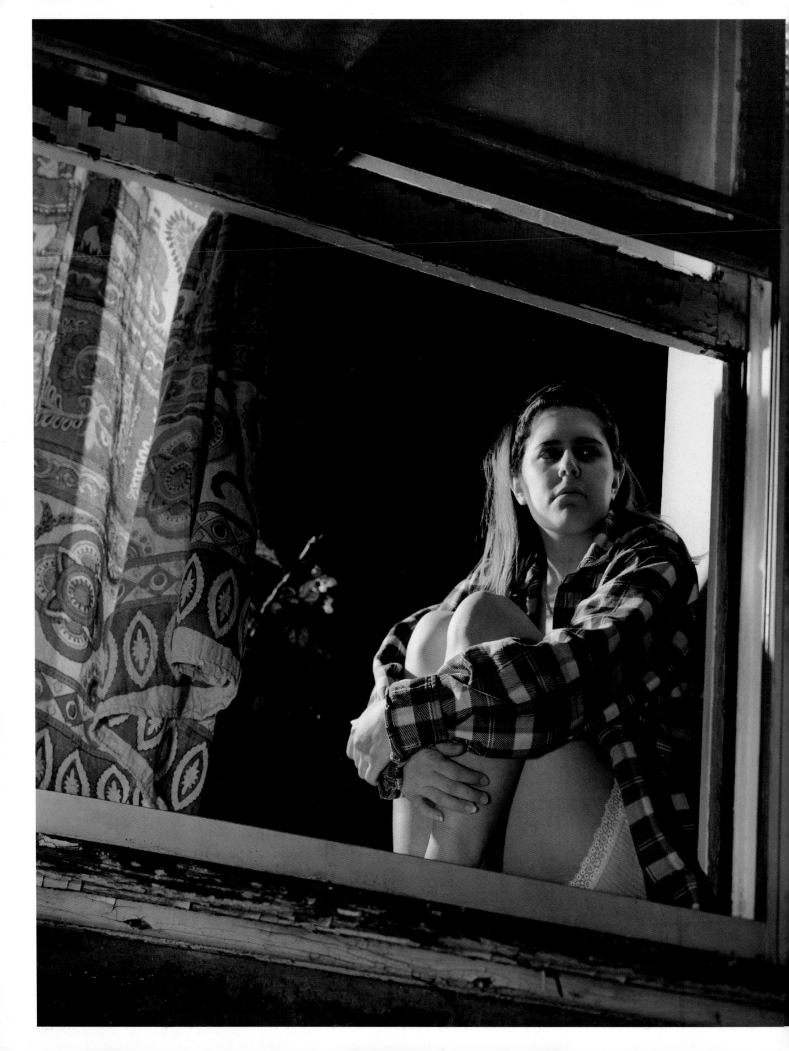

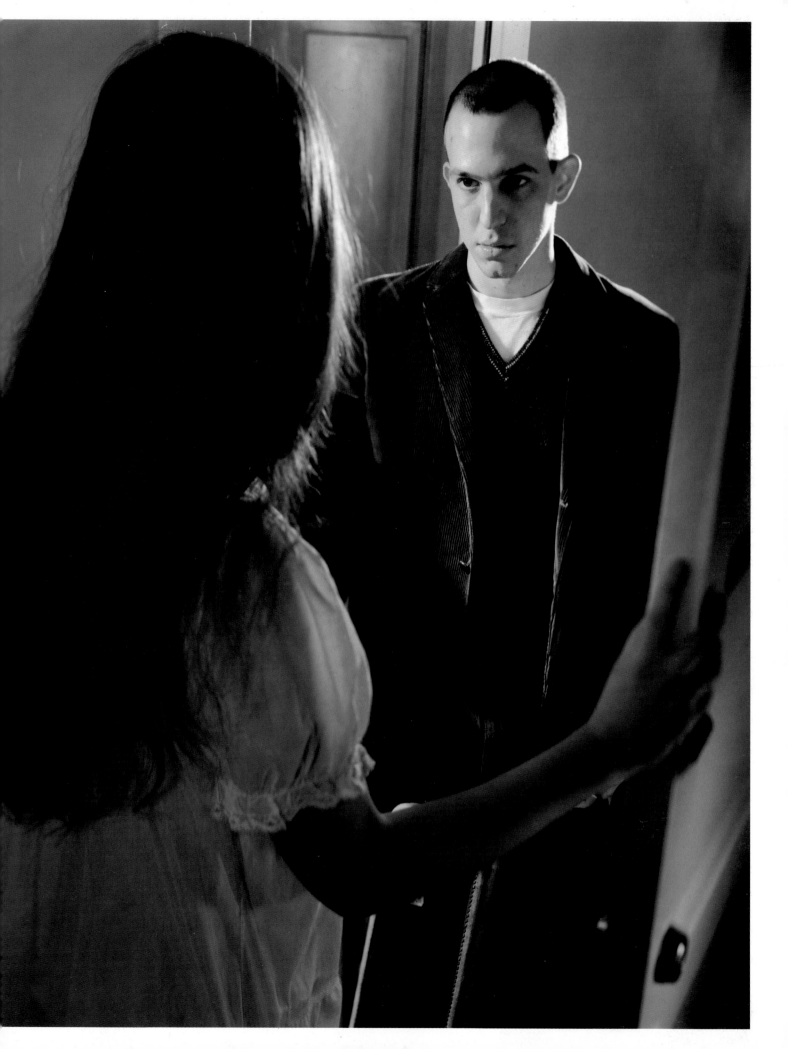

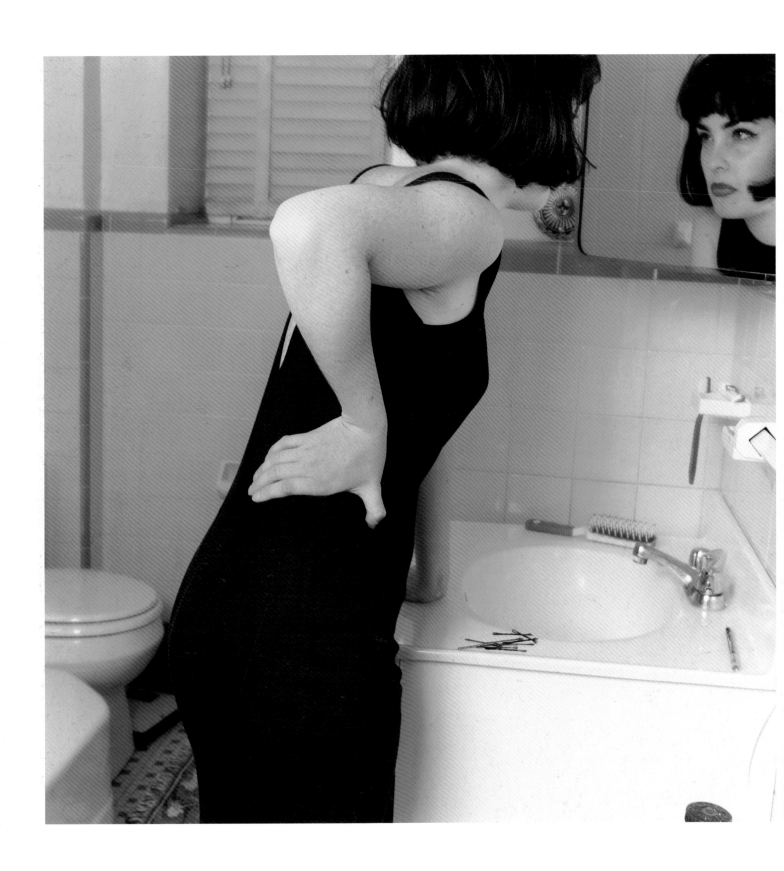

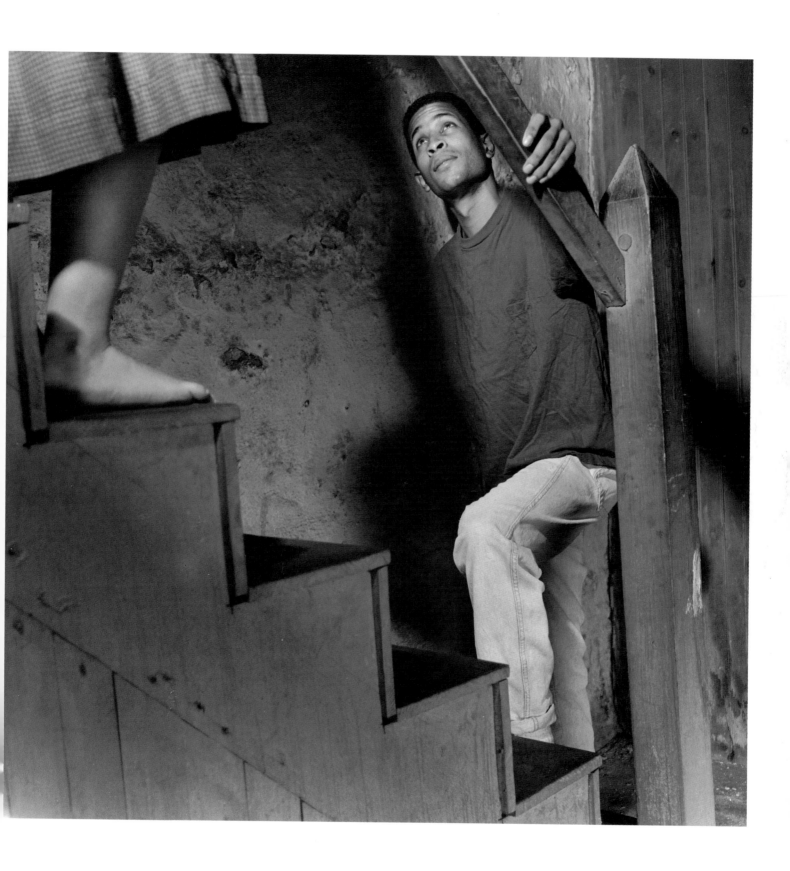

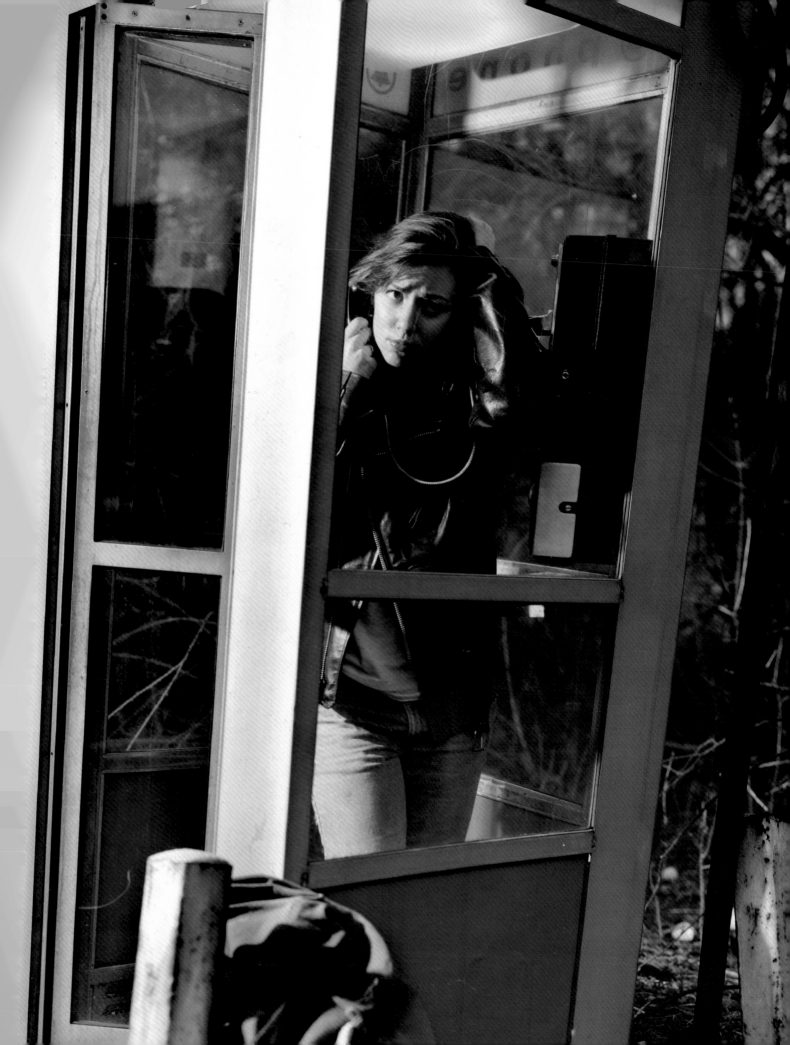

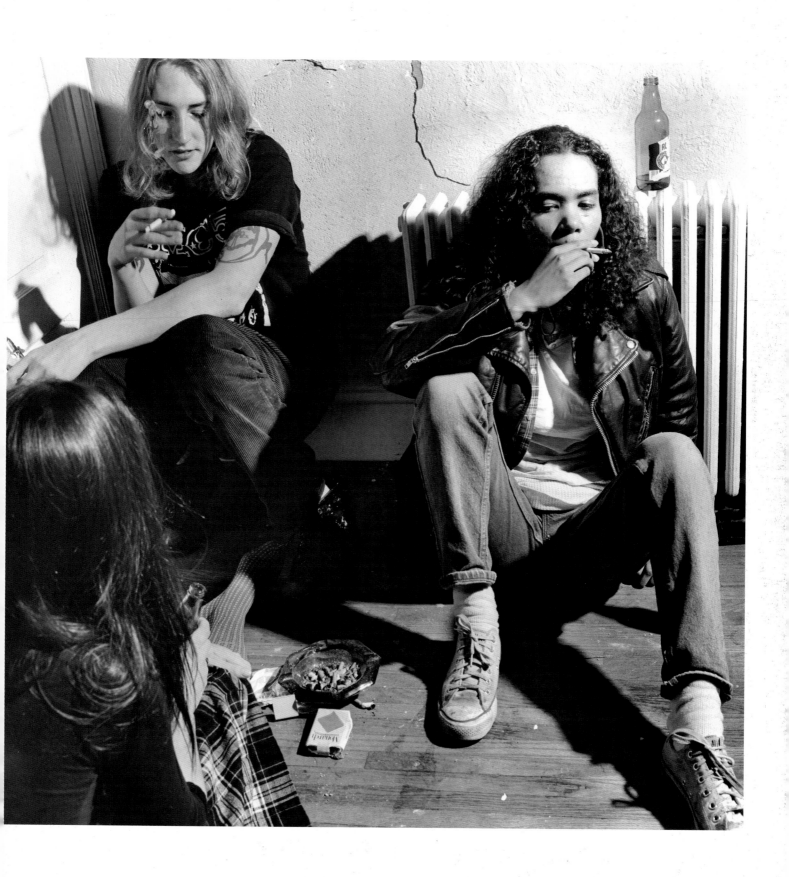

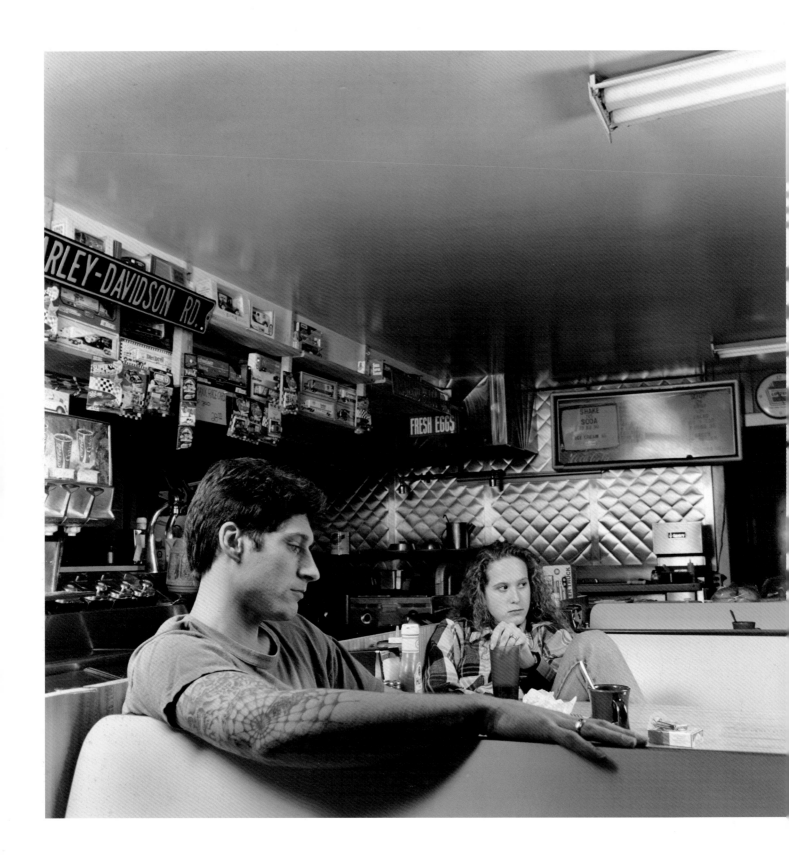

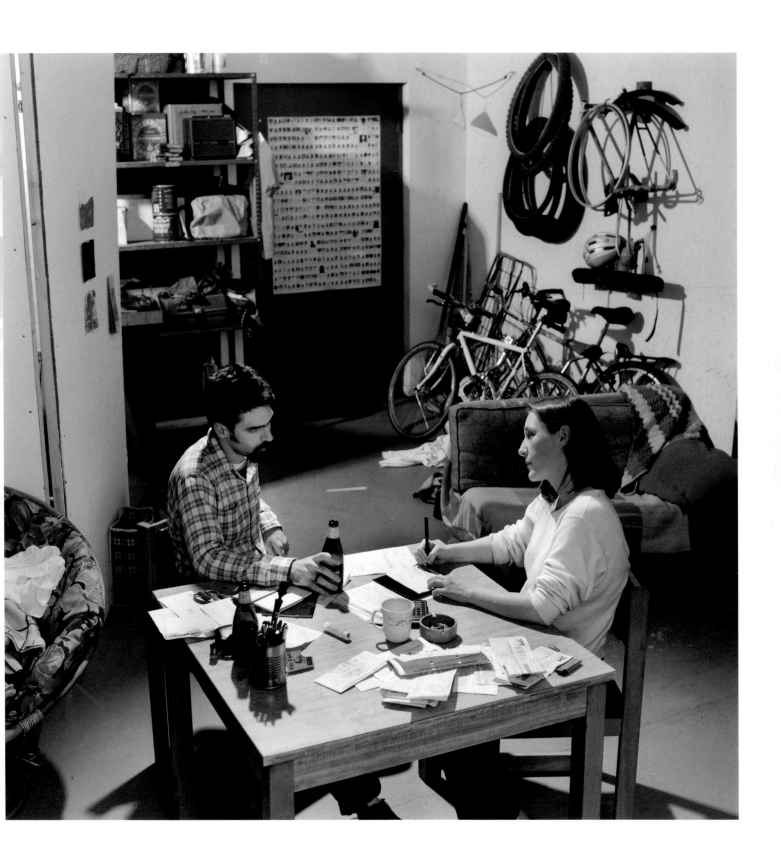

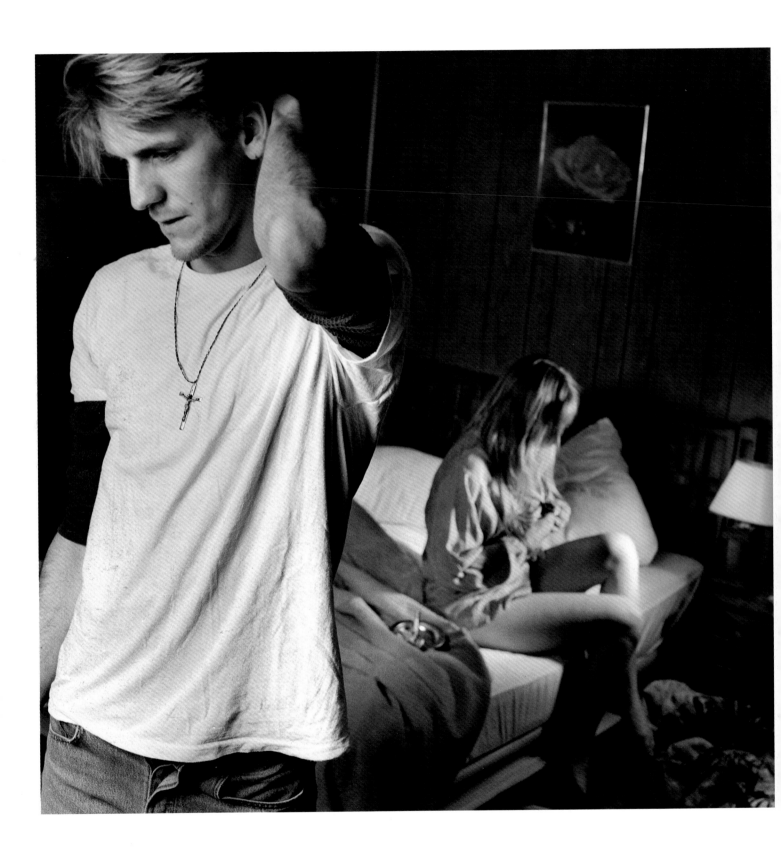

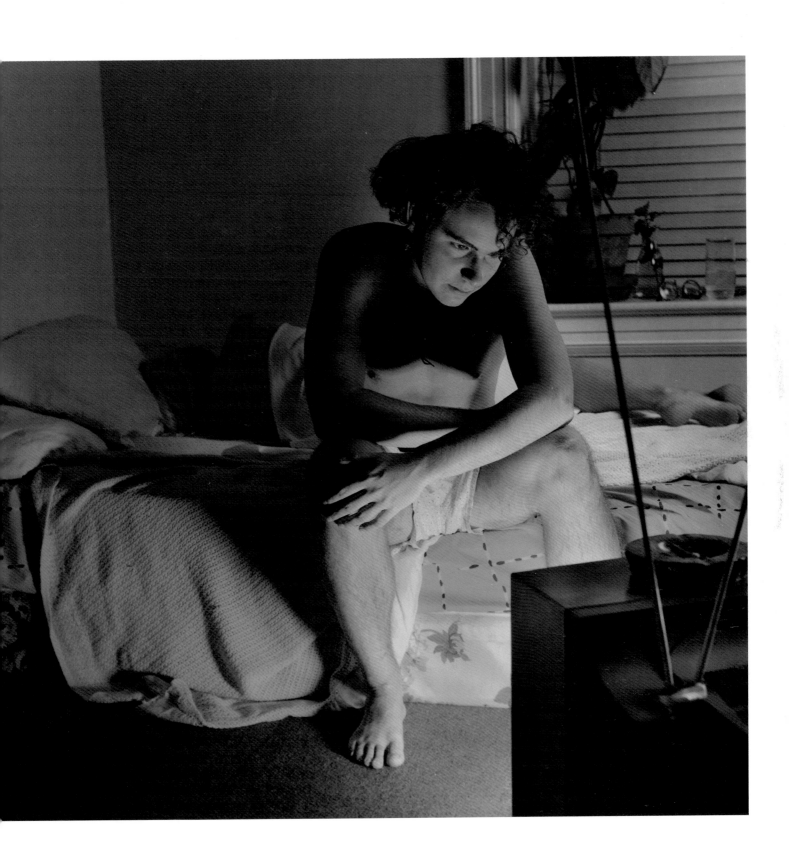

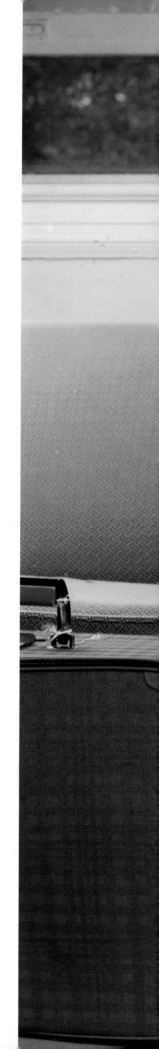

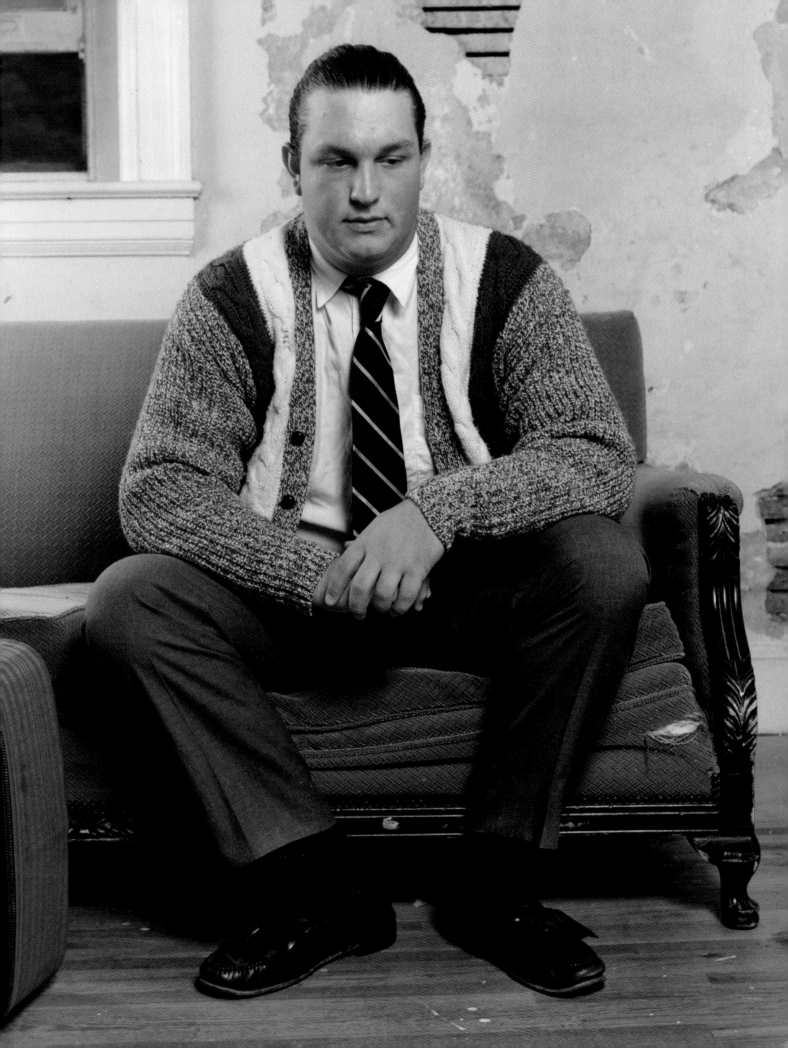

Born 28 December 1976, El Paso, Texas. At the age of thirteen, moved with his family to Montello, Wisconsin. Graduate of high school in Wisconsin. Dustin Schnell signed up to take photography in his sophomore year of high school, partly because he appreciated the artistic nature of photography and partly because the art teacher was the only teacher he got along with. ¶ "The thing I love most about photography is that it lets me express my feelings by creating real and unreal images. To create these pictures, I put two different negatives together. Then I overexposed the paper and used a larger f-stop. ¶ "Now that I'm out of school and don't have the equipment to take or develop pictures, I just listen to music, work on cars, and go fishing, in my spare time. I would like to go to school for photography, or the music and video business. But right now I'm still undecided. I hope that whatever I decide to do, I will succeed at it."

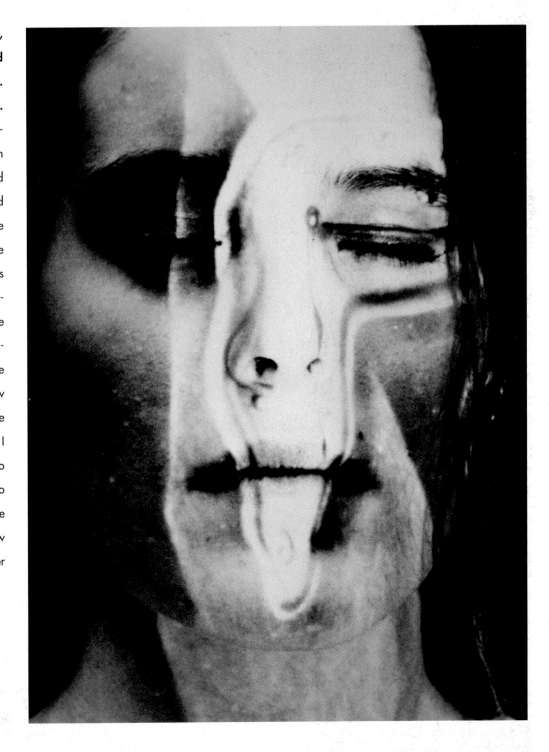

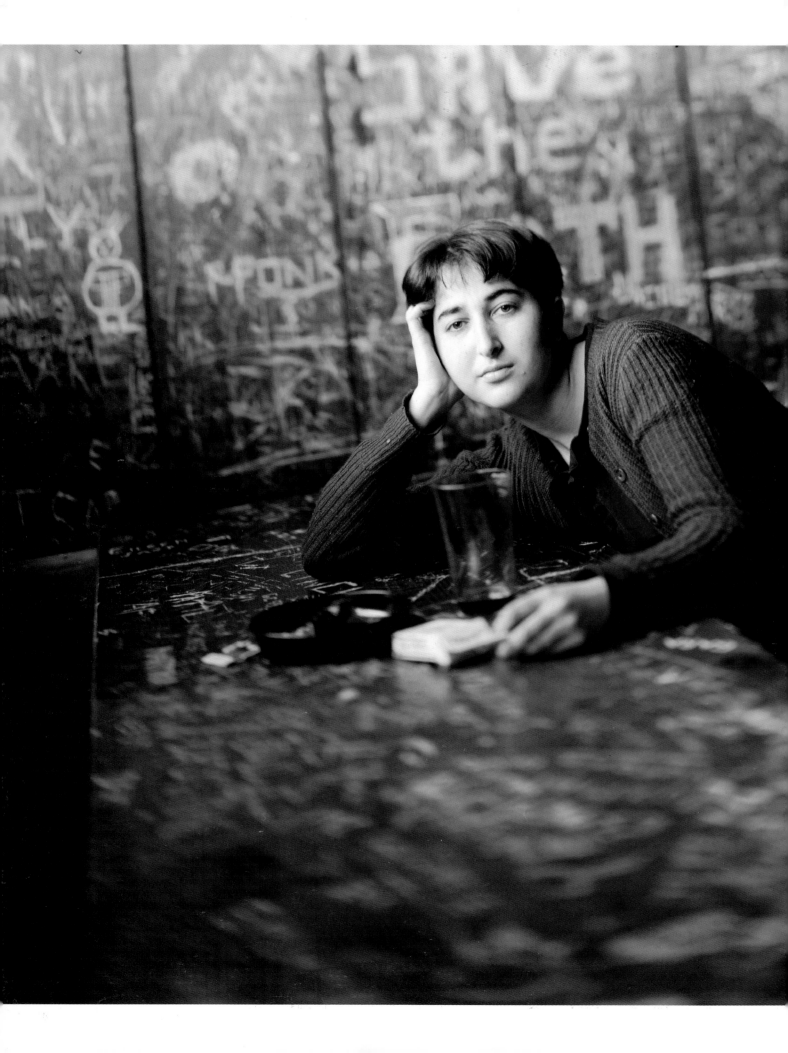

SHIRA WEINERT

Born 11 April 1972, New York, New York. Graduate of Yale University. Shira Weinert's favorites of her own photographs are those of her grandmother in her lavish but decaying apartment on Central Park West. "She lives in the past, when she was twenty-five, a model at the first World's Fair, and newly married. She tells her stories to freeze time and I photograph her to freeze my memories of her. ¶ "Other familial relationships are more complicated and the memories more difficult to articulate visually. My only memory of my parents' marriage neither of them remembers. For our last summer together, we stayed in a real family house, a house with a swing set. One night we were eating at the picnic table; it was covered in candles, maybe for ambiance, or maybe for the mosquitoes. I had a terrible stomachache and desperately needed to be held. But I couldn't decide where I felt better, on my mother's lap or my father's. Each time I began to settle, I would start screaming for the other parent. And so they passed me directly over the table, over the candles, over and over the flames. I want to make a photograph of it now, but I don't know what it looks like. ¶ "I know that staging family photographs is not the same as documenting, but revisionism can be empowering. My narrative is in the process of unfolding and expanding; it's not all about my family, and it's certainly not all about distance and dysfunction, but I still don't know when to let the people smile."

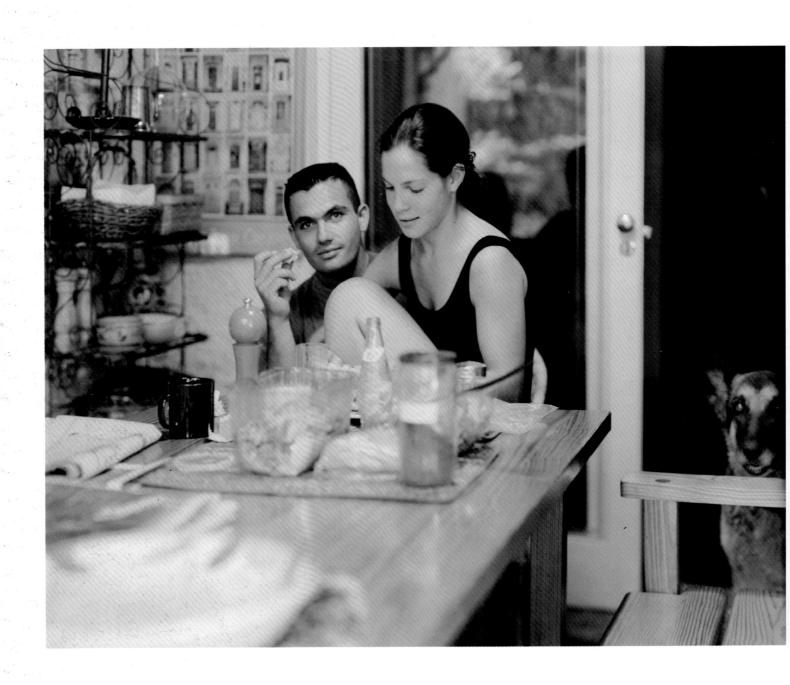

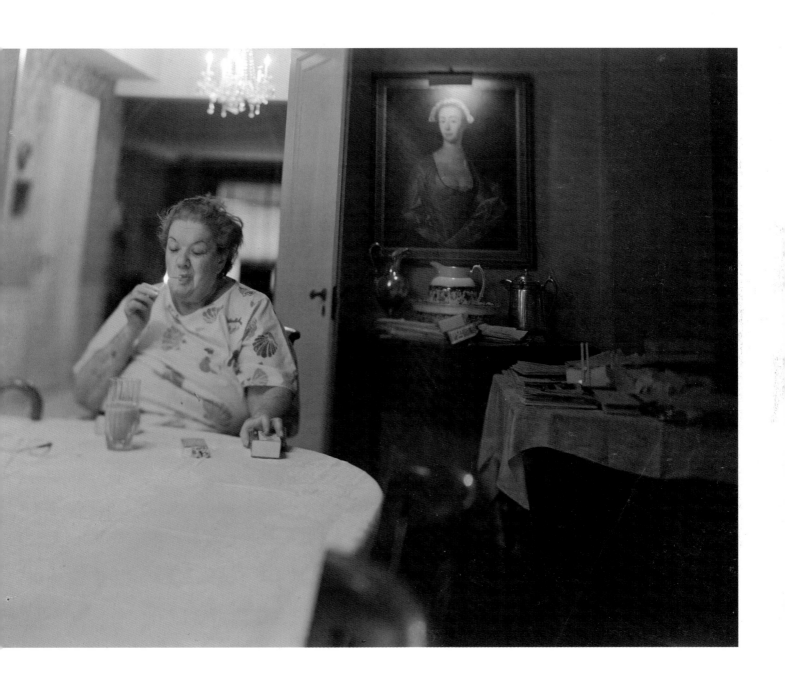

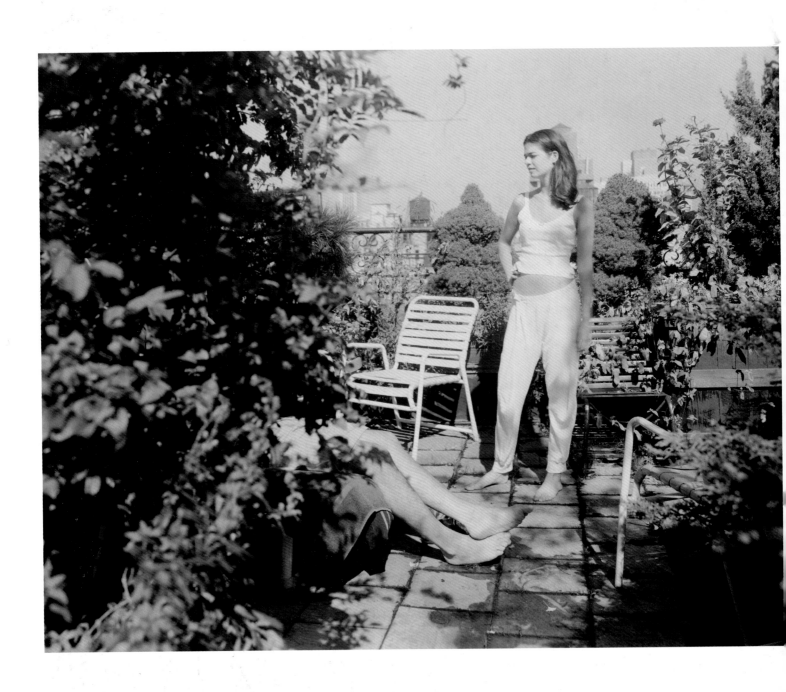

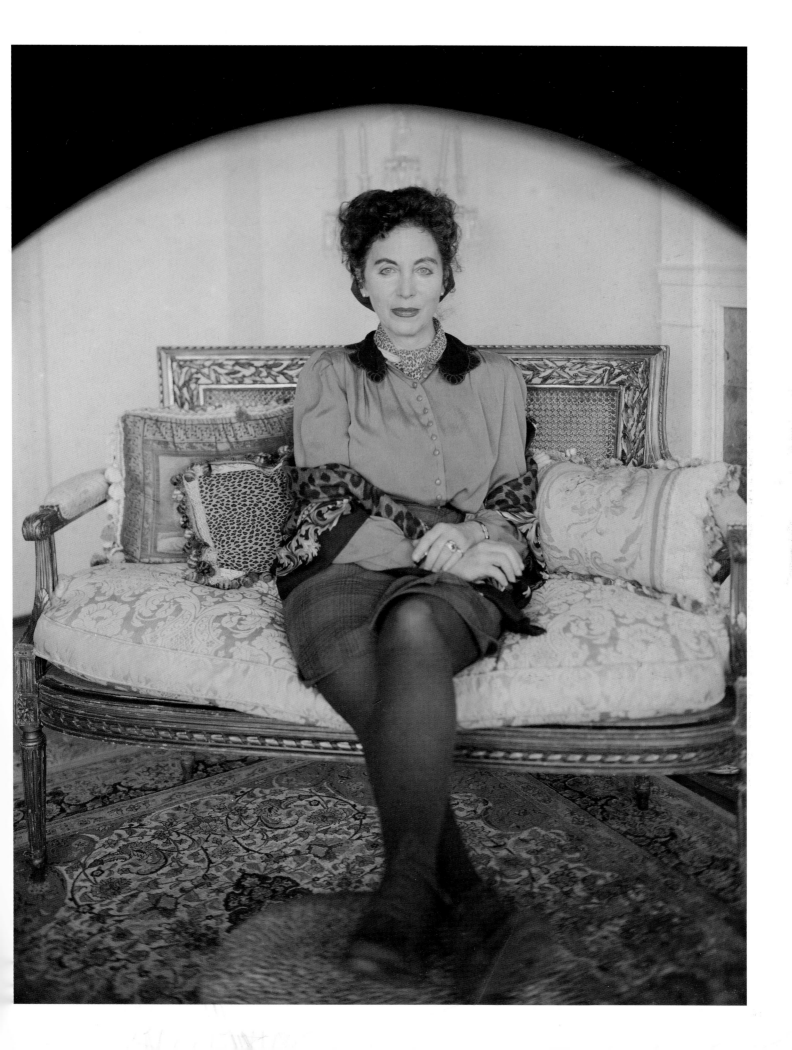

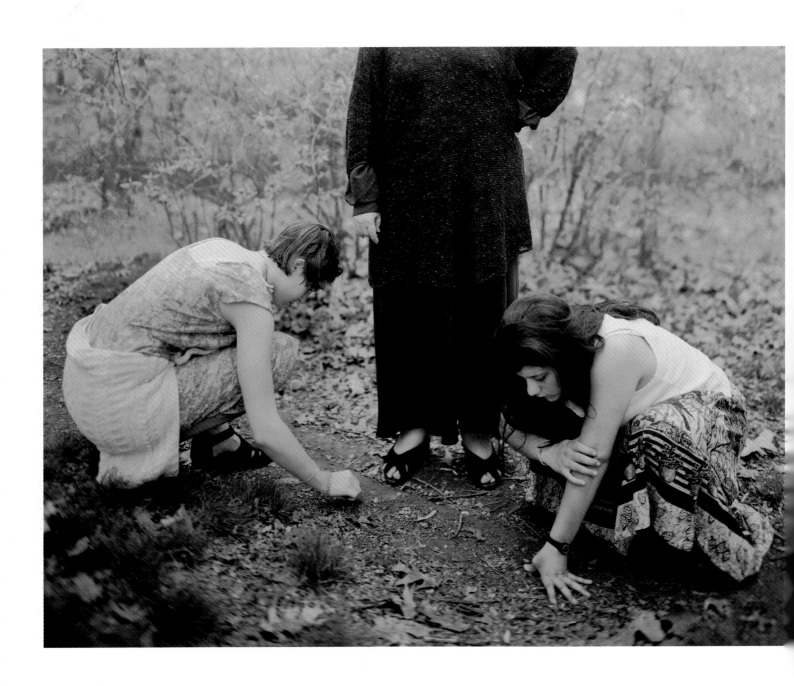

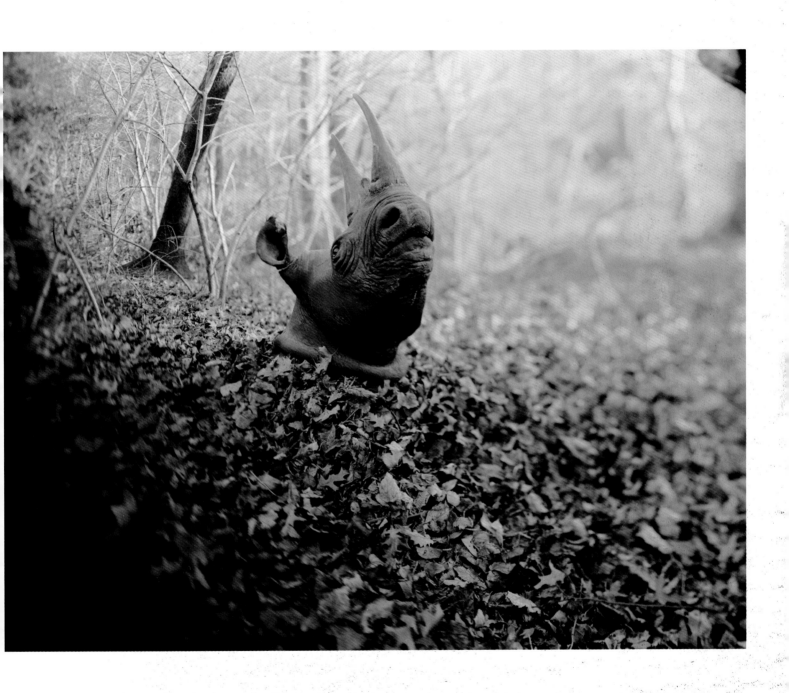

BRIAN DAVID MILLER

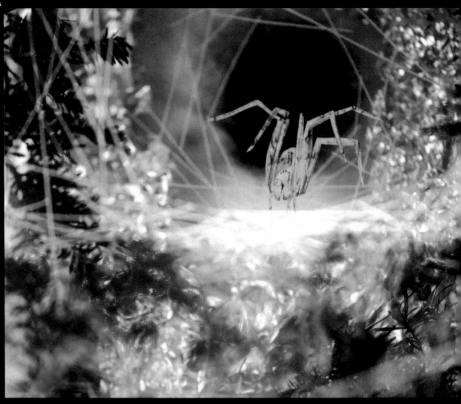

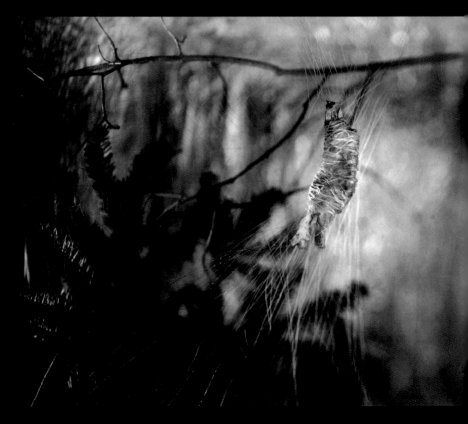

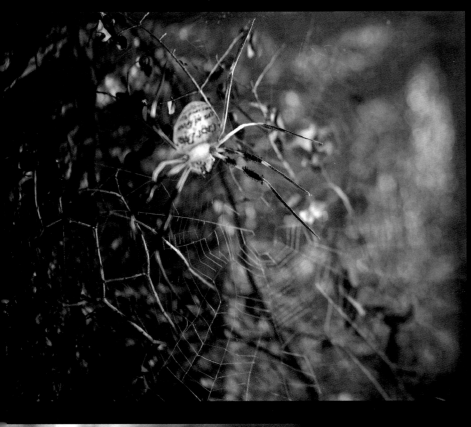

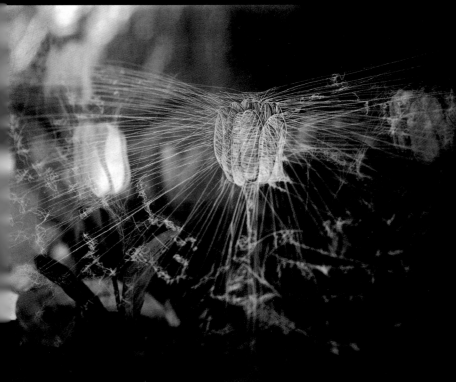

Born 17 September 1970, Greece, New York. Graduate of the State University of New York at Purchase; M.F.A., Yale University. Miller does not see his photographs as illusions that lie, rather as illusions that transform. "The spiders are made from nothing more than discarded paper. Photography transforms the paper into spiders, giving them life. . . . I also see the spider as the perfect metaphor for the artist—a creature who creates an object that is intended to entrap the prey or the viewer." Miller compares artists to a variety of arachnids: the labyrinth spider captures its prey but hides from its enemies in adjoining structures, the leptoparasite uses the webs of others to snare its prey, and the wandering spider—the "webless marauder"—waits in secret to ambush or stalk its prey, all the while clinging to a safety line to halt its descent into the unknown. ¶ "Artists love to spin yarns. Such spinning work dazzles but is often short-lived. Just as analogies between artists and spiders become tenuous if stretched too far. The spider, for example, never becomes trapped in its own web.

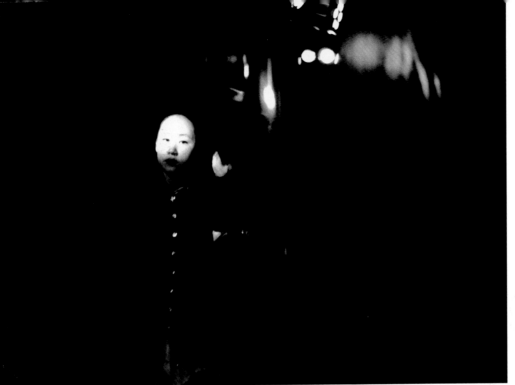

TAI LAM WONG

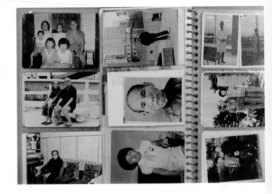

Born 8 April 1973 in a village near Fuzhou, China. Moved with her family to New York City in 1982. Graduate of The Cooper Union. Tai Lam Wong works as a graphic designer, and is a photographer, writer, and filmmaker. In her work Wong uses small spaces as tools to communicate, to view life, to tell stories. ¶ "My family came to the United States illegally. Even though it wasn't like being fugitives, we were still in hiding. My brother, sister, and I were very young and we learned to fear what our parents feared. We were given boundaries of all kinds. And the space within was very small. ¶ "My pictures, arranged in a nonlinear fashion, describe this little space. Like thoughts, dreams, and memories, the space and time they occupy is not rational or scientific. Even though each image is of a moment that is capable of a complete experience, I choose to group them together to create a larger picture. The grouping helps to locate a place larger than just a roof top, or a bathroom. ¶ "The world I portray has little quiet joys, simple pleasures, and burdens so heavy it's like living with huge stones being carried on the back. The pictures describe the dislocation of the self. They are also about lack of faith, lack of trust, and lack of energy. ¶ "I want to use these images to show things that give me joy and things that cripple me. But plainly put, I take pictures to try to hold on to those things that will no longer be there."

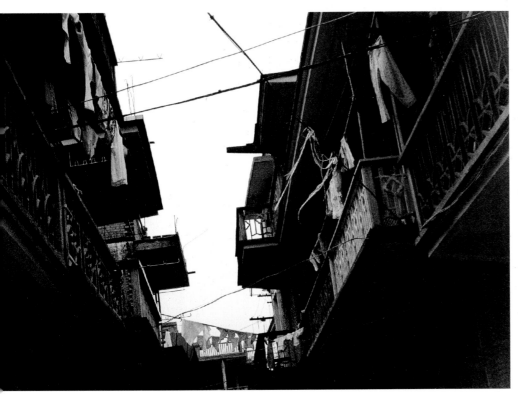

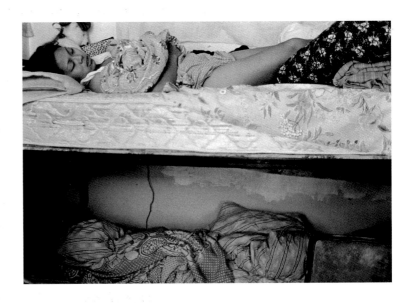

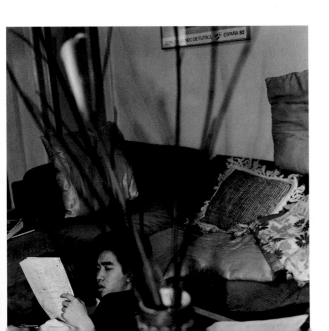

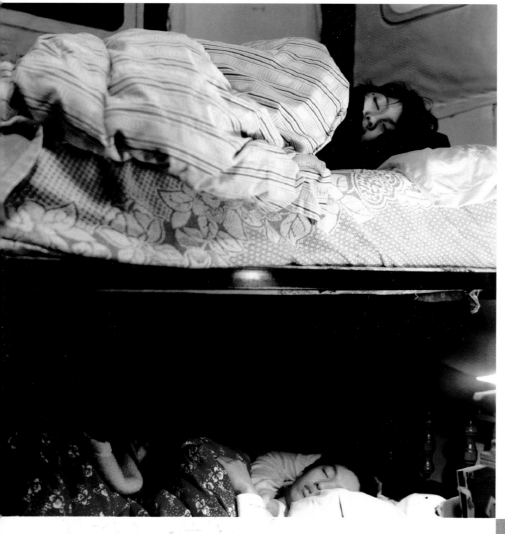

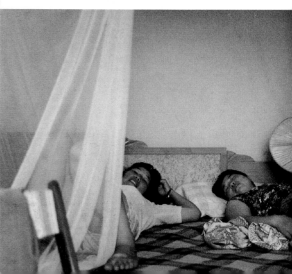

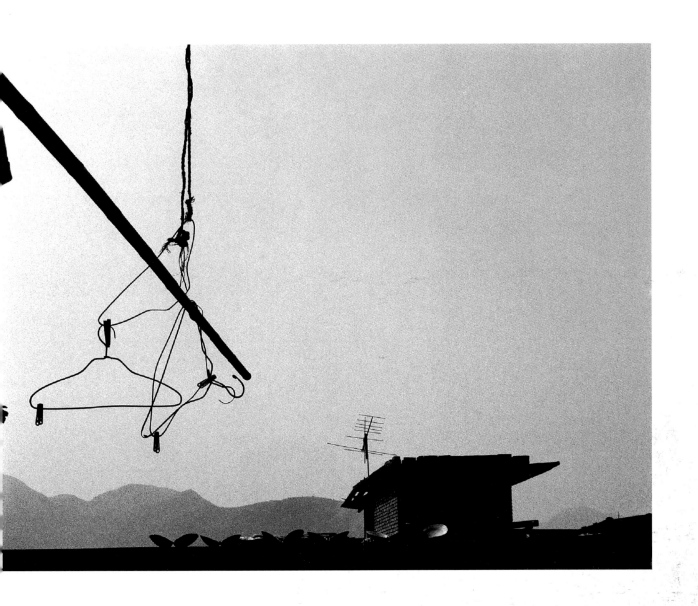

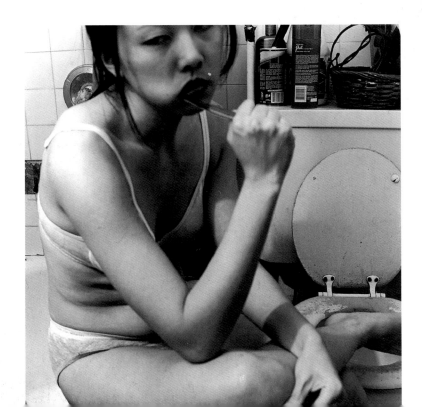

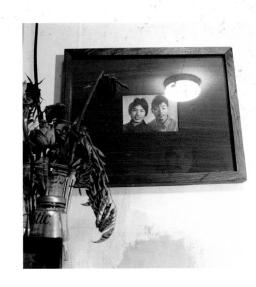

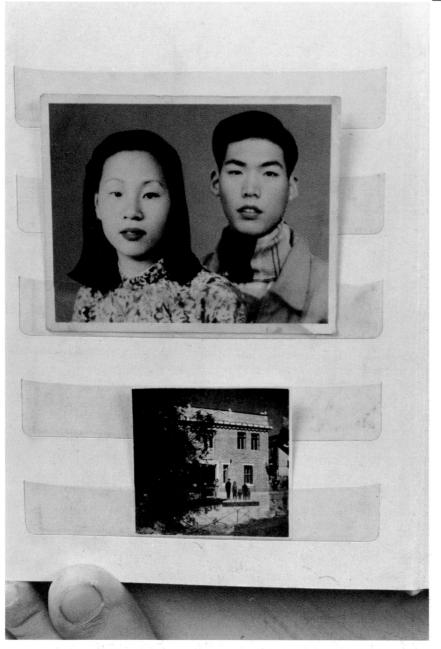

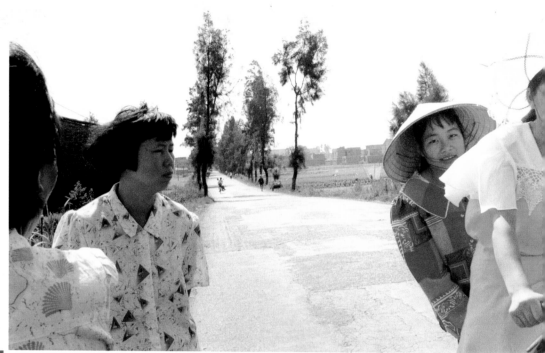

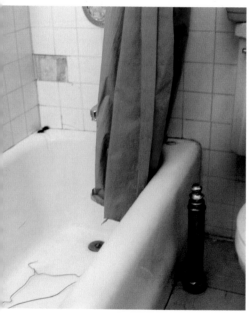

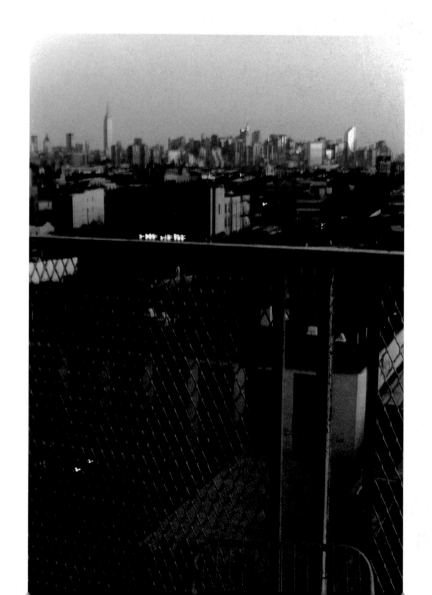

ALLEN RICHARD ADON JR.

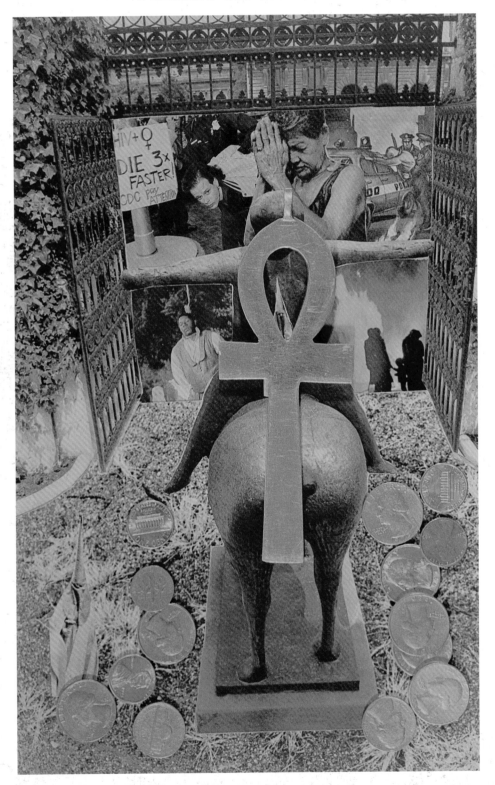

Born 22 December 1977, Washington, D.C. Attending Cleveland Institute of Art. "I began to photograph as a student at Suitland High School in Forestville, Maryland. Don Fear was my teacher and mentor for four years of high school. I still look to him for advice. In a history of photography class, we started out with photograms and pinhole cameras. The following year I took photography—without the history. Our first assignment was a photomontage. I liked the results of this project much better than those of the year before. ¶ "About that time I went on a trip with our foreign language teacher. We went to London, England; Madrid and Malaga, Spain; and Tangiers. That trip had a lot to do with my second photomontage, 'The Gates of Hell.' I wanted to show pain, sorrow, and I wanted the feelings to be depressing."

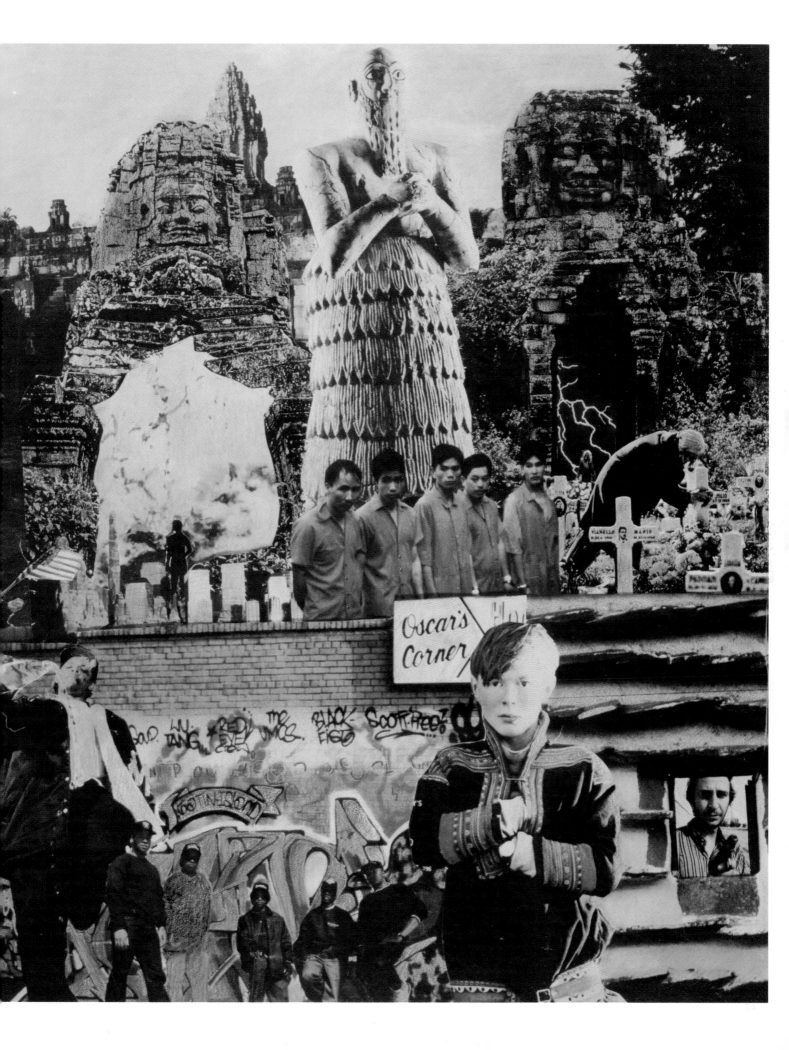

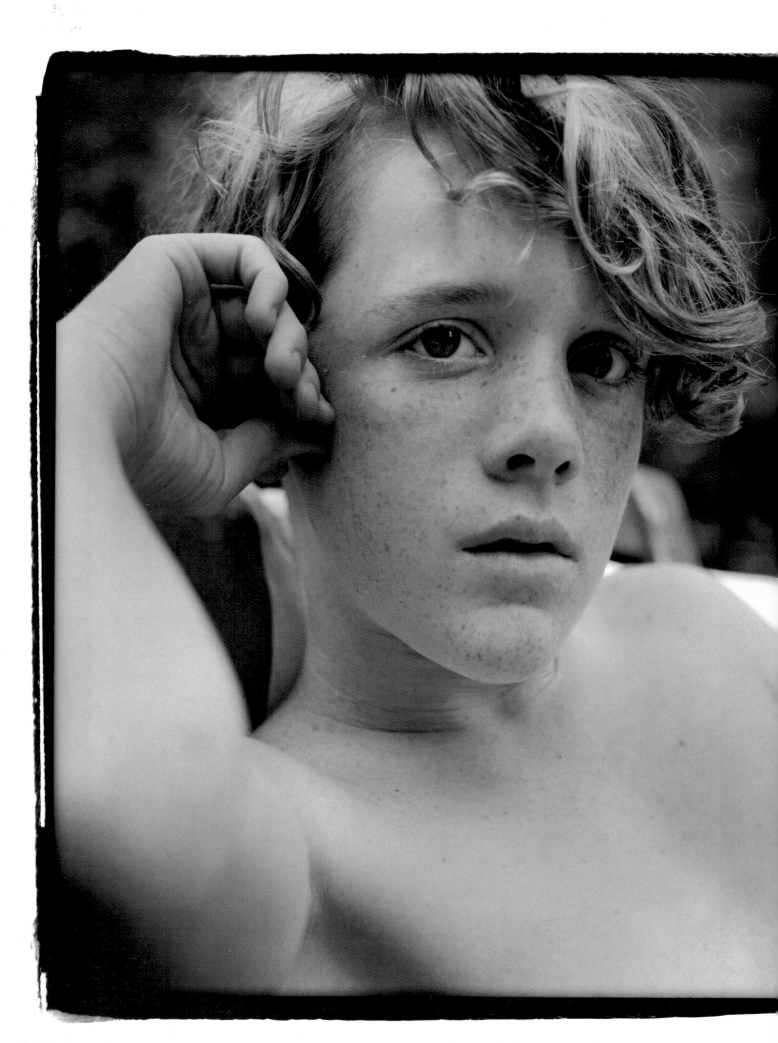

RUTH KENDRICK

Born 18 August 1974, Richmond, Virginia. Attending Parsons School of Design. "My father, William, a lifelong painter, taught me my own way of seeing, and I grew up knowing what to look for. It wasn't so much what he taught me but what I absorbed from him. My earliest memories are of sitting for my father's portraits and following him when he went to do other portraits. I discovered photography at Saint Catherine's High School in Richmond, Virginia, thanks to Dixon Christian, my mentor and friend. Growing up abroad and in Richmond, then coming to New York, made me aware of different faces, attitudes, personalities, and possibilities." ¶ Ruth Kendrick plans to pursue a master's degree in photography, to travel, and to study language and explore the new directions her photography may take.

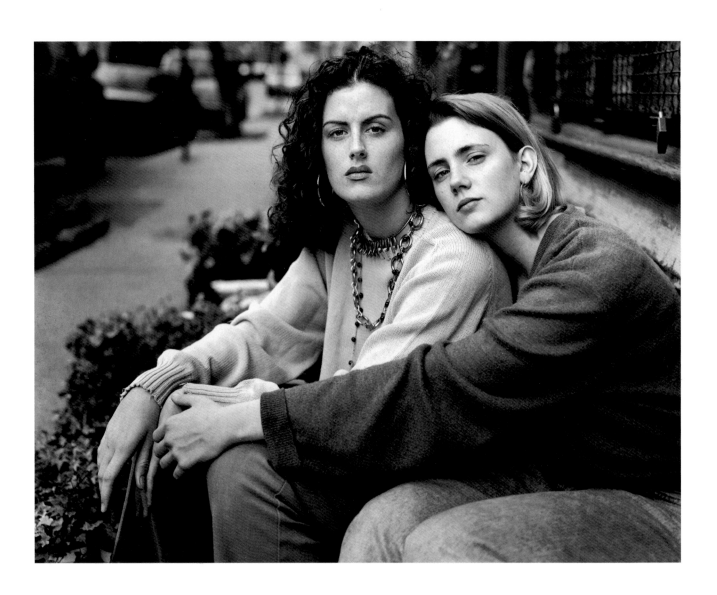

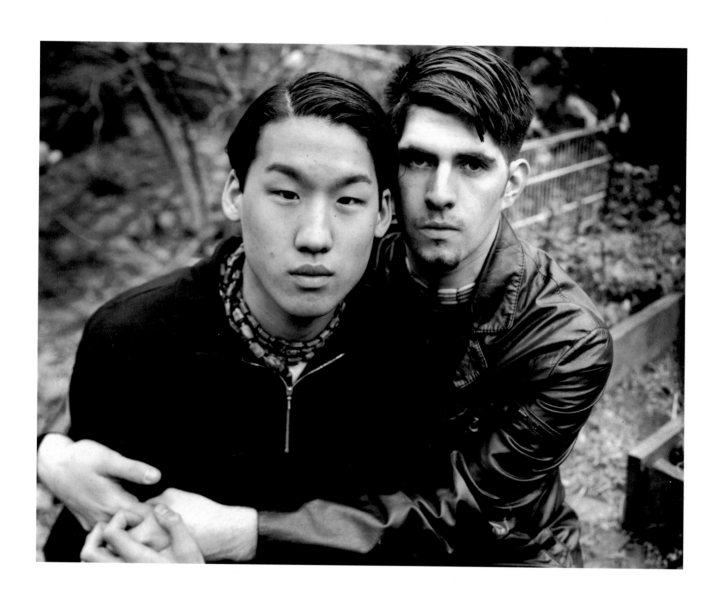

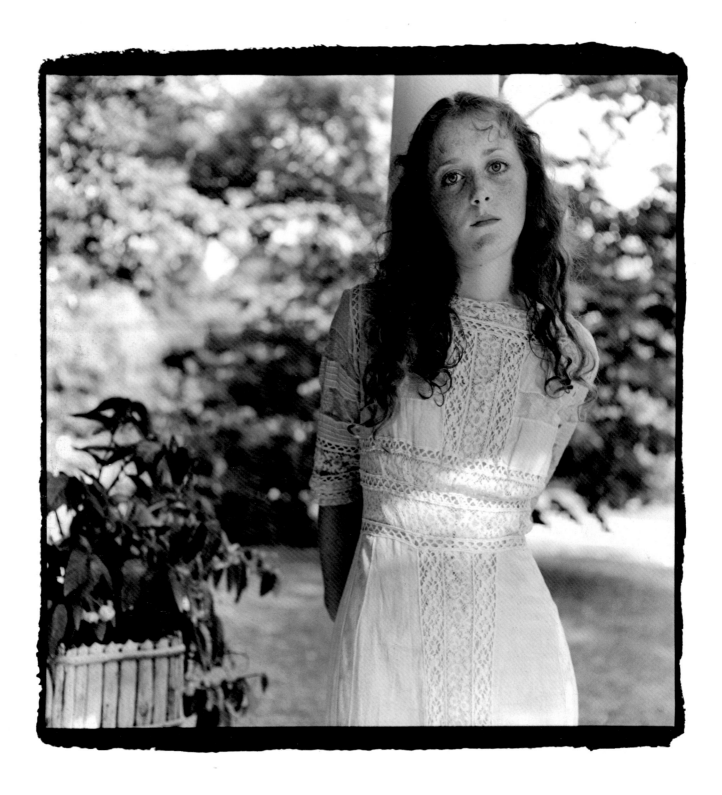

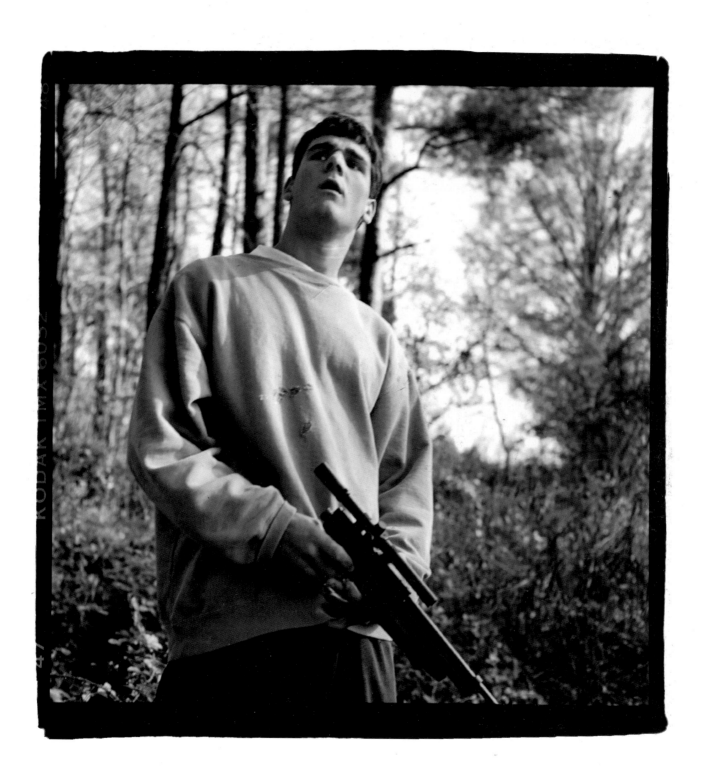

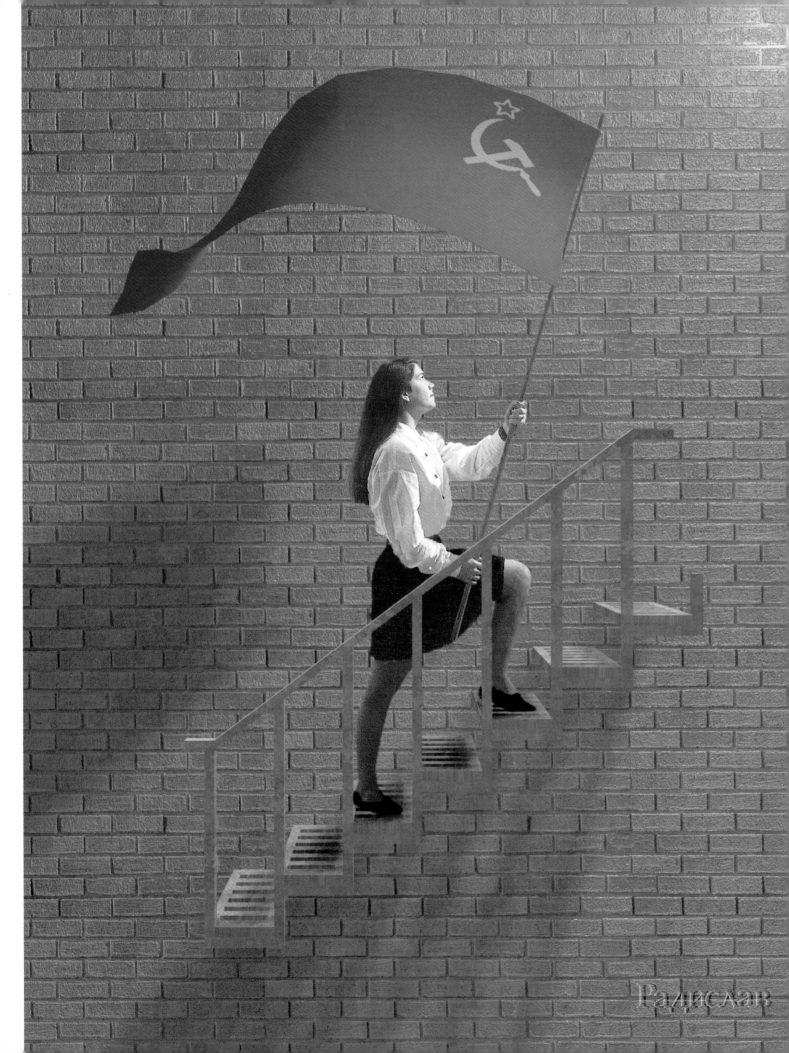
Радислав

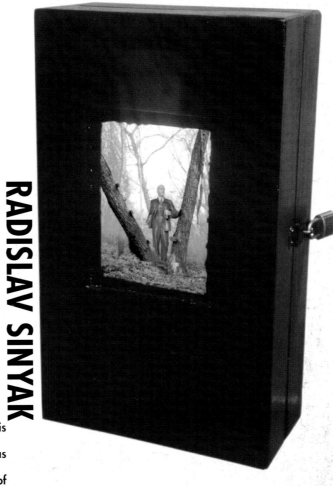

RADISLAV SINYAK

Born 12 September 1971, Kiev, Ukraine. Moved with his family to the United States in 1980. Graduate of East Texas State University; currently in M.F.A. program at University of Houston. The limited nature of real objects led Sinyak to computer technology—he uses computer-manipulated images and multimedia presentations to illustrate his messages with creative freedom. "I create a reality that doesn't exist, yet keep up the illusion of photographic reality. When the Communists took power in the Ukraine, they proceeded systematically to replace religion with Communism. The boxes in my images refer to Russian religious icons. Thus the saints were replaced with party leaders, generals, the proletariat. ¶ "My family and I became U.S. citizens in 1985. For the first nine years of my life, I was taught to hate the evils of capitalism; since then I was taught to hate the evils of Communism. I am now trying to sort out my opinions. I am generating my own kind of propaganda that helps me sort out the propaganda fed to me."

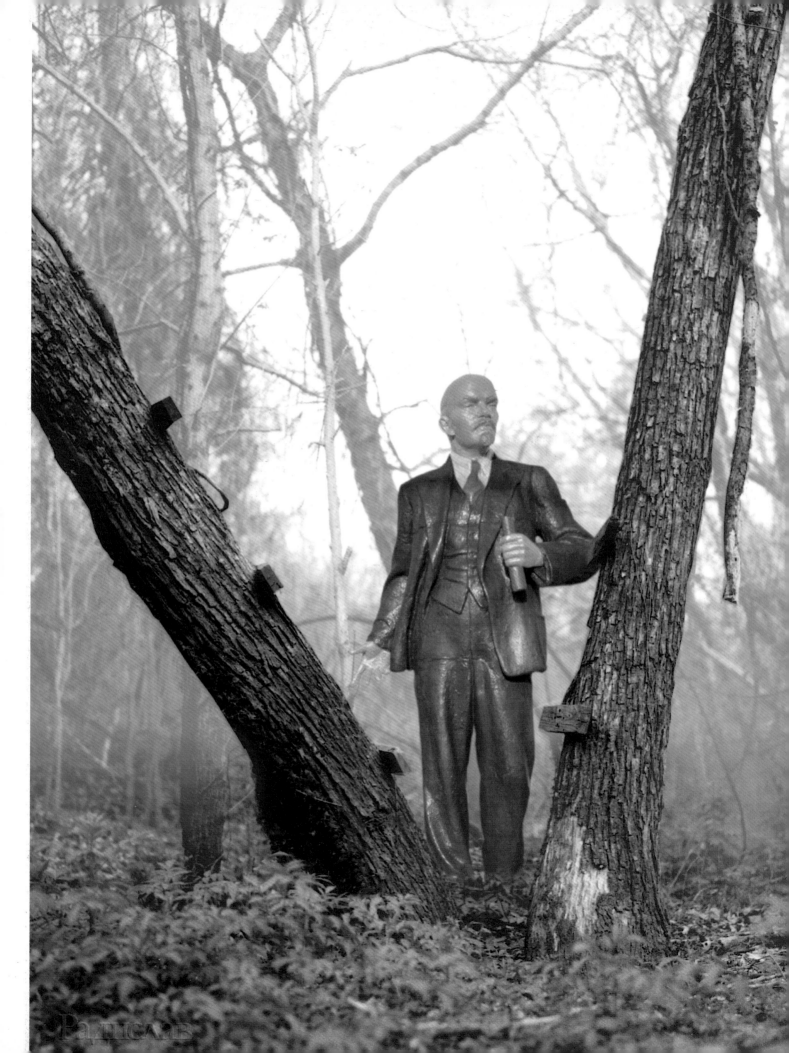

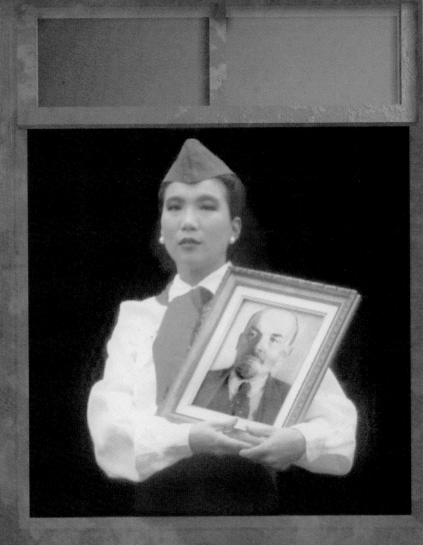

ВЕЛИКАЯ ОКТ

ЛАЛИСТИЧЕСКАЯ РЕВОЛЮ

Радислав

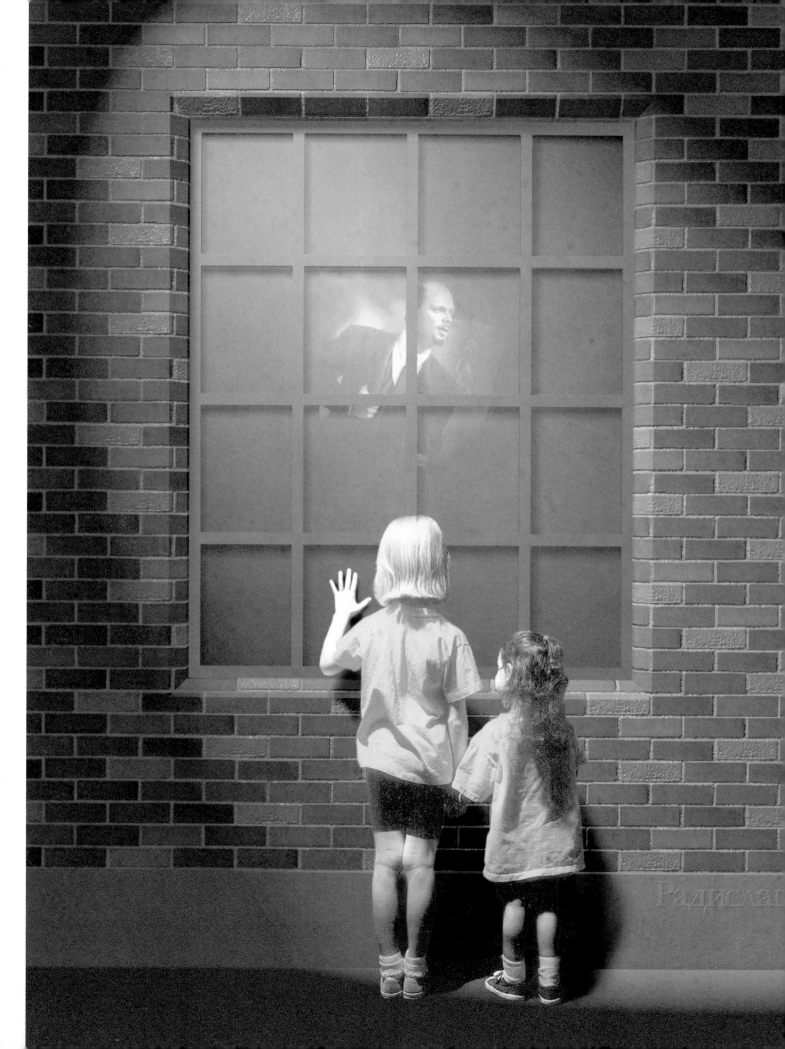

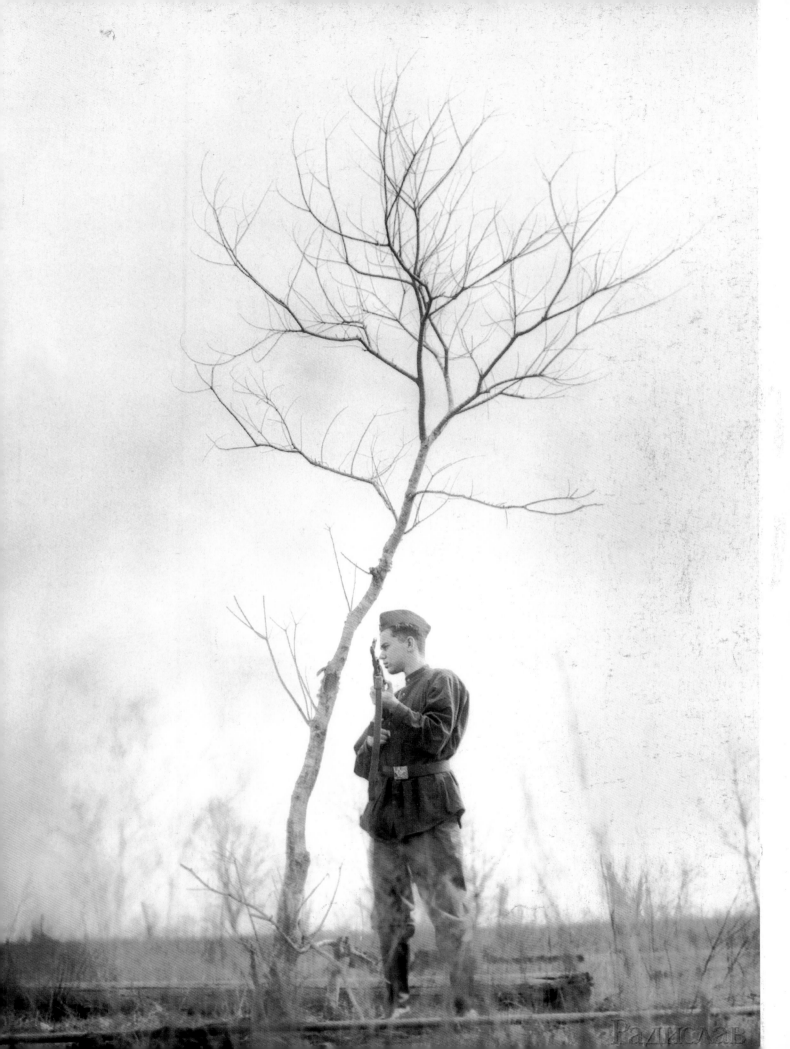

Радиславъ

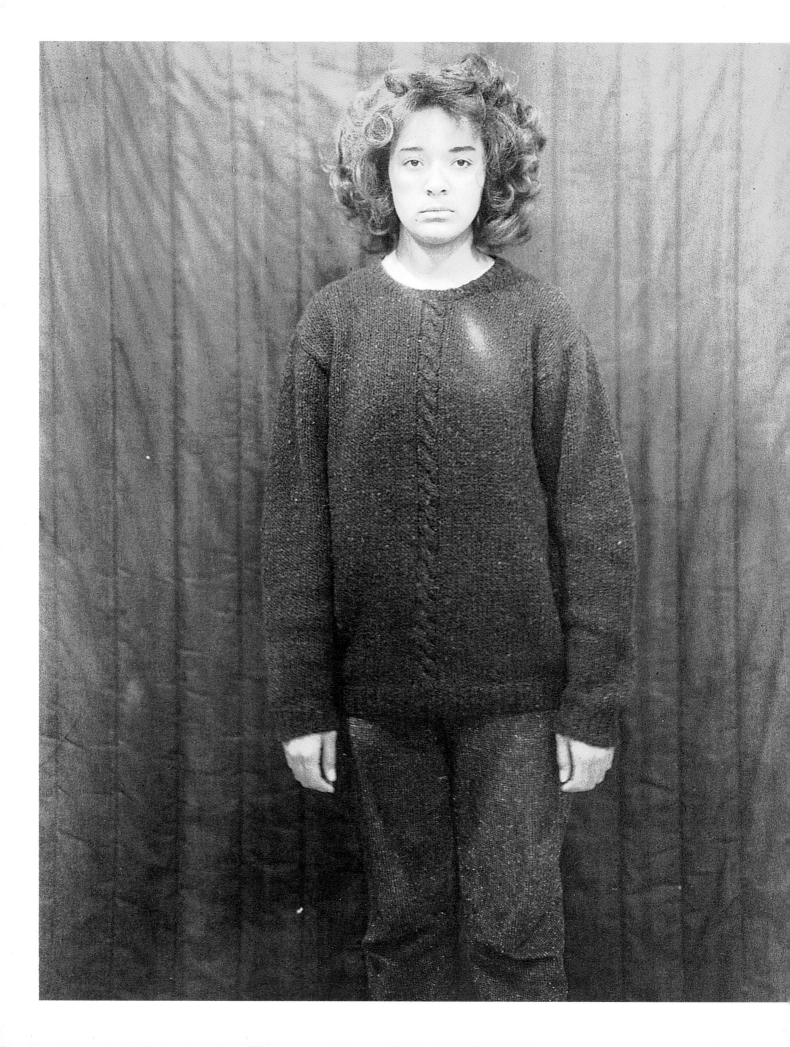

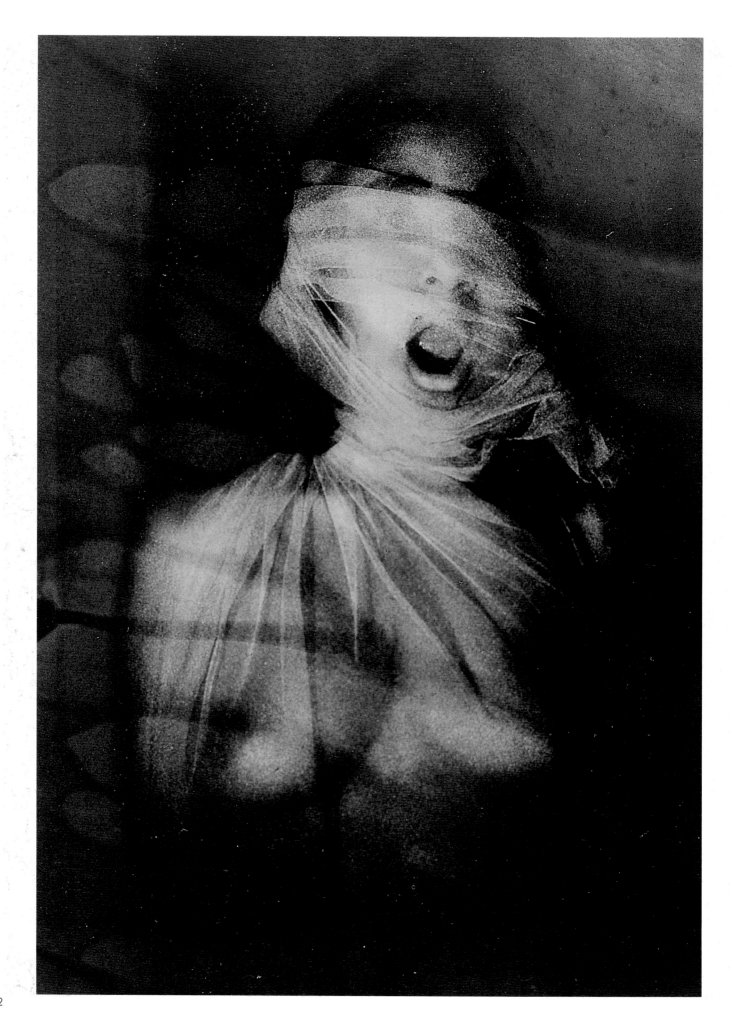

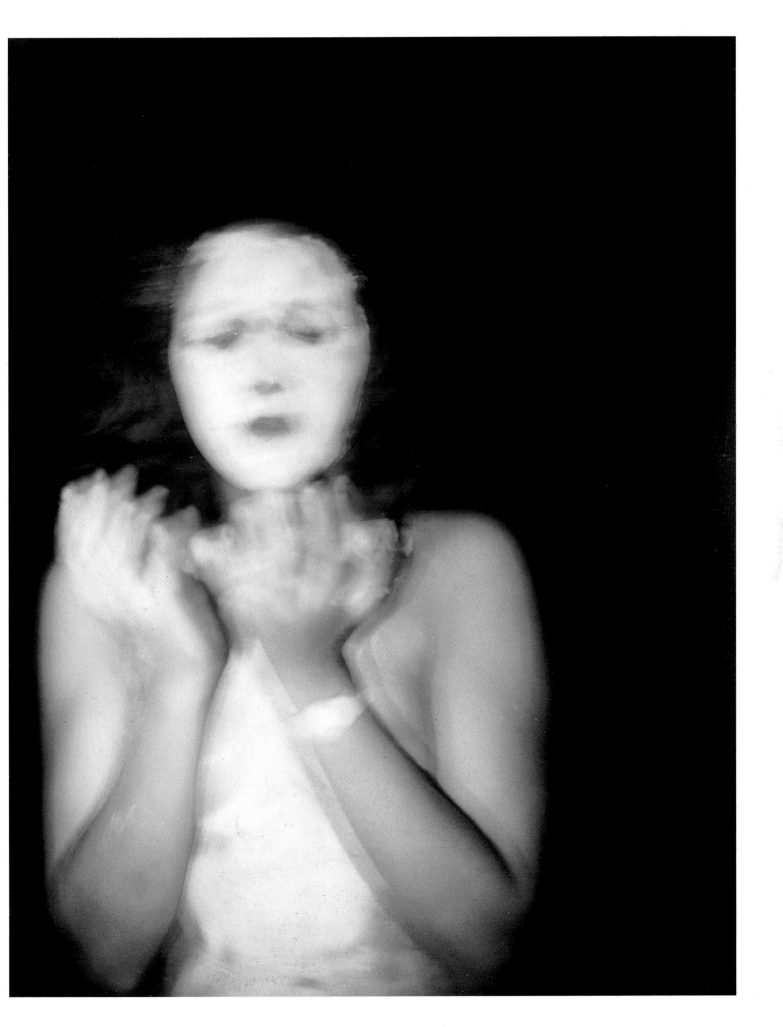

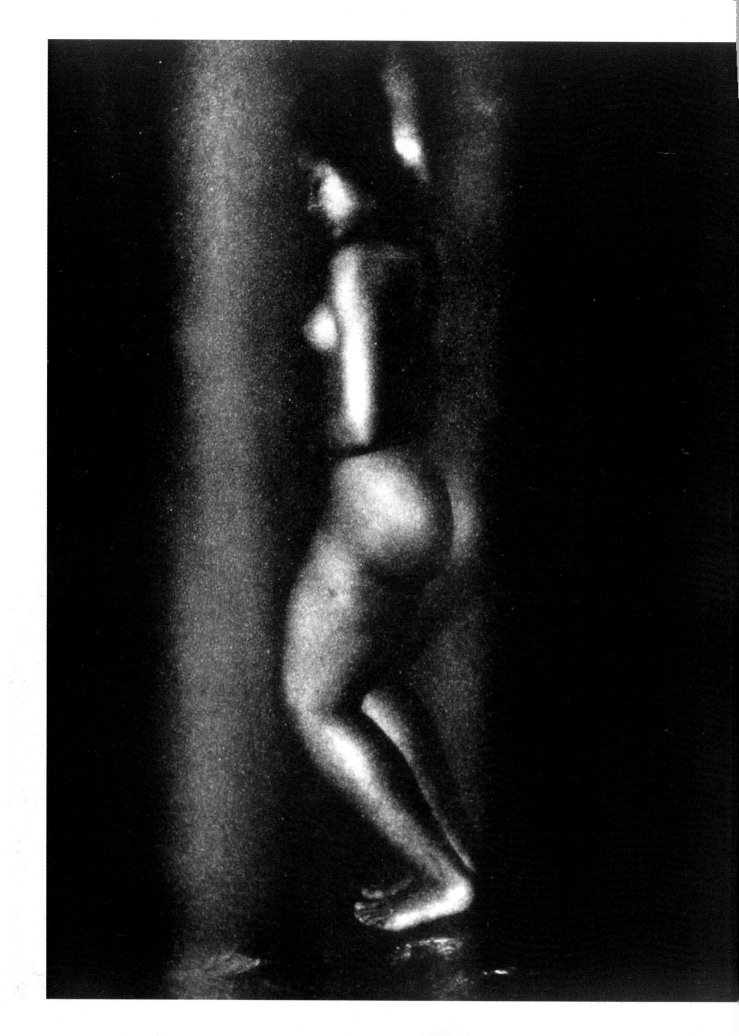

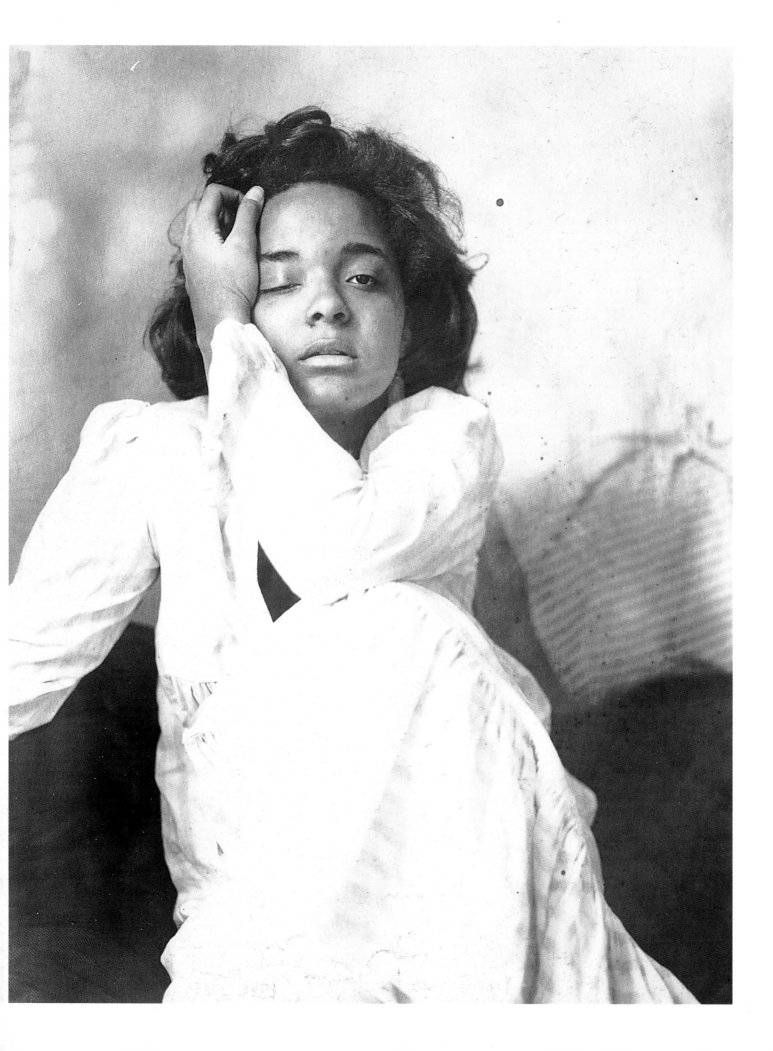

JESSICA WYNNE

Born 13 July 1972, Watertown, Connecticut. Attended Hampshire College; graduate of San Francisco Art Institute. My mother is a potter, painter, and batik artist. My father teaches history and collects old cameras. He gave me my first camera when I was thirteen. ¶ "For the last three years I have focused my attention on doing portraits of people in their home environments. The images featured here are from a series on people living at a residential hotel in San Francisco—the Broadway Hotel. Most of these new friends were very gracious about allowing me, and my camera, into their private worlds. For many, this hotel is the only affordable alternative to life on the streets. These residents are fiercely individualistic and have resourcefully established comfortable homes out of what most would consider to be a marginal setting at best. ¶ "My friends at the Broadway Hotel tell me they trust me, and wouldn't be able to work this way with anyone else. Some residents say that now, when they are walking down the street or riding the bus, someone will stop and say, 'Hey, I know you from your photograph.'"

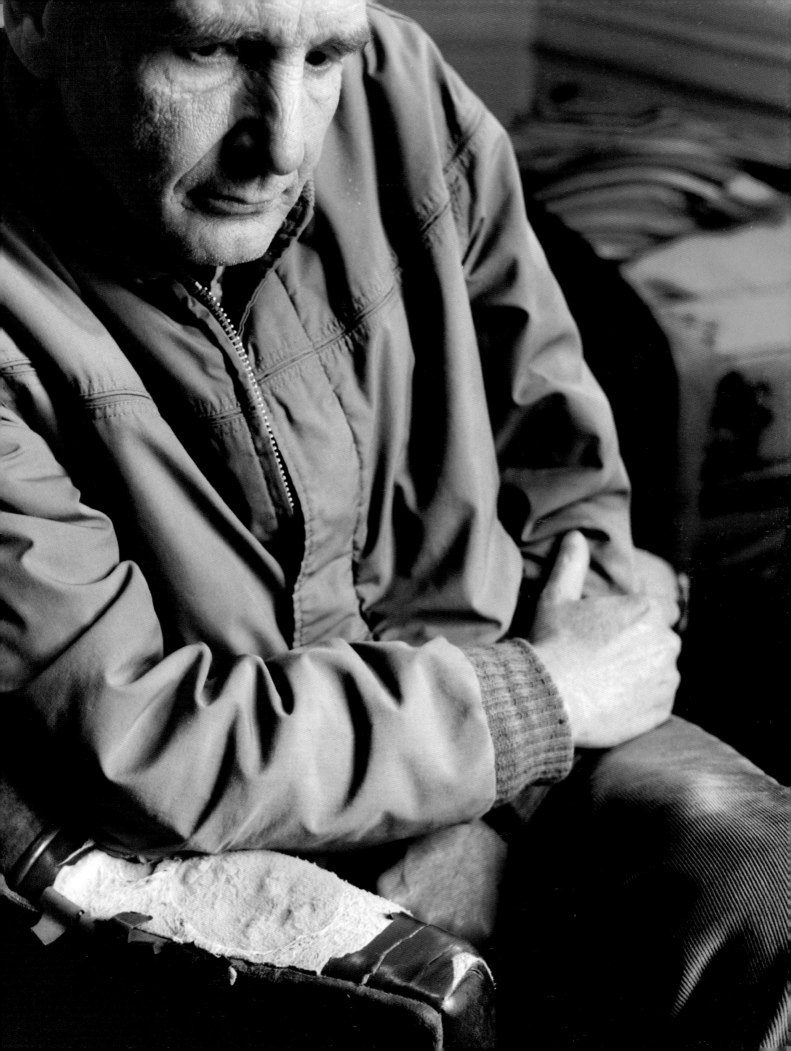

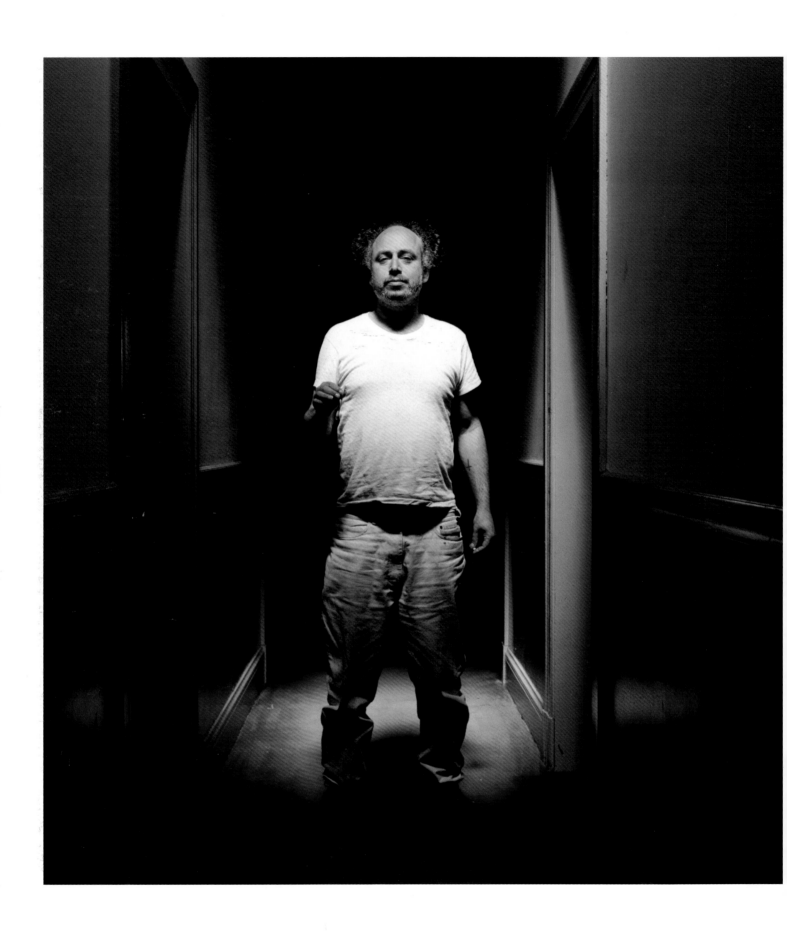

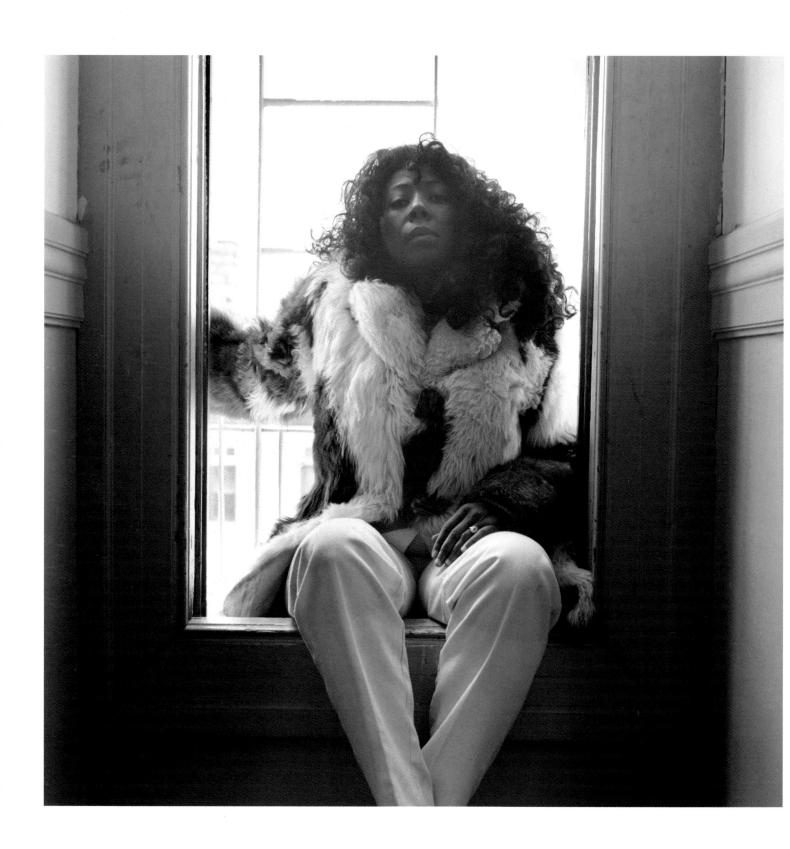

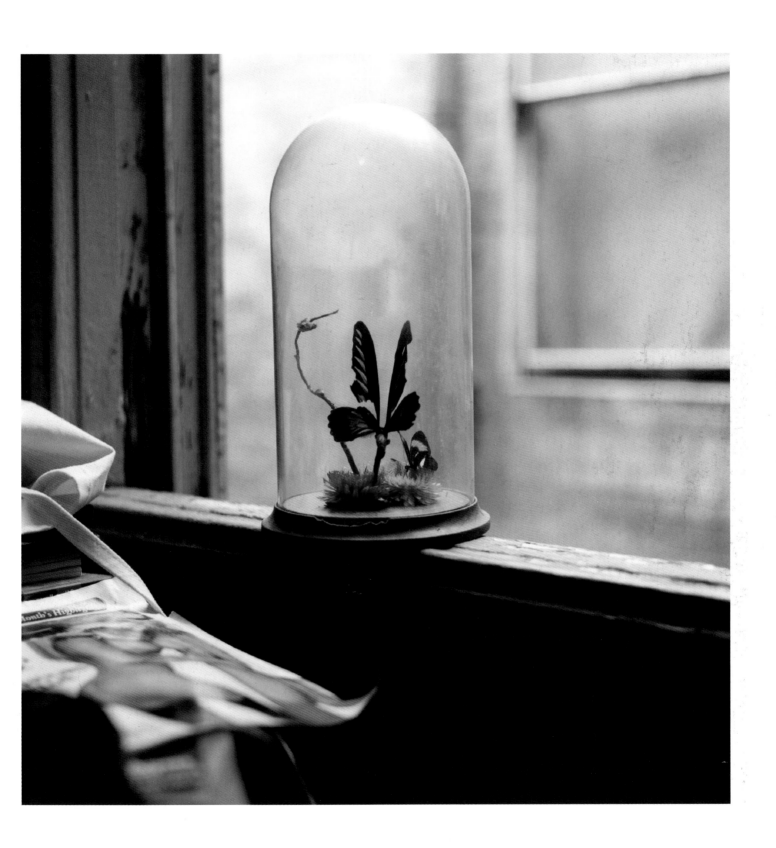

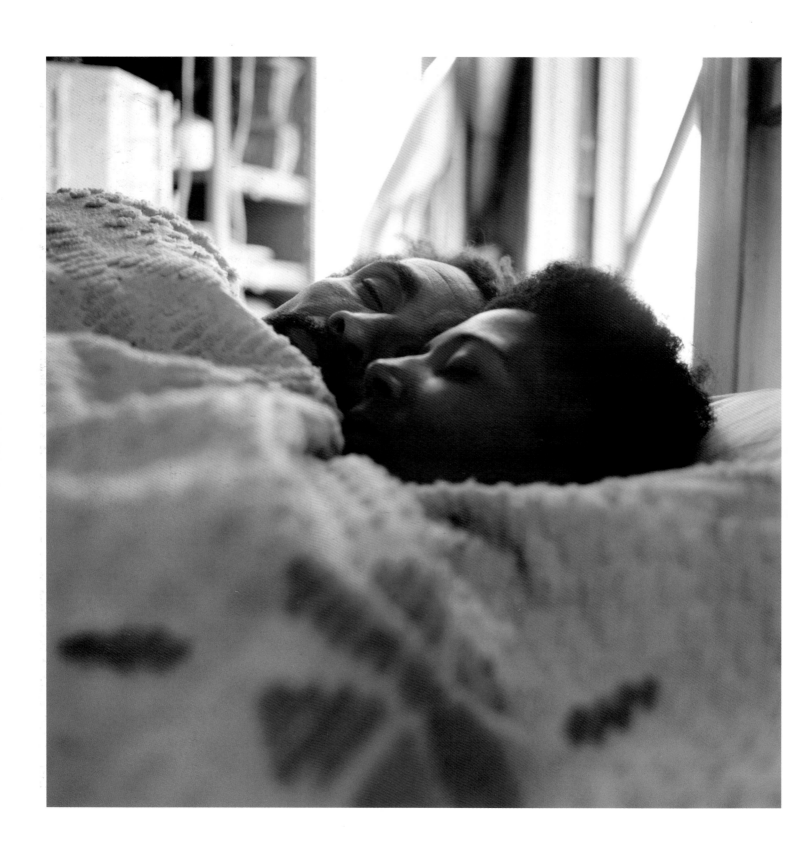

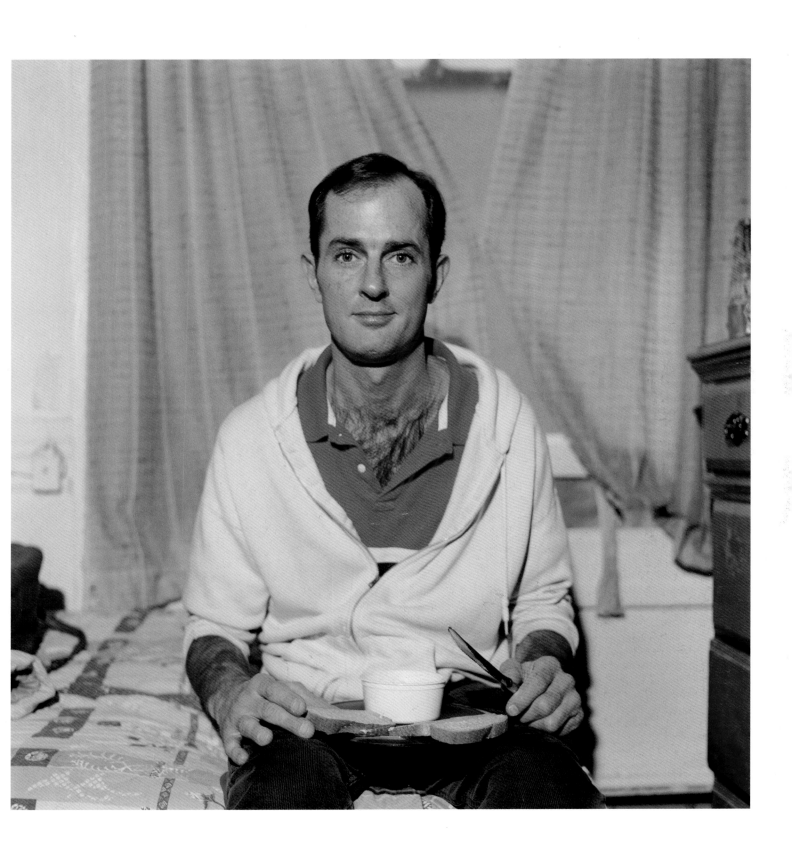

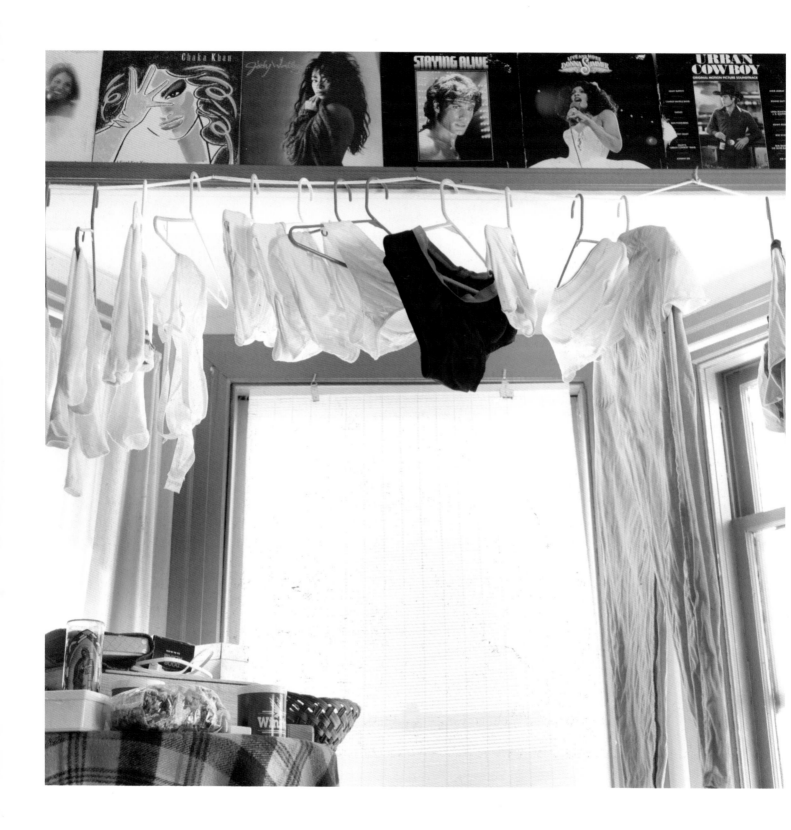

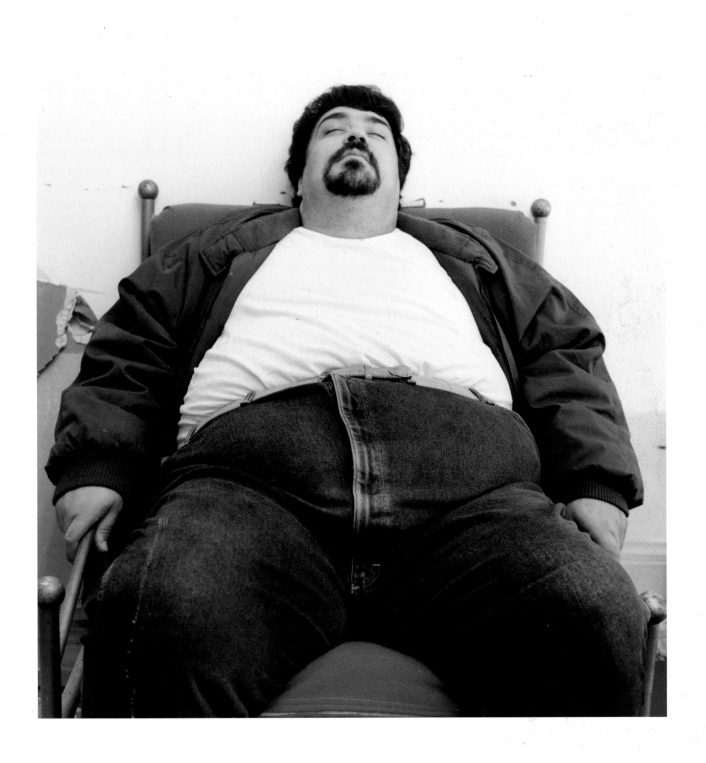

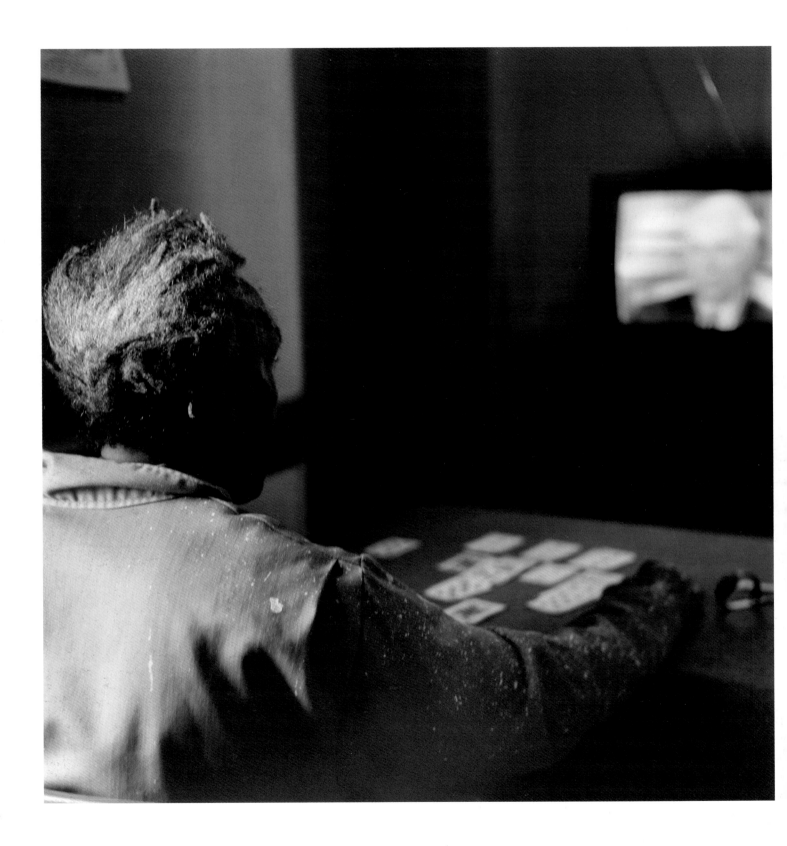

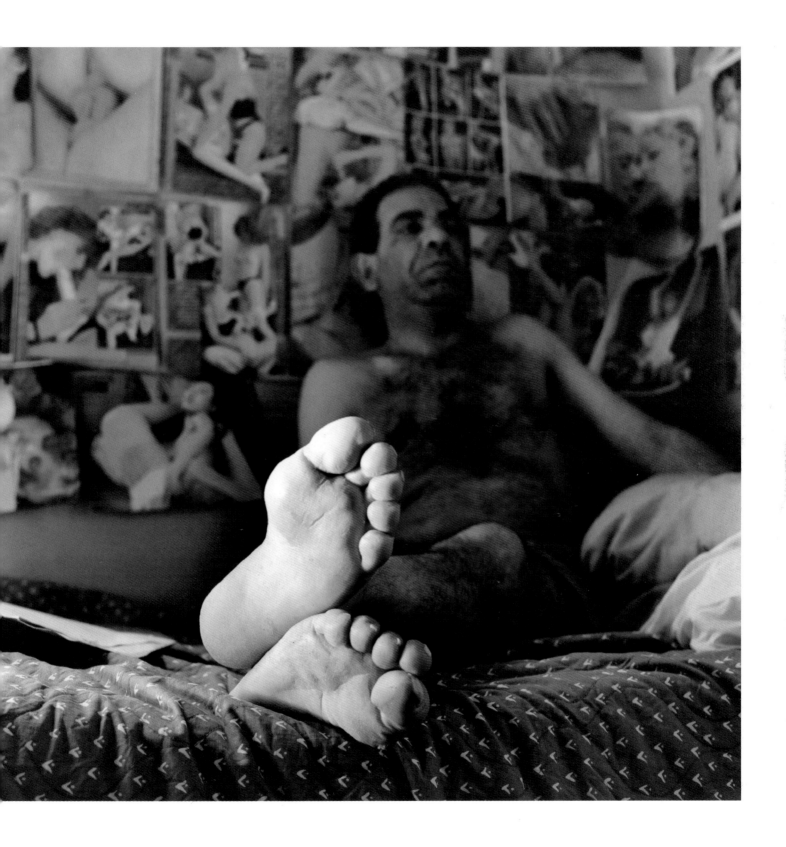

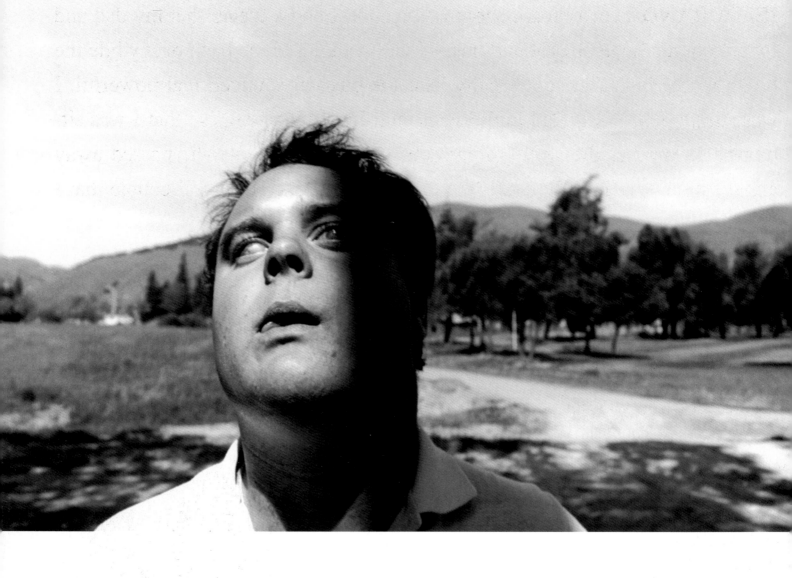

JUSTIN WALSH

Born 13 July 1971, Pittsburgh, Pennsylvania. Graduate of Carnegie-Mellon University; M.F.A., San Francisco Art Institute. Justin Walsh's father was a teacher turned social worker, and his mother, a nurse in a burn unit at a local hospital. His parents made a strong impression on him at an early age. He says, "My own work as a photographer stems from and is connected to their goals of social help and change." ¶ For over two years, Walsh has worked at the California School for the Blind with students from eighteen to twenty-two years of age—a transitional period for these young people as they undergo job training and master basic living skills. From two years of photographing and recording interviews with them, Walsh created a multilayered documentation of the interior world of the blind. "It is their interpretation and translation of the world around them that has become the focus of the work," says Walsh. "Whether it is about dreams of buses or memories of fishing, the work is not about documenting indisputable fact, but trying to be clear about intuition and hope."

JEFF CRANDALL: I dream about buses a lot. I had a dream that my dad and I were on this huge Greyhound bus—I was walking to the back of it while the bus was moving. You could really hear the bus—it sounded real powerful. I was sitting next to my dad in the seats, and I turned my legs so that I was sitting backwards in the seat. I dream about my father a lot—he passed away about a year ago. I really don't like to talk about his death. I tell people that I lost him.

KHAM NGUYEN: My vision used to be normal—my accident happened in Texas. I was in the hospital for six weeks and lost mobility in my left arm. I can still feel with it and I can lift it up—but not all the way. I used to work with my two brothers on a shrimping boat. I remember the water—the sound of it as it hit the side of the boat. The water was smooth and blue, and at night the sky

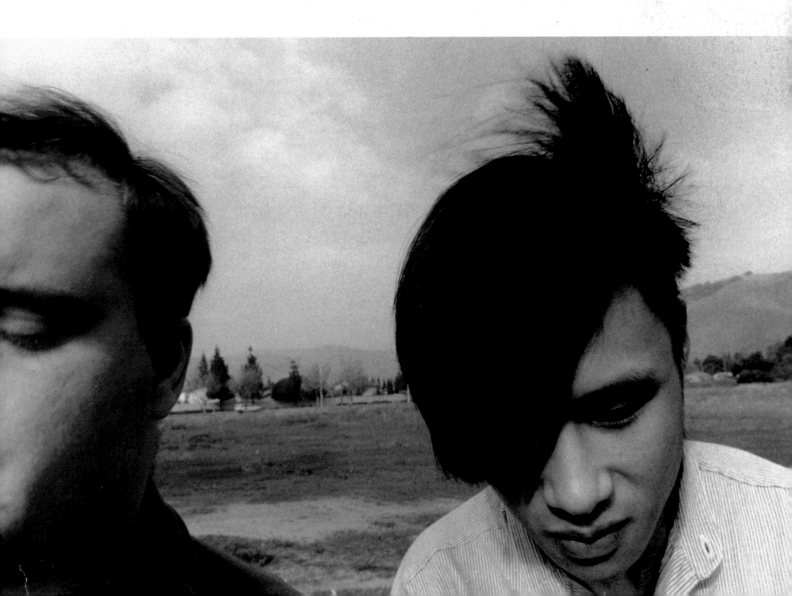

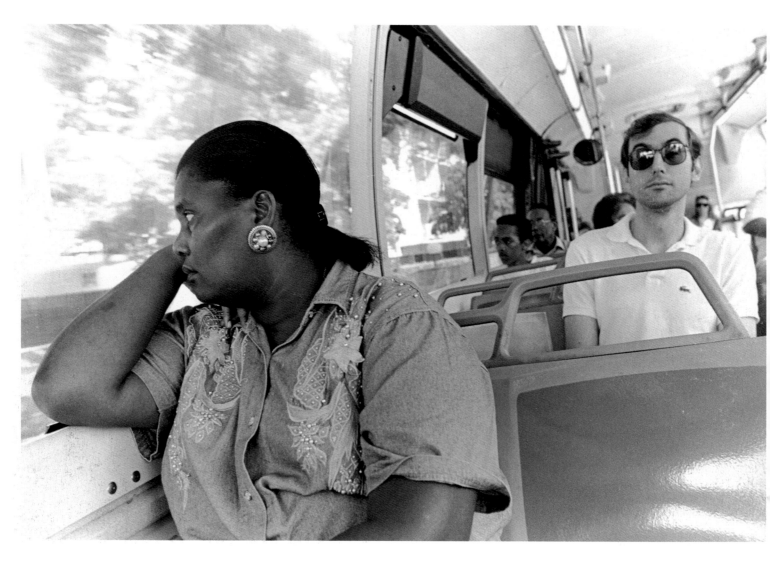

EDDY JOSEPH

Born 18 September 1974, Cap Haitien, Haiti. At the age of ten moved with his family to Brooklyn, New York. Attending Florida International University. Eddy Joseph's sister introduced him to photography when he was twelve. At South Miami Senior High School, he worked on his photography three hours a day. "I have photographed everything—street scenes, arranged still lifes, studio portraits. Riding the bus has been my primary mode of transportation since my family moved to Miami, Florida. I wanted to explore all the different things that can happen while a person is taking the bus from one place to another, to visually capture the essence of the bus ride. I agree with John Szarkowski when he said, 'The object is not to reproduce that subject matter, which is impossible, but to make of it a good picture—a thing with its own energy and order.' ¶ "Some people like to attach a political or social meaning to the bus photographs. I didn't have a political or social agenda. I am a photographer who rides a bus. That's where I made my pictures." ¶ Now a college senior, Joseph is making photographs of black men in college, as well as other subjects. "I am continuing to take pictures to capture precise moments of time when forms, composition, and meaning coincide."

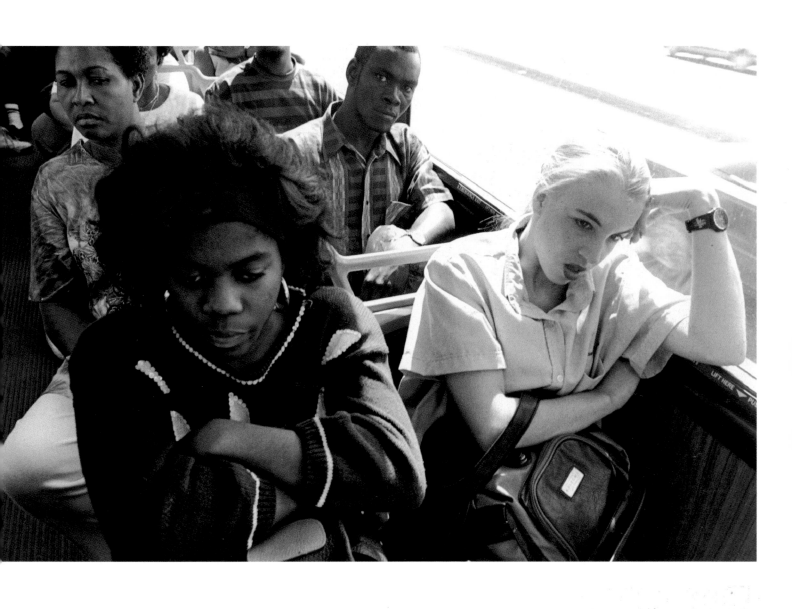

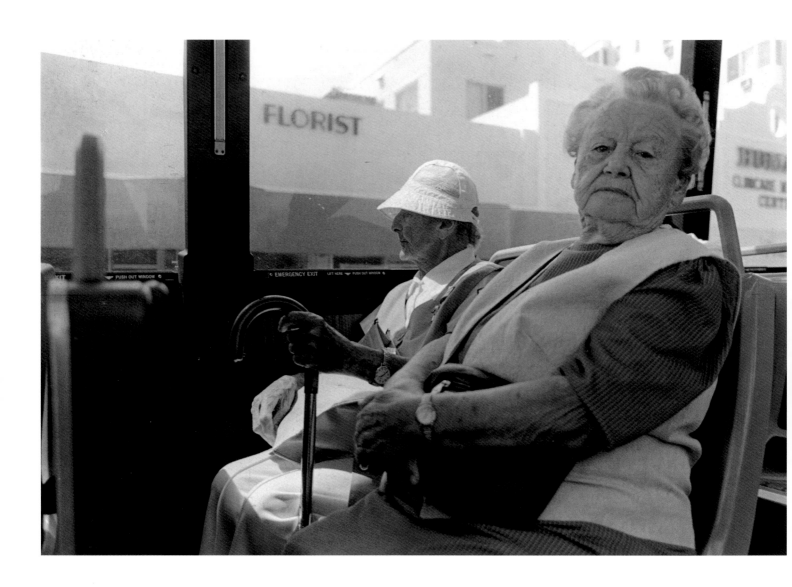

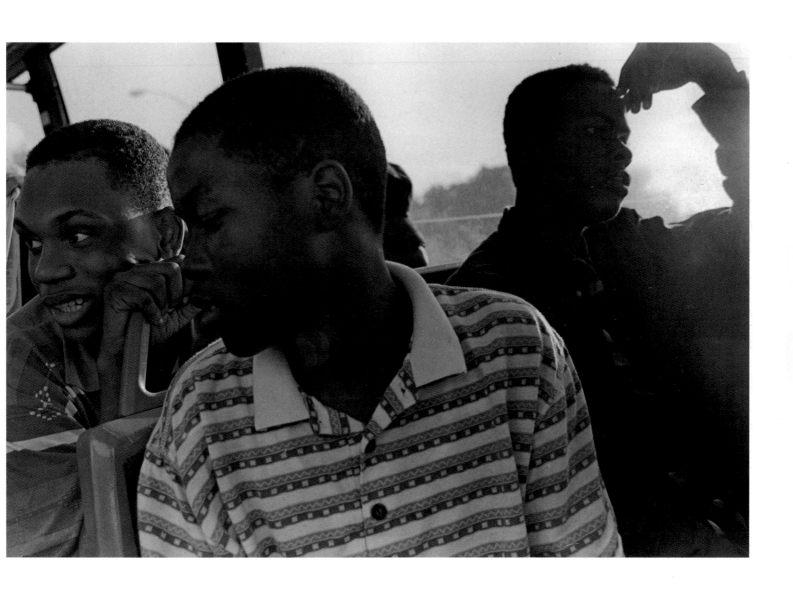

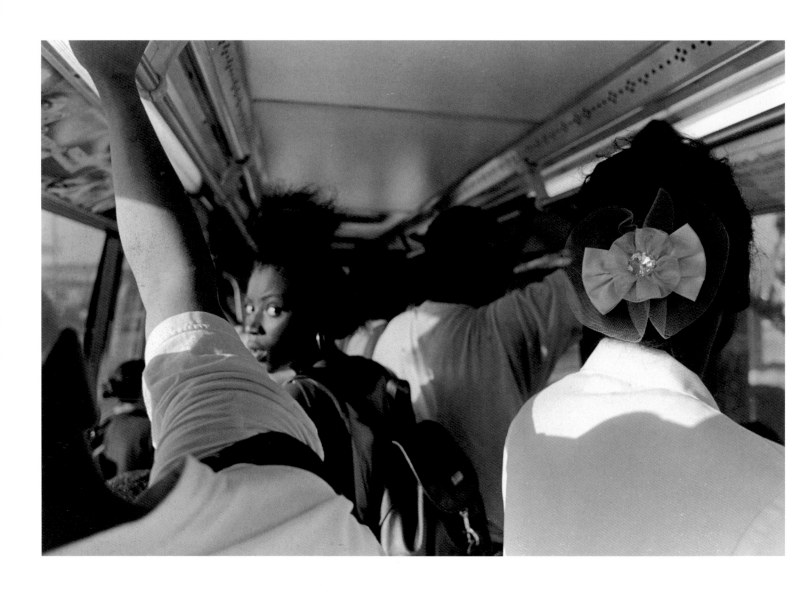

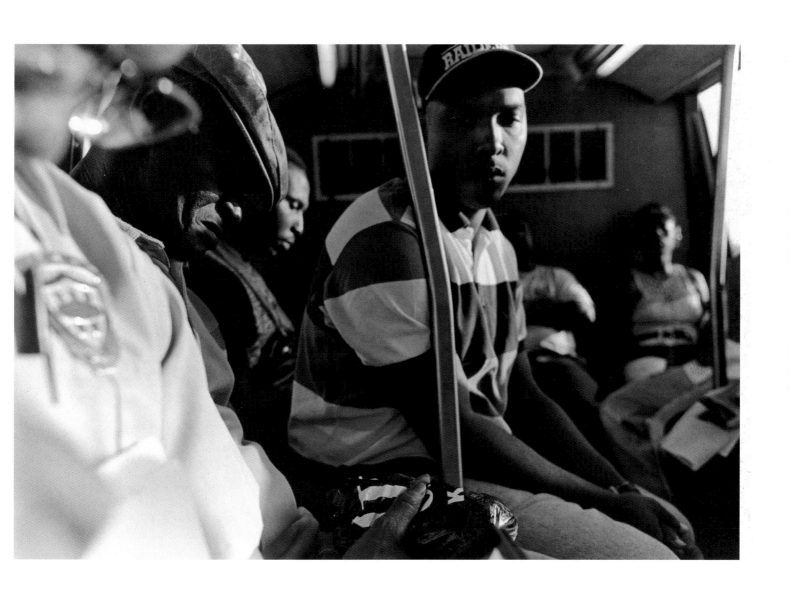

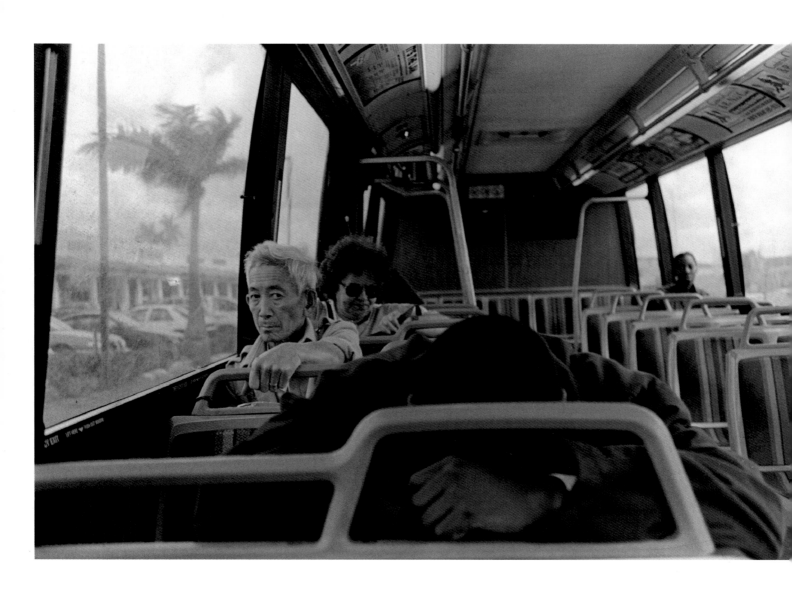

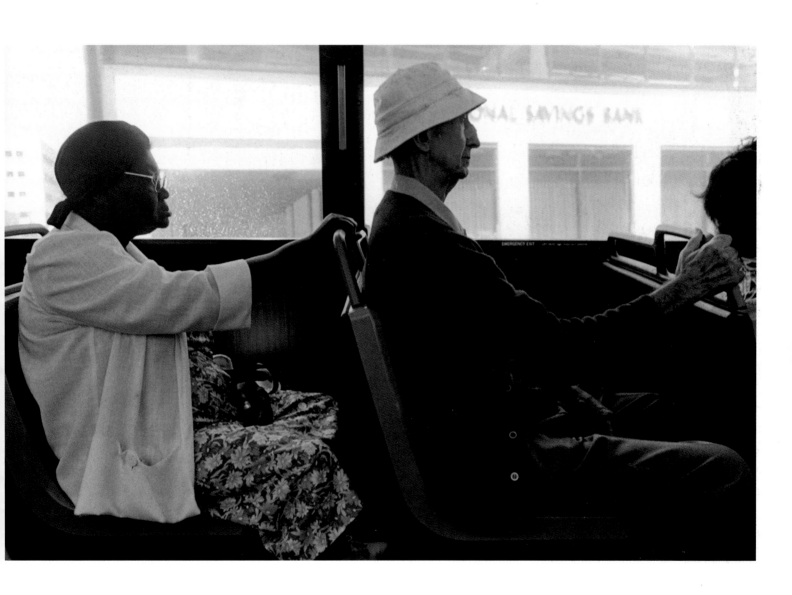

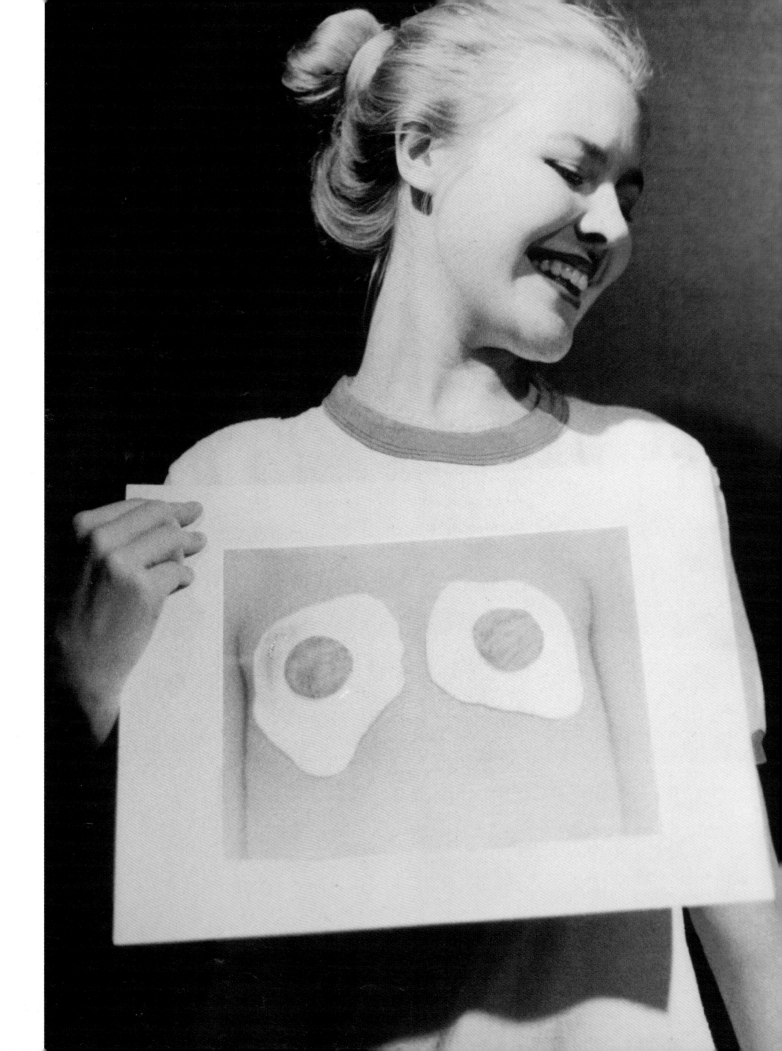

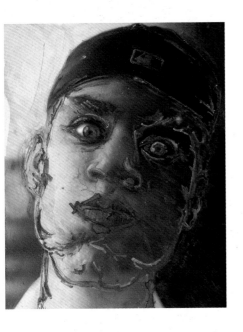
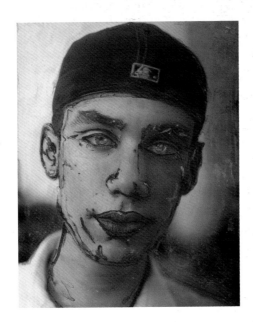
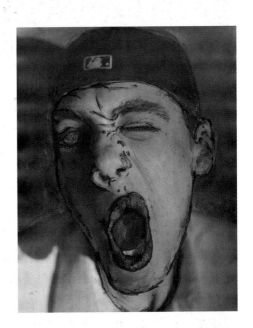

HEATHER HOGAN

Born 9 February 1977, Windsor, Ontario. Has lived in Michigan since the age of six. Attending Center for Creative Studies College of Art and Design. "When I was growing up, I pretty much did my own thing. I wasn't any good at sports and stuff like that. I mostly liked to read and draw." Heather Hogan continued drawing and added painting and clay sculpture in high school. In her junior year, she tried photography. "It's very realistic, but you can manipulate it into something very personal and abstract. ¶ "When I first started taking pictures, I was intimidated by the camera and all the chemicals, but once I learned the technique I became quite comfortable with it and began looking at things differently. I let my ideas and sense of humor show in my work. I also began photographing with ideas in mind—I like to do something to make people think. I think people need to think more often."

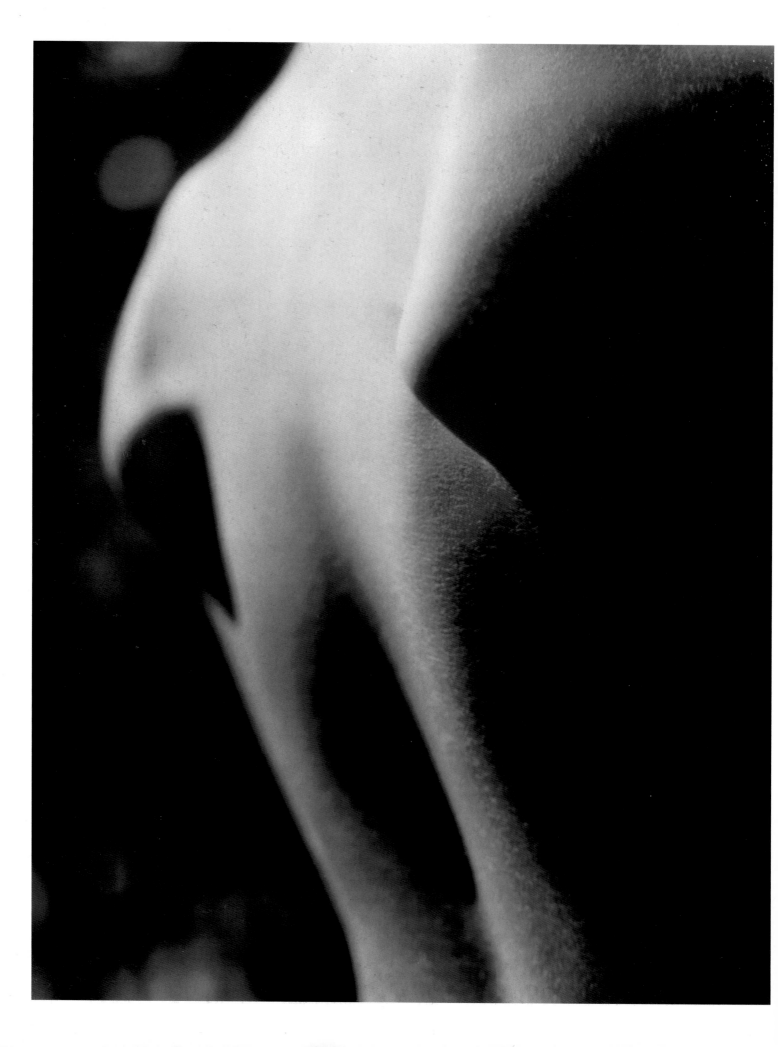

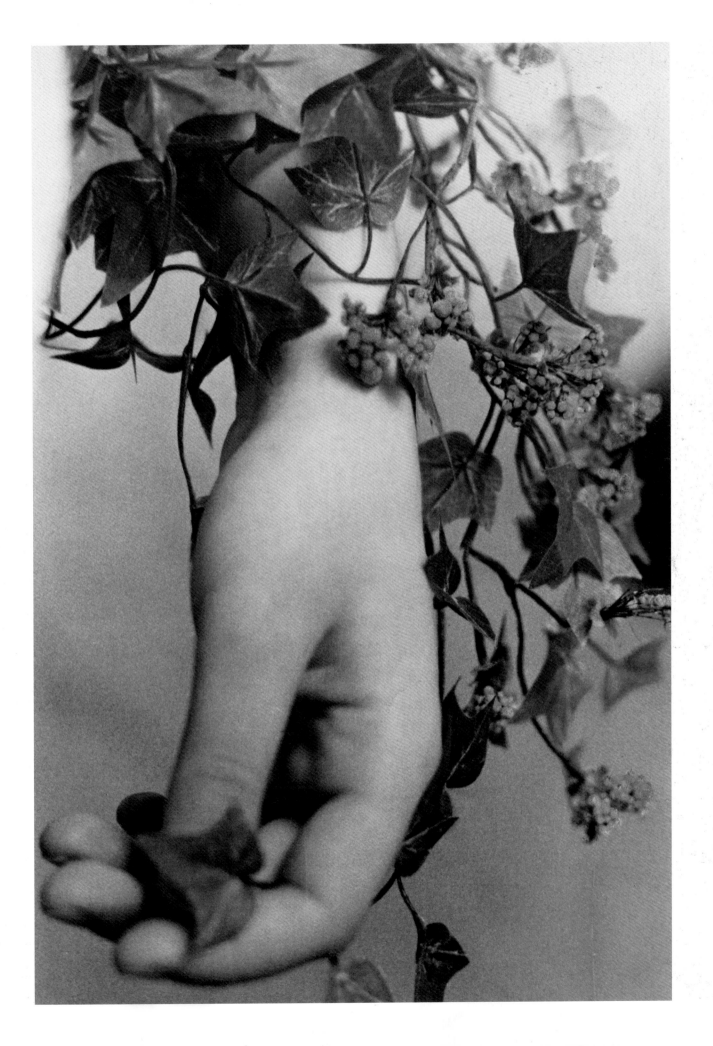

AMANDA FAITH CAMPBELL

Born 14 October 1969, Brooklyn, New York. Graduate of the School of the Visual Arts. "Photography gives the curious a license to observe, and it is my ticket to places I wouldn't normally be invited. I choose very specific places to make pictures, and photograph what is familiar to me: families and men and women involved in everyday dramas. As I roam the streets in Brooklyn and Queens, I strive to incorporate mystery, drama, and joy into my pictures leaving just enough distance to invite an audience to help me make them into fiction. ¶ "In *Tropic of Cancer* Henry Miller wrote, 'In every poem by Matisse there is the history of a particle of human flesh which refused the consummation of death. . . . As if the inner eye, in its thirst for a greater reality, had converted the pores of the flesh into hungry seeing mouths. By whatever vision one passes there is the odor and the sound of voyage.' This journey will be the reward of my pursuits."

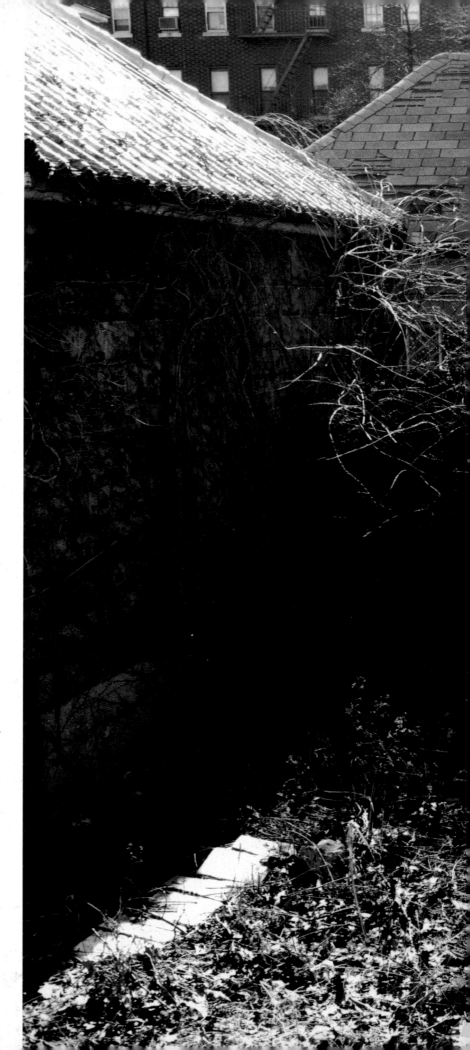

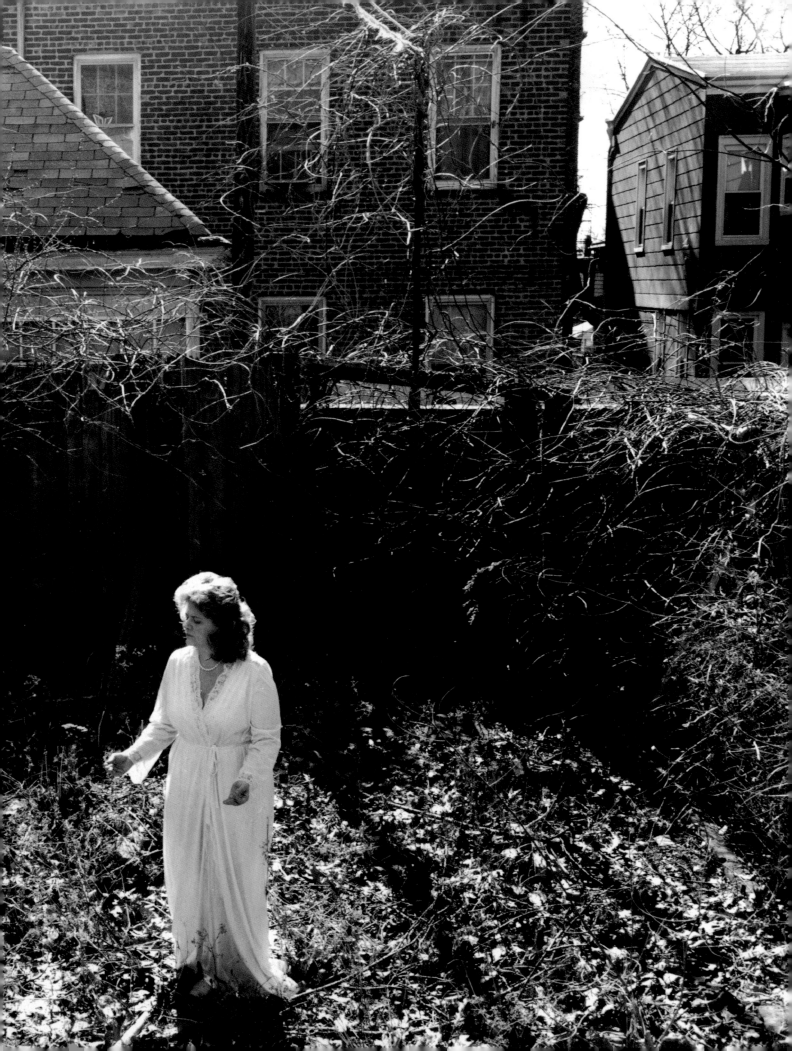

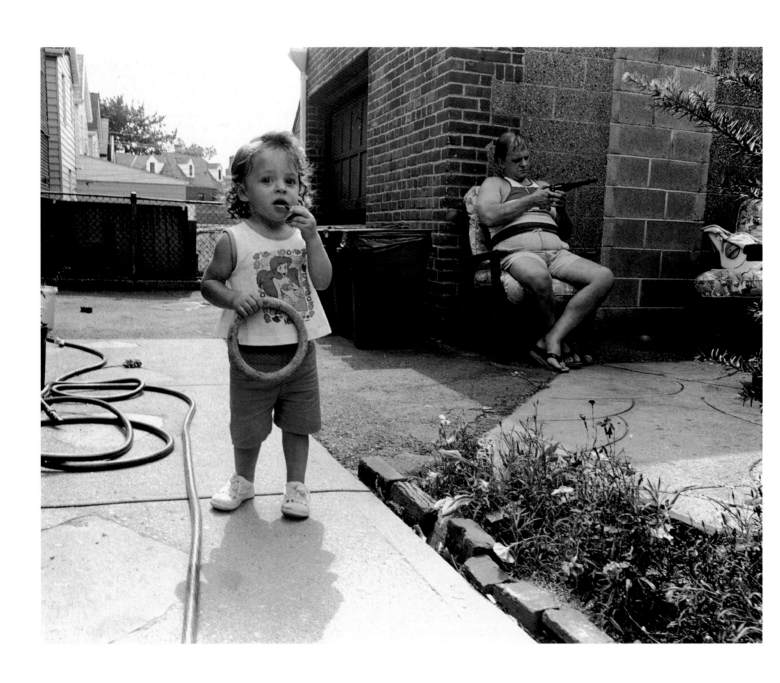

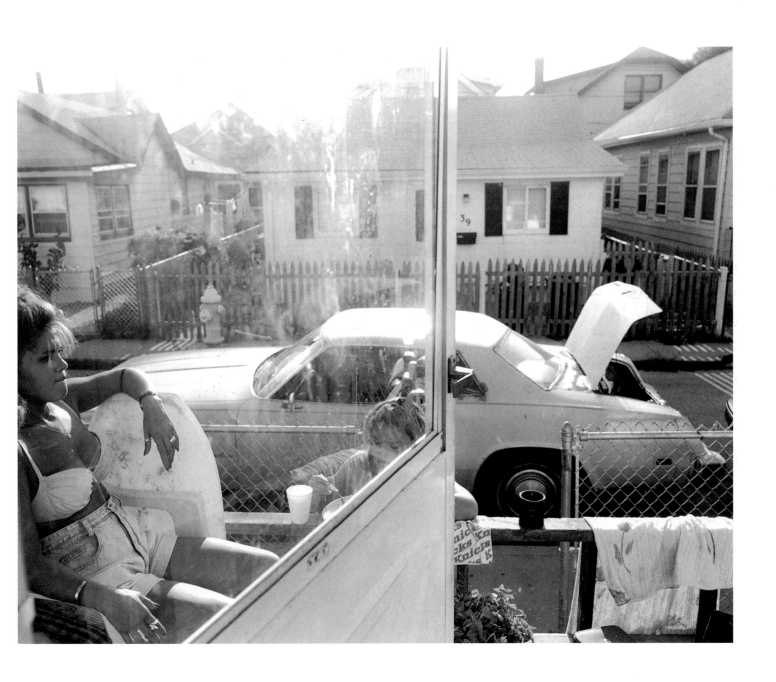

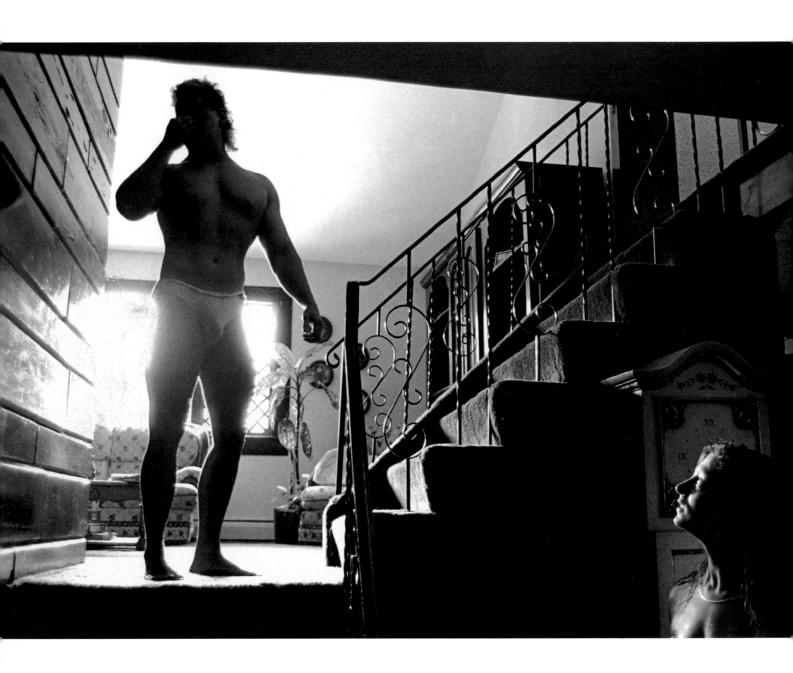

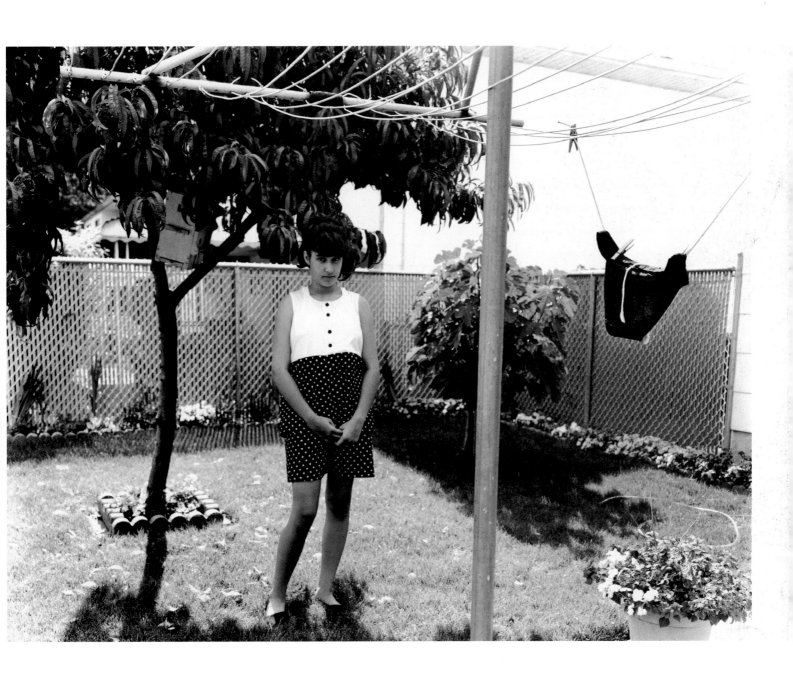

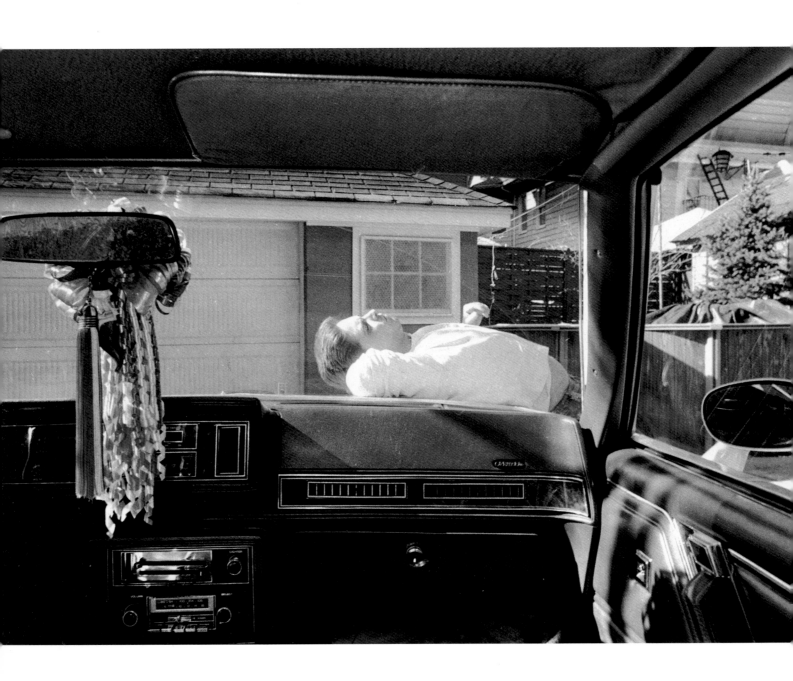

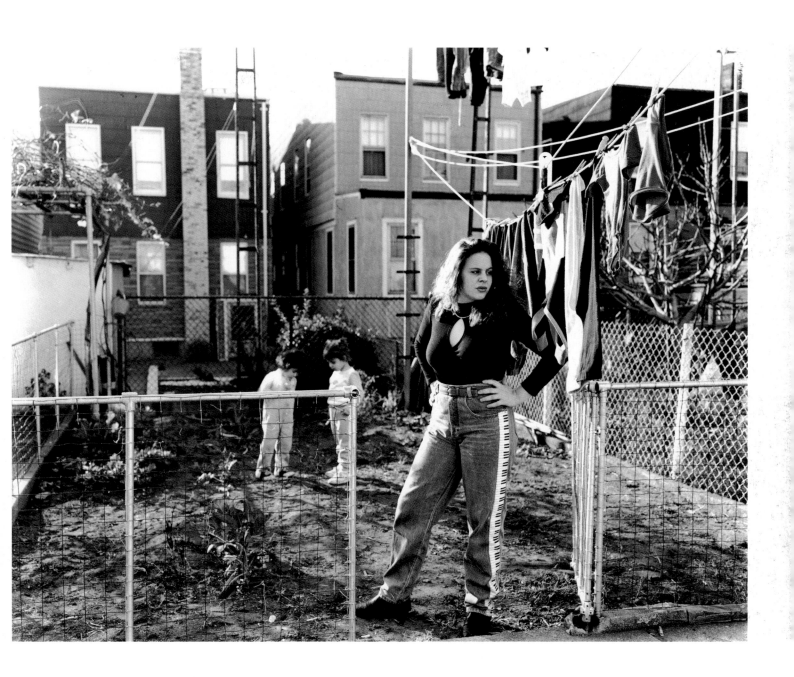

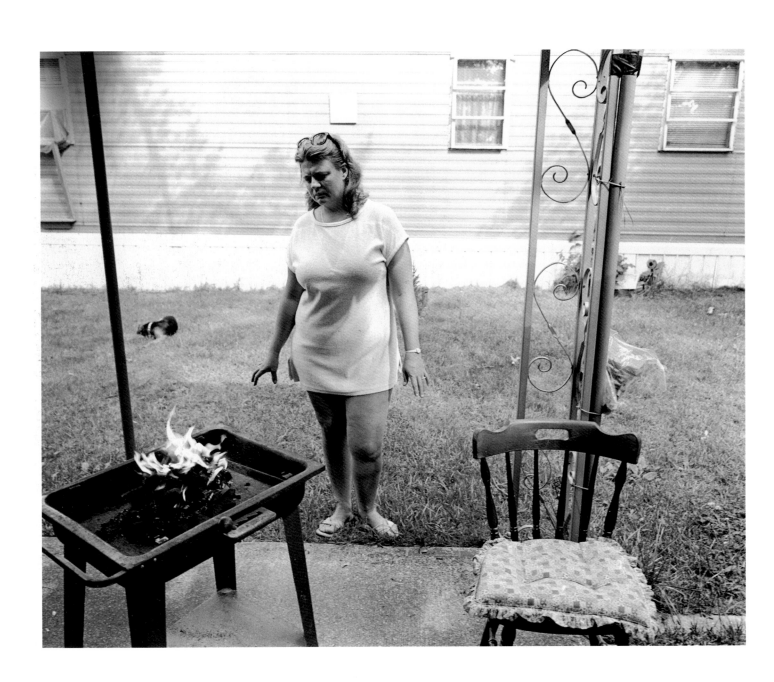

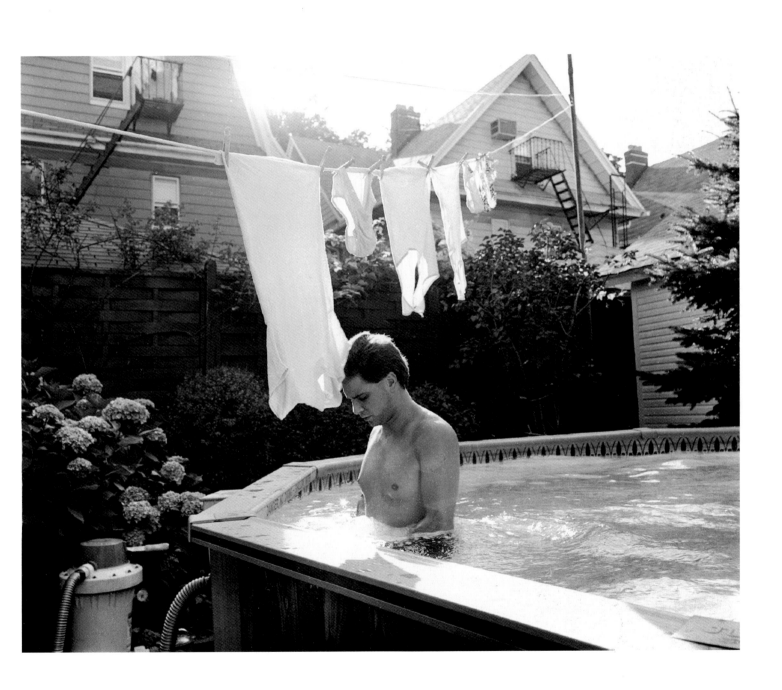

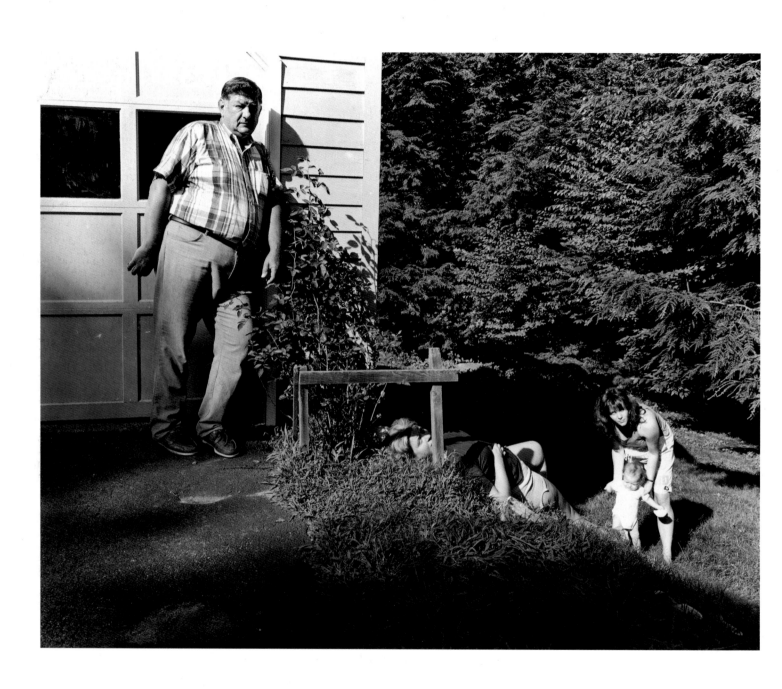

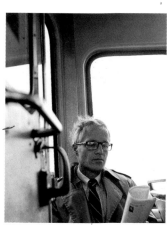

just like Clark Kent

He was ~ ~ a journalist on a major
metropolitan newspaper

r kids' dads

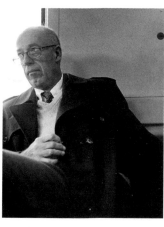

(who were local optometrists or
Toys "R" Us executives)

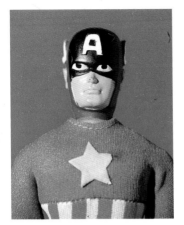

(who was really Superman)

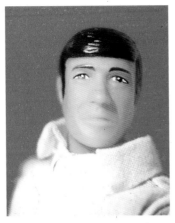

as played by Christopher Reeve

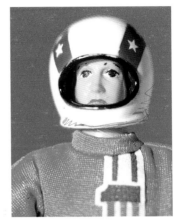

they would always slip down his nose because they were too big and he would push them up with his middle finger

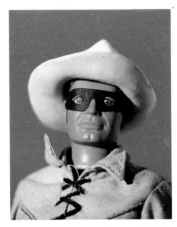

just like Clark Kent

just like Clark Kent

(who was really Superman)

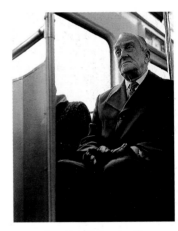

as played by Christopher Reeve

My mother reminded me of this, but

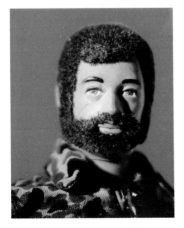

led much more exciting lives

Born 27 January 1971, Wilmette, Illinois. Attended University of California–Santa Barbara; graduate of the School of the Art Institute of Chicago; M.F.A., University of Illinois. "My obsession with these guys could translate into what many people would say is an immersion in pathetic ideas about masculinity, and a lack of critical distance to patriarchal culture." Ken Fandell's sense of playfulness and everyday things is the core of his work. He downplays the degree to which high art influences his work. "If this work is about the creation and construction of identities it only makes sense to go right to the source of so many of them—the entertainment industry." Fandell lists Chicago, sports, Hollywood, and MTV as major influences. ¶ "These images are from a 1993 project entitled *Brought to You By*. The piece is representative of my explorations into the malleability of the border separating so-called facts and fictions. The mixture of traditional documentary practices—the black-and-white images of the men on the El, as well as the autobiographical information about my father—with the consumer-fetish images of the 'created' male icons confuses (erases?) the distinctions between constructs of truth and fantasy. I also think it's kind of funny."

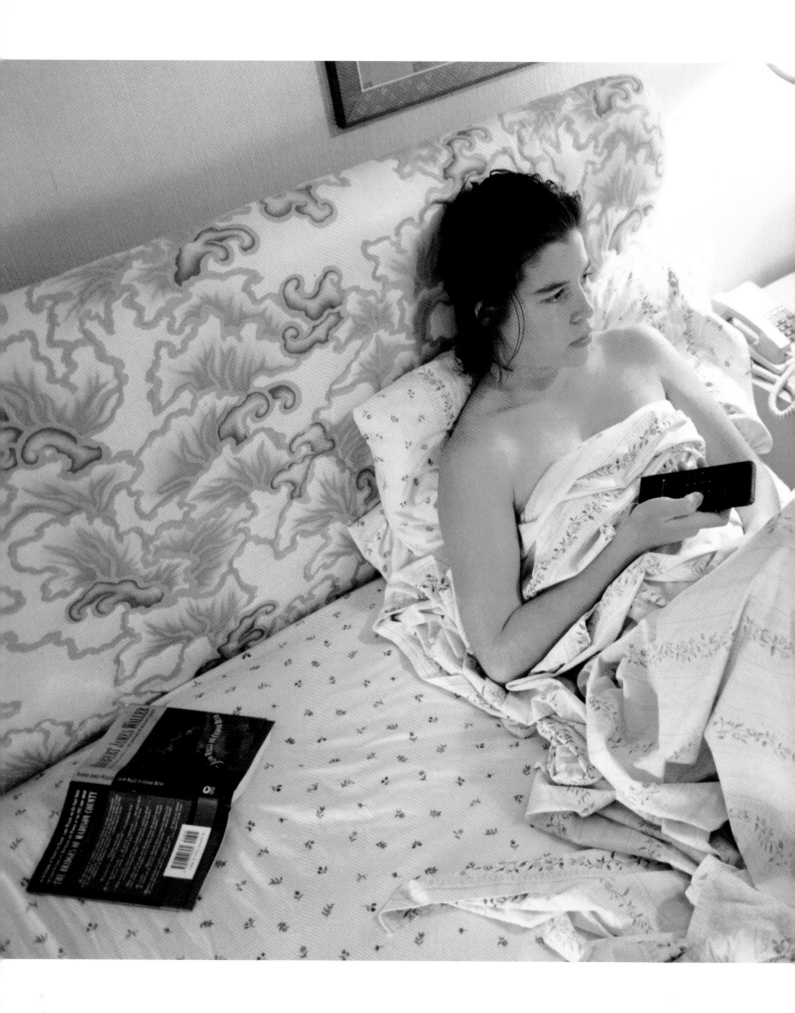

KORA MANHEIMER

Born 20 December 1972, Thisted, Denmark. Family returned home to United States when Kora was two. Attending The Cooper Union.

"Most of the work I do is not concerned with any one subject or message—it is concerned with the reality of human experience. But photography is not a medium that does a very good job at this. People teach the easy things in public by interacting; private relationships are more complicated. I learn by watching people. I try and figure out what it is I want to know, then take what people give away to the camera."

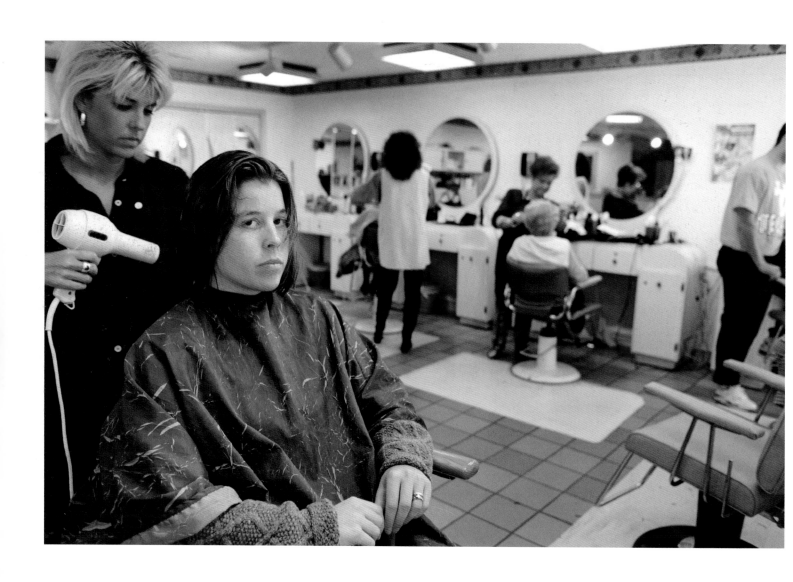

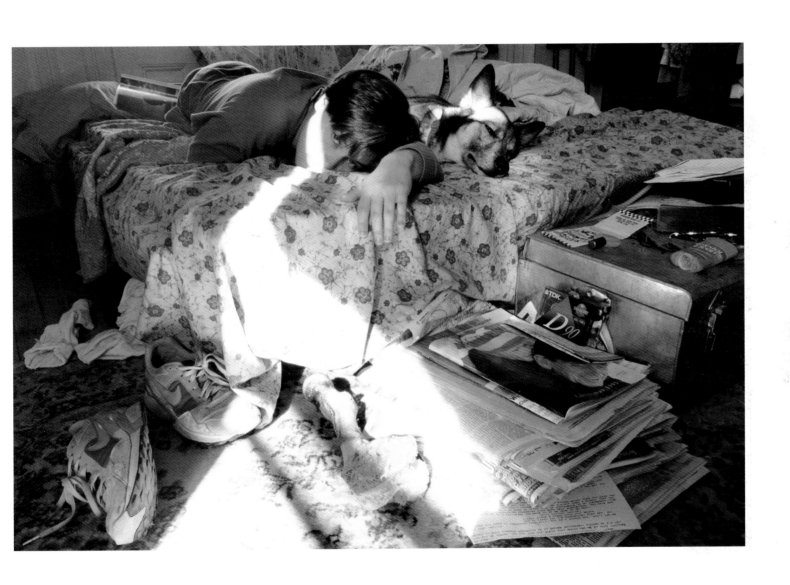

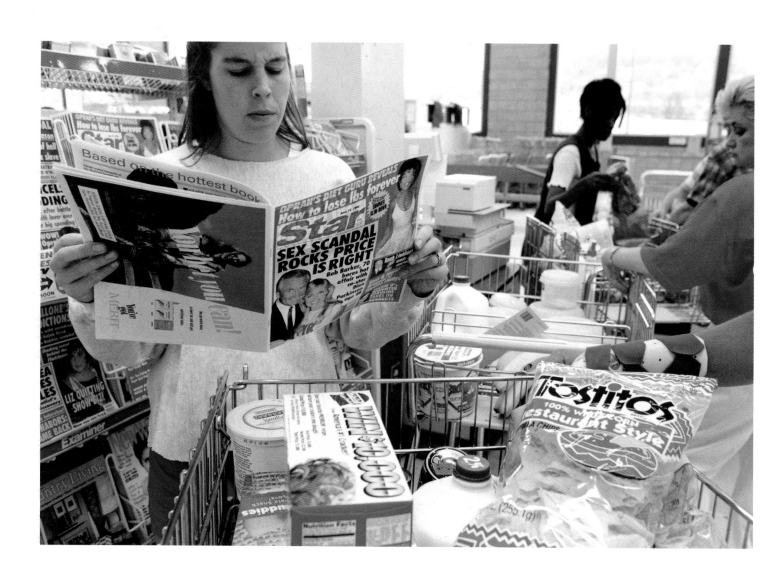

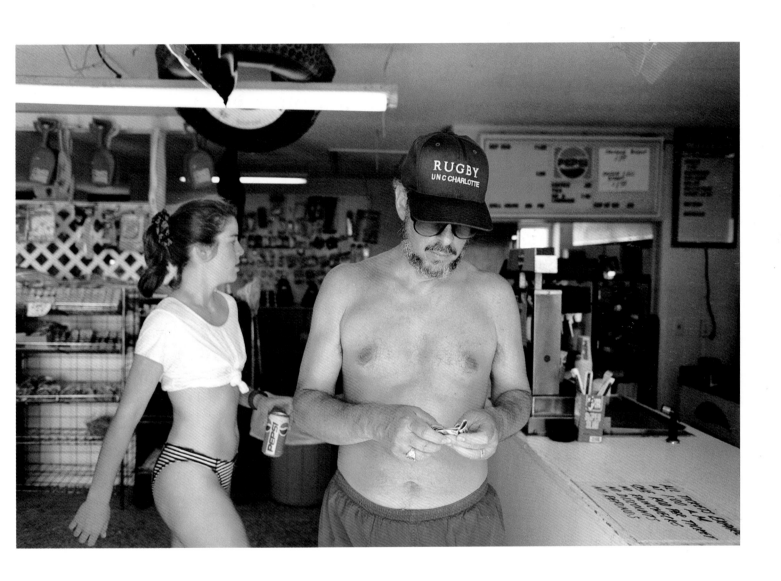

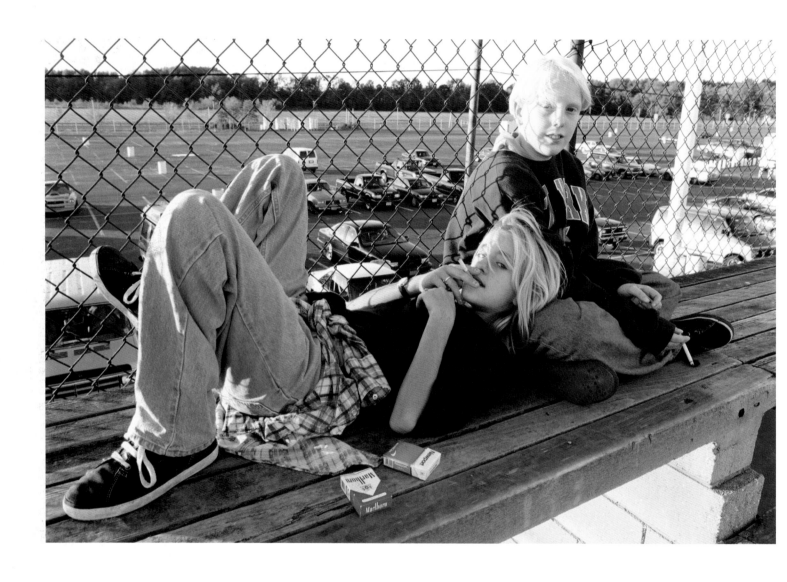

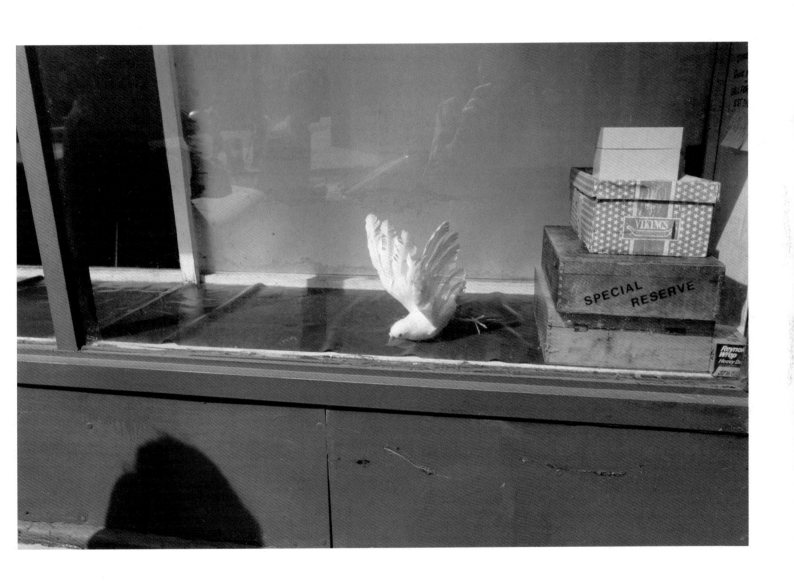

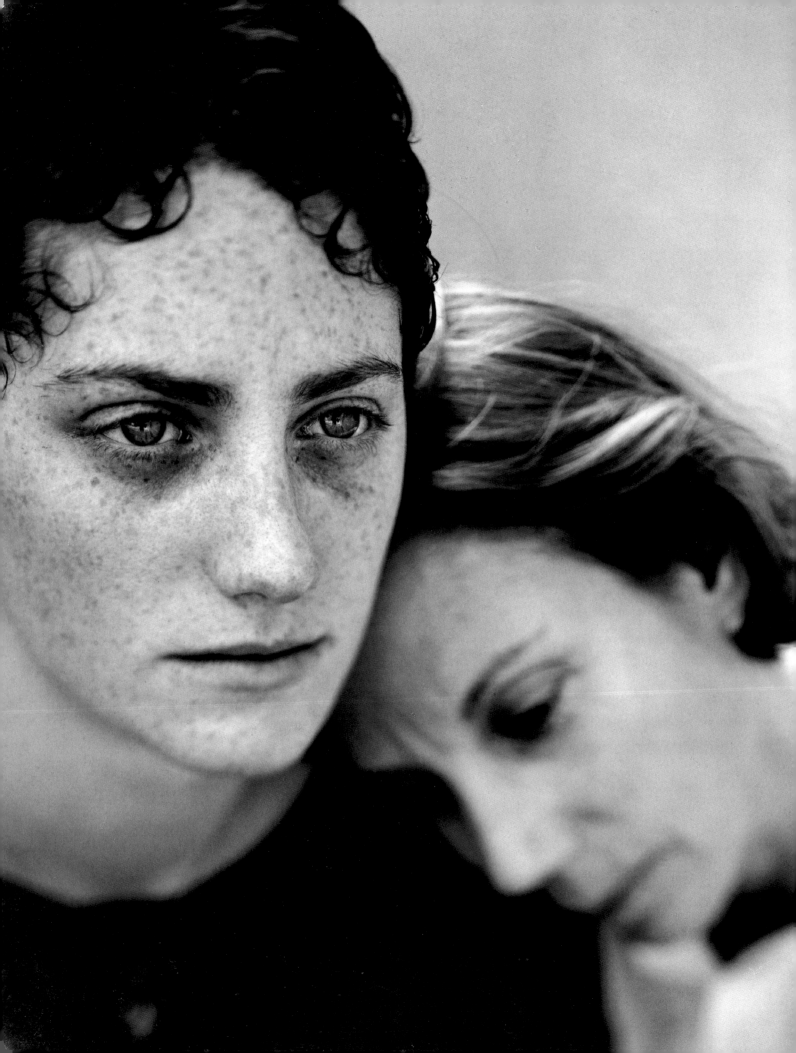

MALERIE MARDER

Born 27 February 1971, Philadelphia, Pennsylvania. Graduate of Bard College. Malerie Marder's first pictures were of family, friends, and lovers because they were the people she was most intimate with. Marder refers to these images as "a photo album of sorts." When asked about her process, she says, "I don't know why I photograph the way I do. I often guess at exposures. My picture taking can be slightly haphazard. Some of my favorite pictures from college were obtained by using my flash incorrectly. I've never had a problem letting the accident happen. It's not that I deny that I'm a technician, but I think my greatest successes have come through a willingness to be awkward. All of this is why I take pictures of people, because, unlike still life, people are random. I like to find the part of the person that is not in control. And I don't mean frenzied or crazed, I mean open. I heard a man in his nineties being interviewed on National Public Radio. He talked about a recurring dream. It was really more of a phrase, a feeling. He said, 'I don't want to leave this party. I don't want to leave this party.' That's the kind of person whose picture I want to take."

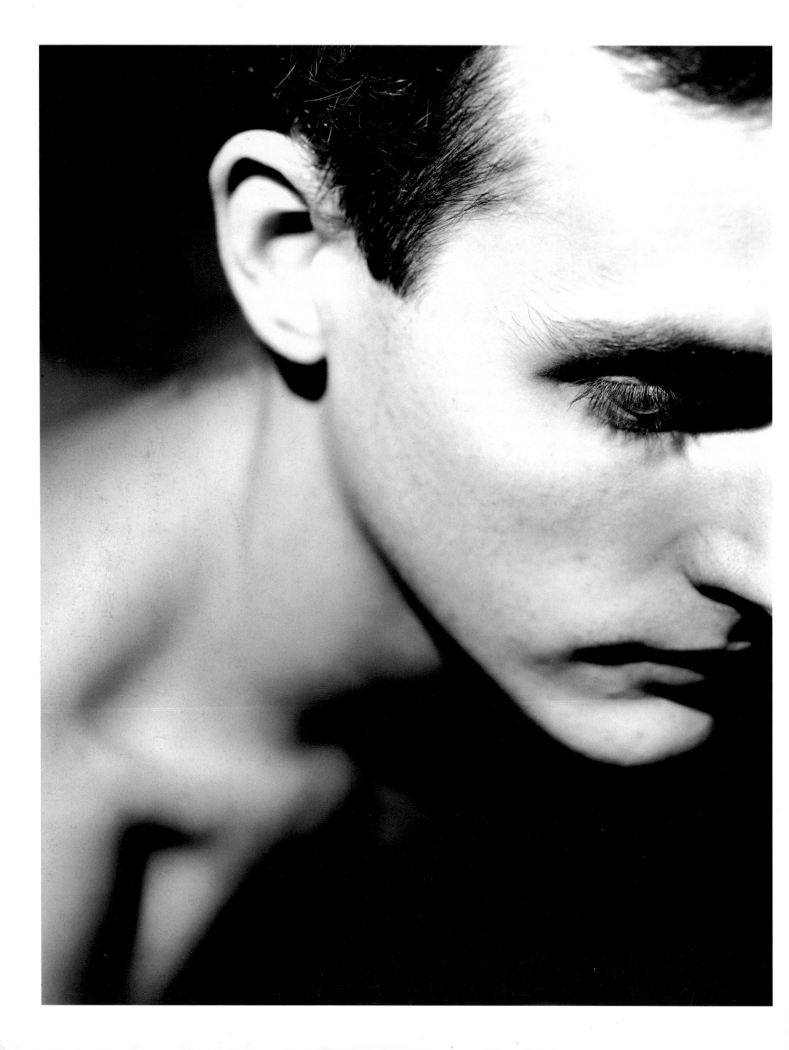

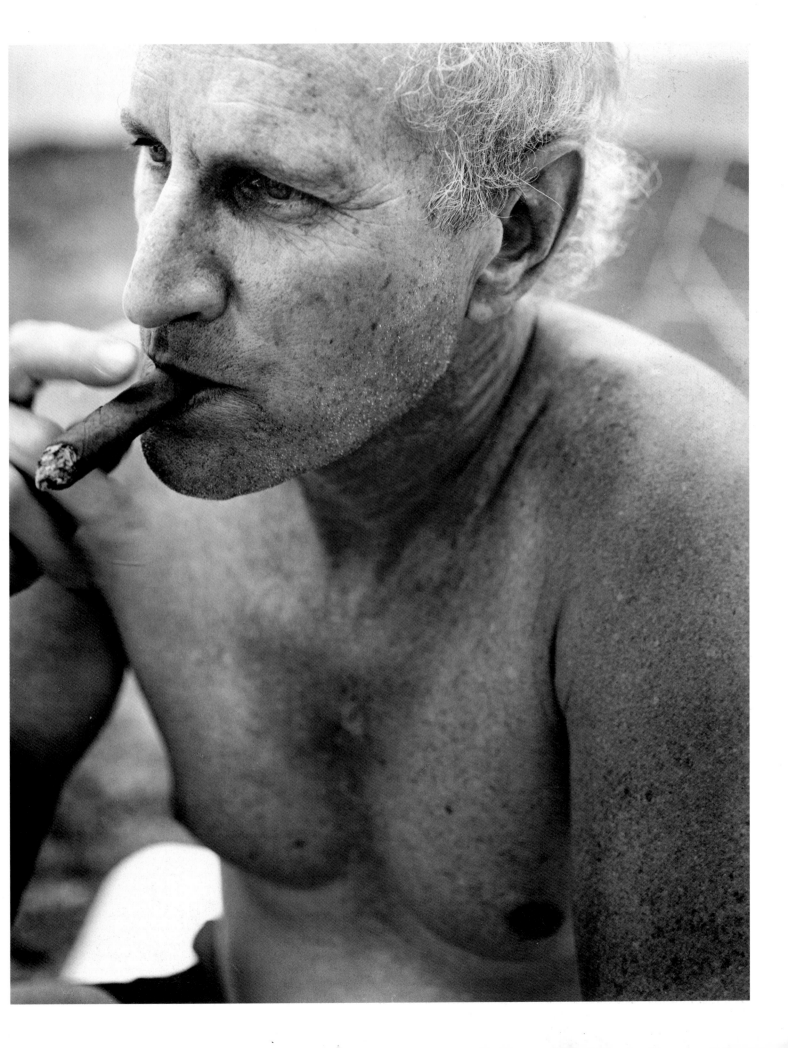

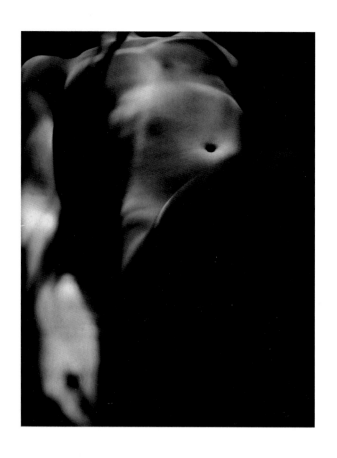

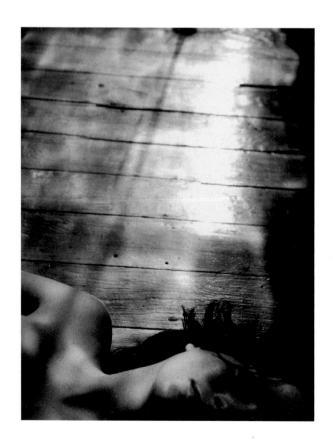

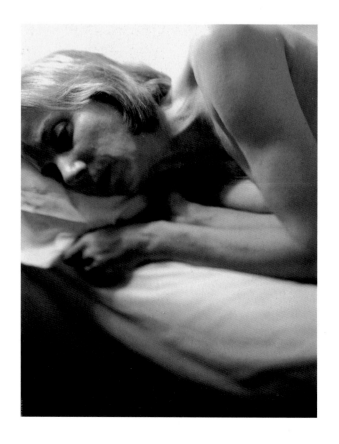

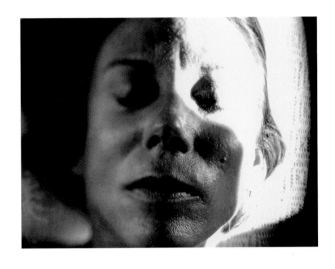

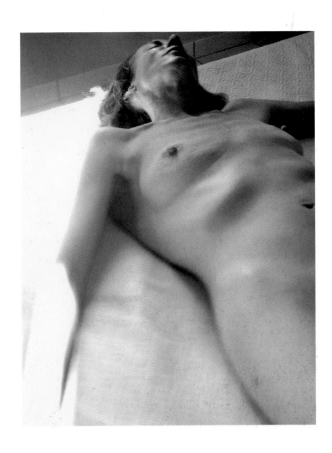

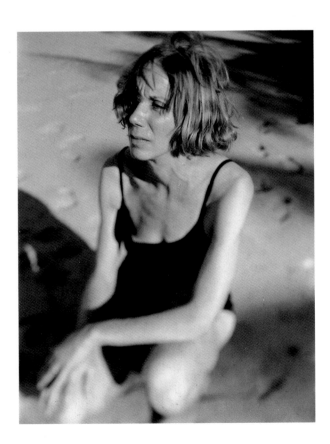

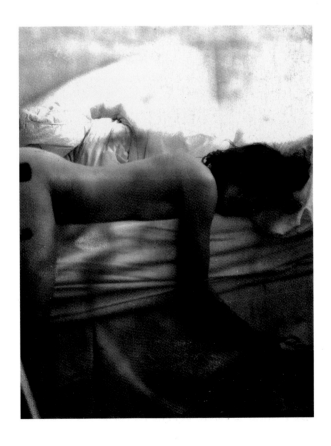

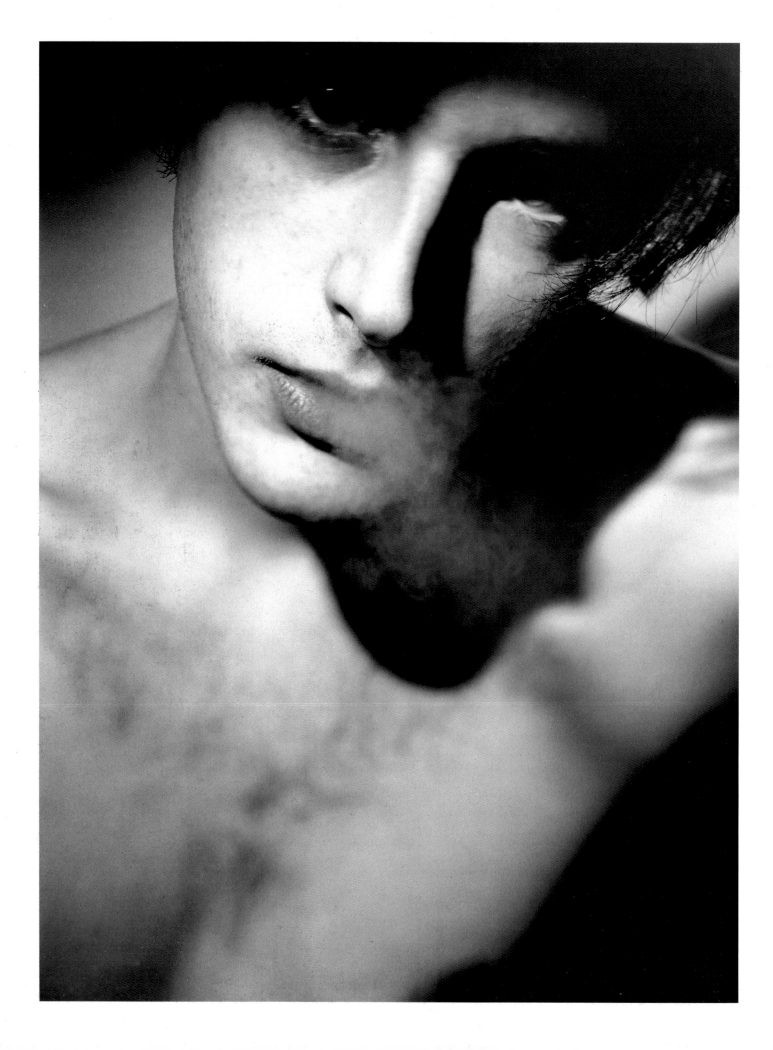

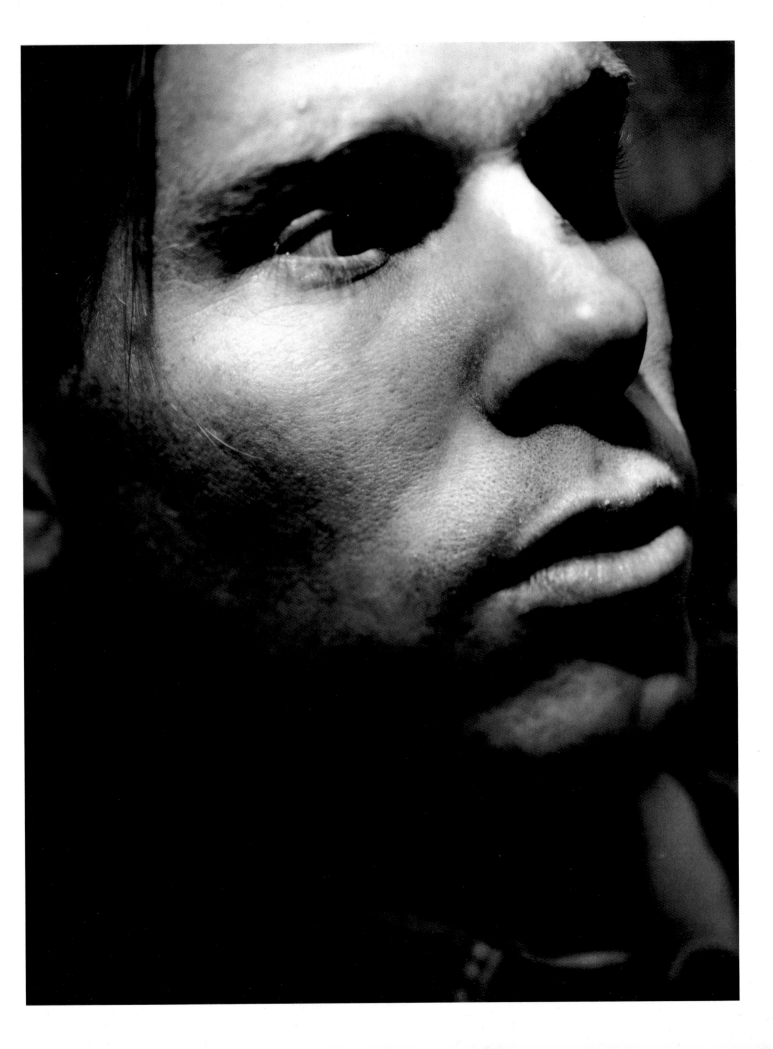

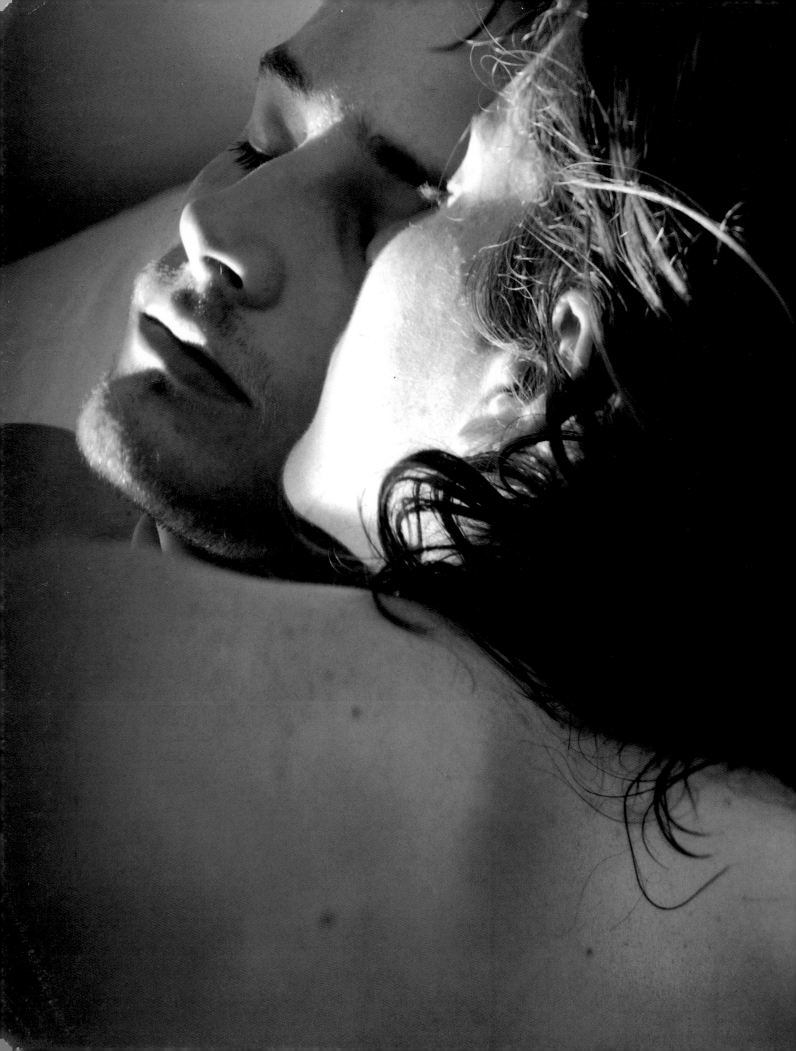

25 and Under / Photographers
© 1997 by Alice Rose George
Introduction © 1997 by Robert Coles
All photographs appearing in *25 and Under / Photographers*
are copyright by the artist.
All rights reserved
Printed in Singapore
First Edition

The text of this book is composed in Futura
with the display set in Futura Condensed and Futura Heavy.
Manufacturing by Tien Wah Press
Design associate: Francesca Richer
Managing editor: Alexa Dilworth
Editorial associate: Armin Harris
Cover photographs by Tracey Chiang, Brian T. Moriarty, and Reuben Cox

Library of Congress Cataloging-in-Publication Data
25 and under: photographers / edited by Alice Rose George;
introduction by Robert Coles.
p. cm.
"A Doubletake book."
1. Photography, Artistic. 2. Young photographers--United States.
I. George, Alice Rose, 1944-
TR854.A1633 1996
770'.92'1273--dc20
ISBN 0-393-31576-2

W. W. Norton & Company, Inc.
500 Fifth Avenue, New York, New York 10110
http://web.wwnorton.com
W. W. Norton & Company, Ltd.
10 Coptic Street, London WC1A 1PU

1 2 3 4 5 6 7 8 9 0

DoubleTake Books & Magazine
publish the works of writers and photographers
who seek to render the world as it is and as it might be,
artists who recognize the power of narrative to
communicate, reveal, and transform.

DoubleTake
Center for Documentary Studies at Duke University
1317 West Pettigrew Street
Durham, North Carolina 27705
http://www.duke.edu/doubletake/

To order books, call W. W. Norton at 1-800-233-4830.
To subscribe to *DoubleTake* magazine, call 1-800-234-0981, extension 5600.

BOOK DESIGN BY YOLANDA CUOMO, NYC